John Coplans

London Projects

Provocations

Writings by John Coplans

Edited by Stuart Morgan

First published in 1996 by London Projects

ISBN 1 900602 00 8

London Projects
47 Frith Street
London W1V 5TE
Tel 0171 734 1723
Fax 0171 734 1722

A limited edition of 50 copies with an original
drawing by John Coplans is available from the
publisher, price on application

Co-ordinated by Robert Violette
Designed by Peter B. Willberg
Typeset by SPAN, Surrey, England
Printed and bound in Italy by Grafiche Milani

Contents

Introduction by Stuart Morgan

In the course of his life, John Coplans has been a soldier – during World War II he served with the Kings' African Rifles in Ethiopia and Burma – then a painter; a teacher; the founder and editor of an art magazine (*Artforum*), first in Los Angeles, then in New York; a curator and director at two large American museums and latterly a photographer. In each of these fields he has excelled, and in each his voice has been informed and independent and, in the best sense of the word, amateur. "Amateur" means "lover"; he wrote about what he liked or what seemed to demand comment. Between 1962 and 1980 when he wrote art criticism – articles, interviews, catalog introductions – his voice was informed and independent. What was distinctive about his mind and the way it worked was ingenuity, curiosity, independence, range, above all the sense of a pattern emerging without pressure, and of its importance.

One of Coplans's strengths was empathy. Descending Robert Smithson's *Amarillo Ramp*, wrote Coplans, meant retracing your steps. In his own words, there was no choice but to move "past your own past" in order to understand "the construction of the construction." His *own* words? Suddenly the reader is aware that something strange has happened. So familiar has Coplans become with Smithson's mind and its perverse workings that a feat of ventriloquism has taken place, and the critic's phraseology has become an exact imitation of his subject's. ("Imitation," perhaps, in its true classical sense). A similar but more deliberate act of transference is effected in Coplans's freewheeling, poetic homage to his friend Philip Guston. Half Bottom, half H. C. Earwicker, Coplans's Guston inhabits a private world in which "appurtenances" become "portents" and where to others his perpetual, age-old battles seem ceremonial, phantasmagoric. Is Guston asleep or awake? (Morton Feldman remembered watching him stand very close to a canvas, take his brush, paint a long vertical stroke, then, spluttering with laughter, ask where it was and what on earth he had just done.) He "cocks a drowsy eye," the author remarks: a phrase that recalls nursery-rhymes. But such studied simplicity is short-lived; in the penultimate paragraph, Coplans seems on the point of revealing his darker purpose. When it is revealed, it is not at all what we anticipated; the entire essay, he tries

to pretend, has been nothing more than a defense of smoking. Perhaps a red herring – or a smoked herring – was only to be expected. For by this time Guston's "agglutinations" and "muddled slurps" have acquired a psychoanalytic aspect, not to mention a political one. Literally and metaphorically, Coplans reminds us, artists live from hand to mouth.

How, then, do *critics* live? Though art historians pride themselves on their expertise, the cosiness and specificity of such a legitimized role can become a barrier to perception, particularly to any personal dialogue with the art. Though he can write like an art historian when he chooses, Coplans is too passionate to be a pedant. In addition, his interests are his own. As we should expect from a photographic expert, time and space become talking-points, but also the particular times and spaces that photographs permit. So in his essay "C. E. Watkins at Yosemite" Coplans's rediscovery of an ignored nineteenth-century photographer provides opportunities to envisage pre-history as well as to ruminate on the relationship between photography and landscape in nineteenth-century America. "They throb with a mythical quality," Coplans says of Watkins's studies, and proceeds to describe an Adamic sense "of mystical revelation that somehow manages to impart an allegory of American space." In the photographs of Watkins and later the painting of Clyfford Still, Coplans was responding to genesis itself: a sense of "shadowy traces of primordial presences or beings," words from the elegy he wrote for the scholar Robert Goldwater, who like Coplans, had travelled to Africa and made contact with pre-Western cultures. The similarity of that phrase to certain imagery in Abstract Expressionist painting – Mark Rothko's early painting *Slow Swirl by the Edge of the Sea*, to choose just one – is so marked that a question arises. Is it possible that every analysis Coplans has undertaken has also been a chapter in history of the relationship of space to its depiction? He marvels at Brancusi's "astonishing" ability to make a photographic adaptation of the principles of Synthetic Cubism, for example, or describes the particular sense of "urgency" about Cézanne's watercolors that led first to Cubist theory in Paris and even, finally, to structures in the paintings of Willem De Kooning and Franz Kline in New York. Underpinning all these studies is the possibility of a shared, social ideal, and the prospect of the collapse of the avant-garde.

8

If Coplans's idea of Modernism is of Europe ending in New York, then his attitude to Post-Modernism – a word he would never use – is of an eternal return: the same ideas continually reincarnated in ever cooler, ever more ironic guises, as in the paintings of Roy Lichtenstein. The thinking, the operations and the products of Pop involved a "hands off" approach. ("I want to be a machine," Warhol stated.) Instead of regarding this as a straight-faced urge for self-erasure or extreme realism, Coplans chose a different option, one resistant to ready-made stylistic categories. For him, the logical result of Pop – in other words, art as fashion, the acceleration of the avant-garde – was to propose a single, timeless *lingua franca* which escaped the various, independent languages of Modernism. Perhaps it most closely resembles what others called Constructivism, albeit that purposefully dumb take on Constructivism which characterizes (say) an early Donald Judd. But there are reasons why Coplans's writing on serial imagery flouts details of nomenclature; serialism, as he defines it, leaps over fences – fences like "Conceptual Art," a term he disregards. And though seriality is a matter of process, it has nothing to do with what others called Process art, or the drama of the brushstroke but instead with one kind of mental and physical decision-making. "When is a painting finished?" was a question debated a decade before at the Cedar Bar. (Coplans may or may not have been present but he certainly had the last word, answering "Never," as any self-respecting critic should.) Though, ironically, his self-appointed task in his study of seriality was to remind readers of the significance of framing, size, stretcher thickness, and other Ab-Ex fetishes, his recommendations would not have been music to the ears of Cedar regulars. Indeed, instead of a solution based on touch, amount – in short, sensitivity – he advocated what to them must have seemed the dumbest solution of all: that none of this mattered. More important was the fixity of the chosen unit, the evenness of the beat. Ironically, the result was what every Romantic yearns for: a recipe for creativity itself, the possibility of a vehicle for increasingly subtle meaning as well as ever greater significance, as additions are made to the series and to the idea of that series. In retrospect, too, it is a vindication of classic statements such as Warhol's notorious "I want to be a machine," as well as an attempt to satisfy a long-term need of Coplans himself: to perpetuate

the avant-garde by making it possible for increasingly intricate problems to be set and solved, problems that arise from independent inquiry rather than general consensus, making of each artist a potential Monet or a Josef Albers. (Only by taking this point is it possible to understand, for example, Coplans's remarks about the uneven quality of Mondrian's brushstrokes.) Was this a full-blooded attempt to subvert the avant-garde at the same time as regenerating it, the prospect that Smithson foresaw and even planned to subvert by the use of paradox and by constant reference to some kind of temporal impaction? Or could it have been an examination of the role of chronology itself as it relates to art – in other words a conflation of Genesis and Apocalypse?

What does Coplans require of artworks? Clues can be found in his Turrell essay: "vividness," "sensuousness," "mysteriousness,"... There are more. From early appreciations of Joseph Cornell and Wallace Berman to his quizzical account of Warhol, who painted his portrait, and above all his essay on Weegee – a "primitive" whose gift of "vital insensitivity" verges on absolute "slobhood" – it is possible to measure the depth of Coplans's regard for the naïve, a word so often employed by others as a term of dismissal but which he reserves for pure genius. (He even describes Cornell as a "Renaissance man.") Respect for naïveté might explain his celebration of Pop: its breadth, its democratic humor, its limited use of irony but above all – a point Coplans is always at pains to emphasize – its surreptitious critique of European culture, which he regards as a graft that, even after centuries, has still not taken in the United States. Americanness, regarded as radical innocence, looms large in Coplans's thinking. For this reason his approach to Pop, for instance, differs from that of other critics; he is prepared to recognize the snobbery involved in displaced "culture," as well as the irrelevance of European paradigms to that genuinely American art which still has to appear. (Coplans's essays on Donald Judd and Roy Lichtenstein praise these men as inventors and prophets of a new perception. In the same way he lauded Peter Voulkos and his reinstatement of the ceramic medium on the West Coast.) What genuinely American art might look like is hard to envisage. Yet Coplans senses democracy of vision in a Judd sculpture, and does not hesitate to use the word "beauty" to describe Warhol's airborne (and therefore free), silver, helium-filled

balloons. Similarly, in the final, contemplative paragraph of "Serial Imagery" he regards seriality as a form of ritual celebration, responding to its industrial aspect as a positive force: music to the ears of a society which allied itself to the machine long ago and which delights in celebrating the subtlety of its man-made rhythms.

But not only in celebrating them ... For in Coplans's writings, Serialist strategy crops up so frequently and with such varied implication that it almost serves as surrogate for "democracy" or "freedom." It has to do with plenty, Coplans decides in his essay on Brancusi's photography, arguing that Brancusi was "pursuing a continuously renewing potential." Despite this, for him Serialism also has to do with the deadening consequences of profusion. In an essay on Andy Warhol written in 1970, Coplans stresses three principles of serial imagery – redundancy, repetition, and abundance – then thinks of three more: equality, inertia, and the appearance of similarity. Add a phrase from the same essay – "neutral emptiness" – used to describe Reinhardt's space in his paintings, then try to translate these words into social terms. The result could be read as a description of the 1960s in America, a nation of cornucopic potential but also of deep-rooted unrest, based on manufacture and the wealth that it brings – the essential subject-matter of Pop – as well as on rigid social roles and the way in which law and order were enforced. This was the decade of Black Power, presidential assassination, and widespread student unrest. Coplans was a friend of the British critic Lawrence Alloway and was aware of his work at the ICA in London. If other intellectual influences are evident here, they are the writings of Gertrude Stein, of George Kubler (author of *The Shape of Time*), the *dicta* of painter and theorist Ad Reinhardt and the entire existence of the unchallenged *maestro* of inertia, Andy Warhol. It is a short step from these connoisseurs of redundancy to the novels of Thomas Pynchon or the sepulchral Robert Smithson, a Renaissance man gone wrong, with his theories of entropy and passion for making matters worse: the imp of the perverse Coplans might be trying to describe when he pictures Warhol as the combination of Samuel Beckett and Jean Genet.

Coplans's longest essay, first published in 1975 and subtitled "Diary of a Disaster," marked his farewell to curating. In it, focus on ideas and

artworks was replaced by analysis of the museum system itself. The cautionary tale of "Pasadena's Collapse and the Simon Takeover" is neither short nor simple. (Indeed, it involves so many characters replacing others at such speed that it is as if someone kicked the top off an anthill.) Combining the breakneck pace of Marx Brothers comedy with the deep foreboding of a Greek tragedy, this account of the decline and fall of the Pasadena Art Museum would have given Edward Gibbon insomnia. It involves power first and foremost, plus unbridled stupidity and egotism, not to mention mendacity, vanity, betrayal, waste, lack of foresight and sheer, undiluted ineptitude, all on a scale so colossal that Cecil B. DeMille could hardly have done it justice. Nostalgia has no place in these memoirs. What should have been Coplans's wistful farewell to curating reads like a postcard from Hell.

Provocations

Notes on the Nature of Joseph Cornell *

Cornell lives in Flushing, New York. He was born at Nyack, New York, in December 1903. Little is known about the artist's early life, though a schoolboy interest in the theater, history, and symbolist poetry is revealed. There is no record of college education or formal art training.

There is little doubt that there was a special cultural climate in New York during his early years. The Armory show of 1913, which in turn produced the Stieglitz Gallery, the first avant-garde gallery in America, featured photography as much as painting. The climate of opinion at that time considered that photography, and the movie, would open a new avenue of illusionistic and fantastic art. In New Jersey, in about 1916, Mark Sennett formed the Vita-Graph Film Company. Also, during these early years, the first visit to America of Cornell's favorite artist, Marcel Duchamp.

At the very inception of the film media replacing the theater, Cornell sees that this is the new avenue to follow as an artist – fantasy and illusion not achievable on the live stage. Believing that it could be a tool of the highest art he becomes by choice a film artist. He collects one of the most complete libraries of films and stills photographs of Chaplin, Sennett, etc. But the commercialism of this world soon cuts him off: nor, it should be noted, were any of the early film writers great artists. What he thought would open the doors to the furthest reaches of fantasy instead ruthlessly shaped the stereotyped movie star. (He has never met a movie star, yet he reads about them avidly and has written about them. He published an essay in *View* in 1942 on Hedy Lamarr entitled "Enchanted Wanderer.") The only way he had been able to make movies himself was to re-edit and collage existing material, occasionally shooting a sequence. (Bruce Conner is a later spontaneous case.)

The earliest known work of Cornell outside of film is a work of about 1929, called *A Watch-case for Marcel Duchamp*, but there may have been earlier ones. We do not know exactly what he was doing before this time, but we do know that he had begun his incredible collection of

* First published in *Artforum*, March 1963.

documents, primarily nineteenth-century, but ranging widely over other periods. These documents led to the most personal and visionary reconstruction of the history of art.

Cornell's art appears to be based upon the notion that the most basic data on the nature of things is recorded in all manner of ephemera, that is, things short-lived and soon to be destroyed. Decayed and peeling plaster, postage stamps, theater stubs, a fading photo, the movements of a hand of a clock, yellowing newsprint, emblems of nations and insignia of noble and powerful families that no longer exist, soap bubbles (ephemeral planetary spheres that last a few seconds).

A Theater of Things, doomed to vanish, change or be destroyed. The last movie that he did was when the Third Avenue El was torn down in the forties. It has been a dramatic means of transport for the populace of the city. What was originally a shining, new, and clean marvel of engineering shifted from a romantic landmark of New York City life into depressing squalor. Youthful beauty to old age, decay, and eventual dissolution. Cornell arranged to have a documentary made before it perished.

In understanding the importance of ephemera to Cornell it should be noted that he has steadfastly refused the ordinary avenues of publication, such as catalogs and books, in preference to the throw-away leaflet or the magazine.

Cornell sees man in a theater of formal design and elegance, like ballet. He loves the formality of the imaginative theater as much as the formality of science, all of which he sees as poetic revelation where the most banal and trivial facts often carry the reality of the matter, in contrast to the historians, who are most terribly destructive. In their attempt to strip away the trivia they are left with hollow truths.

Two broad categories of work:
 I. On the Nature of Things (in the Lucretian sense)
 A. Soap-Bubble Sets
 II. The Oblique, symbolic memorials and portraits.
 A. The Taglioni Jewel Casket of 1942
The Casket, in the possession of the Museum of Modern Art in New

York, is labeled with the following anecdote: "On a moonlight night in the winter of 1835 the carriage of Marie Taglioni was halted by a Russian highwayman and that enchanting creature commanded to dance for this audience of one upon a panther's skin spread over the snow beneath the stars. From this actuality arose the legend that to keep alive the memory of this adventure so precious to her, Taglioni formed the habit of placing a piece of artificial ice in her jewel casket or dressing table where, melting among the sparkling stones, there was evoked a hint of the atmosphere of the starlight heavens over the ice-covered landscape."

 B. The Nearest Star (M. M.), of 1962.

From the farthest star and physical reality to the most intensified personal identity – the Nearest Star: Marilyn Monroe.

Other categories: The Thirties and Forties:

 I. *Time and Space* (from 1929 to the mid thirties).

 A. *A Watch-case for Marcel Duchamp.*

The watch-case contains a little stack of layer upon layer of pictures. Time and movement revealed through a matrix of images.

 B. *Four Wooden Cylindrical Chemical Containers.*

When opened, a similar compass is revealed in each container and, as usual when compasses are placed close to each other, each points to a dissimilar North. The piece is a complicated visual metaphor: four containers of matter, Air, Earth, Fire, and Water, opened, define space.

 C. *Untitled Object* (1933).

A pillbox covered in shiny black and white lacquered paper. On the inside bottom of the pillbox is a drawn emblematic image of snail-shells, two chromed springs, a chromed ball-bearing and an actual snail-shell. The combined image is another complex visual metaphor on phyllo-taxis: the Golden Mean and Divine proportion. The ball rolls through the springs into the snail shell; it's also a game. This piece reminds us that Cornell, when asked the nature of his art, replied "They are games for mathematicians."

 II. *The First of the Soap-Bubble Sets* (from the mid thirties).

 Evolving around the Galilean concept of the universe, combined with a child's sense of wonder. We are reminded that Einstein

17

completed his Theory of Relativity in the year of Cornell's birth.

III. The Memoriams (1930s, 1940s).

 A. On individuals like Taglioni and Judy Tyler.

 B. On lovers and travelers and journeys involved with love, night, and stars.

 C. Those that involve dancers. In this series of works, women are dancers, men are scientists, men and women are lovers, but dancers are also doves. Cornell has an encyclopedic knowledge of known and unknown ballet dancers of the last two hundred years.

Other categories: The Forties, Fifties, and Sixties. It is from the late thirties to the present that Cornell has really flowered, though the war seemed to interrupt his investigations.

I. The Miniature Palaces.

II. The Natural History Museums.

 A. The Pharmacies.

 B. The Habitat Settings: aquariums, butterflies, bees, rabbits, birds.

 a. *Habitat Group for a Shooting Gallery* (1933–43).

Usually Cornell would ignore evil or violence. Here, however, is a bullet hole through glass. On one level, each different exotic bird might represent one of the great powers at war. Behind the birds, who are wounded, are splashes of colors (various bloods). The birds are still alive, they bleed, yet Cornell has a desperate hope for their survival. The bundle of newspapers and shot-off feathers is the droppings at the bottom of the box.

III. Back to the Nature of Things.

 A. Sand Fountains.

 B. Sand Games.

 C. Map Toys.

IV. The Hotel and Night Skies.

 A. *Hotel (Night Sky)*, 1952.

Through the window, its panes divided like a gun-sight, the Most Distant Star.

V. The Space Object Boxes.

 A. Smiling Sun.

B. Lunar Level.

C. Other Planets.

D. A return to Cosmic Systems.

a. *The Sailing Ship* (1961). The cordial glass holds the earth in place. An astronomer's explanation of the universe is as rude and elementary a conceit as Cornell's cordial glass: one stands for the other. The ball on the tracks is a planet in orbit. The face has tide tables, charts, the blue front has wavy patterns like the sea. The traveler's hand reaches out for water.

b. *Lunar Level #3* (1960). The loose balls at the bottom of the box are satellites as yet unreleased. This work, like many others, is a still-life arrangement that corresponds to the Dutch seventeenth-century painters' use of navigational instruments and charts on walls. The window to the sky becomes a meteorologist's chart of the different types of clouds at various levels in the sky, the flags on the driftwood show which way the wind is blowing.

c. *To the Nearest Star, M. M.* (1962). The symbol of the rings is that one might start at any point to follow the pathway and continuously come back to, and repass, any chosen beginning. It is Cornell's most recurrent symbol, and corresponds exactly with the Einsteinian sense of infinity (space curves and returns, retracing itself, giving a sense of ultimate totality and self-containment, as revealed not in Oriental mysticism but in Western physics and astronomy). Cornell's drive to establish notebooks and journals of data has overtones of the Complete Renaissance Man. He signs his boxes like Leonardo da Vinci, in mirror-writing, and like da Vinci, is struck with curiosity. But he is not a rationalist, designs no war machines, having totally gentle sensibility. Nor is there room for evil in Cornell's world. He wants to observe, document, and record, but changes nothing.

Each box and thing within is put together in the most simple and direct way, with screws, nails, and glue. Everything looks innocent and true. The peeling decayed plaster walls carry the history of generations – they come from old buildings. He is a key assembler, a true assemblage artist, earlier and purer than Dubuffet. The glass front divides Cornell's world from ours, yet at the same time we can enter into it without

difficulty. Our eyes, which peer into the boxes, are the basic scientific instrument, the hands holding the boxes is the basic tool. The mind binds and links the two together. Cornell constantly re-echoes universals, his boxes highlight the continuity of life, awareness, and knowledge of how the drama of decay makes it bittersweet. The pathways of movement and change through the flow of time, stars in the firmament doomed to burn out, and earthly ones, like Marilyn Monroe, fall too, and in falling are extinguished.

Cornell would love to keep everything he makes; it is important to him to have them:
 a. They are part of a total universe he doesn't like to disturb.
 b. He continuously re-works in order to improve and perfect.
 c. When he does release them, he wants them to go to people who would cherish them – he hates the idea of them being in indifferent hands.
 He is heartstricken at the present commerciality of the art world. He does not regard his work as products, but data.

"From newspaper clippings dated 1871 and printed as curiosa we learn of an American child becoming so attached to an abandoned chinoiserie while visiting France that her parents arranged for its removal and establishment in her native New England meadows. In the glistening sphere the little proprietress, reared in a severe atmosphere of scientific research, became enamoured of the rarified realms of constellations, balloons, and distant panoramas bathed in light, and drew upon her background to perform her own experiments, miracles of ingenuity and poetry."
 — Joseph Cornell, in *View*, January 1943

American Painting and Pop Art *

Although this exhibition is the first to attempt a collective look in considerable depth at the current phenomenon of what for the time being is broadly labeled as Pop Art[1] (as well as those artists who now appear as harbingers of this new art), it has been preceded by a series of important museum exhibitions within the last year that have examined various aspects of the heterogeneous activity:

September 1962 "The New Painting of Common Objects" organized by Walter Hopps at the Pasadena Art Museum

March 1963 "Six Painters and the Object" organized by Lawrence Alloway at the Solomon R. Guggenheim Museum, New York

April 1963 "Popular Art" organized by Mr and Mrs C. Buckwalter at the Nelson Gallery of the Atkins Museum, Kansas City

April 1963 "Pop Goes the Easel" organized by Douglas MacAgy at the Contemporary Art Museum, Houston

April 1963 "The Popular Image Exhibition" organized by Alice Denney at the Washington Gallery of Modern Art

July 1963 "Six More" organized by Lawrence Alloway at the Los Angeles County Museum (mainly a repeat of the Pasadena Exhibition) and show with the travelling version of "Six Painters and the Object"

Abstract Expressionism, the first brilliant flowering of a distinctly American sensibility in painting, is a movement in which the prime innovators and the most important artists are largely based in New York. Another characteristic is that, without exception, all the early work of the painters in this movement can be seen as a direct

* First published by the Oakland Art Museum, September 1963, in the exhibition catalog *Pop Art USA*.

confrontation of, and struggle with, the dominating influences of European painting. In contrast, Pop Art reveals a complete shift of emphasis in both geographical location and subject matter. The first body of work that has emerged from this new movement is widely dispersed between the two coasts – this simultaneous eruption is an important factor neglected by all the organizers of previous exhibitions, with the exception of Pasadena's "New Painting of Common Objects." It points up several aspects of the new art that have received little consideration in the past. The curious phenomenon, particularly in these times of easy communication, of a group of artists widely separated geographically, who appear at roughly the same time with images startlingly different from those which dominated American painting for two decades and yet strikingly similar to each other's work, points to the workings of a logic within the problems of American painting itself rather than to the logic of dealers and pressure groups. If the logic of Abstract Expressionism was hammered out in fiery quarrels in Greenwich Village bars by the most intensely speculative group of painters America has yet produced, the logic of this new art, by a quite different but equally valid process, forced itself on artists geographically isolated from one another and yet faced with the same crisis.

The subject matter most common to Pop Art is for the most part drawn from those aspects of American life which have traditionally been a source of dismay to American intellectuals, and a source of that glib derision of "American culture" so common among Europeans: the comic strip, mass-media advertising, and Hollywood. Some critics argue that the employment of this subject matter places the artists in the morally indefensible position of complacent – if not joyous – acceptance of the worst aspects of American life. Others, however, insist upon finding a negative moral judgment implicit in the work. The artists, for the most part, remain silent or, worse, perversely make public statements feeding the fury of the party they consider more absurd. For of course neither position approaches the real problems of this new art or searches the nature of the crisis which has brought it forth. That crisis is essentially the same crisis the Abstract Expressionist painters faced, and solved so brilliantly in their own way: the problem of creating a distinctly American painting, divorced from the stylistic influences and

esthetic concerns of a tradition of European art which has lain like a frigid wife in the bed of American art since the Armory show. (And why hasn't anyone seen the re-creation of the Armory show as the greatest irony possible in the light of this new American painting?) If, during the last decade, Abstract Expressionism has been thought of – at least in this country – as finally having solved the problem of the creation of a distinctly American art, here is a whole new generation which has engendered widespread confusion by thinking otherwise. Seen from this point of view the painters of the soup can, the dollar bill, the comic strip, have in common not some moral attitude toward their subject matter that some say is positive and others say is negative, *but a series of painting devices which derive their force in good measure from the fact that they have virtually no association with a European tradition.* The point is so utterly plain that one is astonished at how often it has been missed. For these artists, the Abstract Expressionist concern with gesture, with the expressive possibilities of sheer materials is out – *all* Expressionistic concerns (and Impressionistic ones as well), abstract or otherwise, are out. A sophisticated concern with compositional techniques, formal analysis or drawing, is also out, and indeed Lichtenstein will depart from his usual comic-strip paintings to lampoon a famous Picasso Cubist painting, or a well-known art book's diagraming of the composition of an important Cézanne.

A further challenge to this new direction in art is that of shallowness. This condemnation is based upon the principle that transformation *must occur* in order to differentiate an art image from a similar image in the real world. Certain artists within the broad category of the movement, it is claimed, in particular Warhol and Lichtenstein, fail to effect such a transformation, and if they do, it is so minute as to be of relatively no importance. The very essence of this new art lies precisely in its complete break from a whole tradition of European esthetics. This is accomplished by the particular choice of subject matter which is put into a new fine art context. This *is* the transformation.

While it would seem neither to damn nor approve the material of its inspiration – indeed to appear totally disinterested in the moral problems it raises – Pop Art does take subtle and incisive advantage of deeply rooted cultural meanings and demonstrates how for the artist

the seemingly common and vulgar everyday images, messages and arti-facts of a mass-communicating and consuming society can give rise to the deepest metaphysical speculations. Warhol's rigid, simple, mass-produced, and standardized symmetry is only a point of departure behind which lies an assertive individuality, despite his non-committal painting technique. Hefferton's deliberate and highly disciplined suppression of the decorative quality of paint by substituting a non-esthetic and primitive handling is also totally personal and at the same time his images insidiously recall a host of associations concerning "political expediency." Lichtenstein's flattened, blown-up, and arrested images from the comics subtly pose real issues of the crisis of identity. In contrast to these three, Goode in his highly ambiguous milk bottle paintings employs a rich sensuous quality of paint. Oldenberg's painted plaster edibles parody the anxious, violent type of caricature and expressive use of color that has marked so much of modern art since Van Gogh but which has now become an inexpressive formal device and cliché in academic circles. If some of these images are deadpan, an underlying violence seeps through as in Ruscha's calculated word images.[2] Blosum's cool, detached and simply painted monotone image of twenty-five minutes ticking away on a parking meter may appear indif-ferent to the tortured quality of life, the subject matter of the human condition painters, but it is in fact loaded with suppressed anxiety.

What at first sight appears to be a rather restricted movement employing a narrow range of imagery is in fact enormously rich in the variety of artists it encompasses; at the same time this is not meant to imply that there are no sharp qualitative differences among these artists as in those of any other movement. What is of intense interest, however, is that these artists are looking at and using the most thoroughly and massively projected images of our time – images so looked at that they have become accepted, overlooked and unseen – as a raw material for art.

The emergence of this new art forces the re-evaluation of those artists in the past who have seemed merely eccentric or whose imagery and direction seemed peripheral to the course of American painting since World War II. Obviously Stuart Davis and Gerald Murphy, both considerably influenced by Léger, anticipate certain aspects of Pop Art

in imagery and technique – Davis for his use of blown-up sign fragments and references to popular culture and jazz, Murphy for his billboard style and American vulgarism. A more recent forerunner activity than that of Davis and Murphy spanned the last fifteen years in various cities. In Paris it was the American expatriate William Copley, a post-Surrealist with images full of cheesecake eroticism, patriotic folklore and sophisticated vulgarism. In New York were Larry Rivers with an imagery derived from American folklore and contemporary popular sources, but without the radical innovation of technique that would separate his work from Abstract Expressionism, and Ray Johnson, a pioneer in the use of the cheapest graphic techniques. In San Francisco Wally Hedrick traced ironic reflections onto radios, television cabinets, and refrigerators, and Jess Collins "rewrote" the action and content of comic strips by collaging within existing printed images. Another curious figure is Von Dutch Holland, the southern Californian hot rod striper, a genuinely popular artist whose eccentric imagery and high craft technique combined with a visionary attitude was admired by younger artists. The two key and most significant artists who are usually included within the Pop category are Jasper Johns[3] and Robert Rauschenberg, but they should rather be regarded as direct precursors who provided the momentum, concentrated insights and focus of ideas that triggered the broad breakthrough of this new art, Rauschenberg for his concern with art as a *direct* confrontation of life, transforming his environment into art in a strange, compelling new way, and Johns for the potent questions he raised on the discontinuous quality of symbols. Billy Al Bengston[4] appears to be one of the first artists to have recognized exactly what Johns and Rauschenberg were opening up from 1959 on he completed a broad spectrum of work within the new idiom, but his more recent penumbric, hard-surfaced optical images are more concerned with a heightened awareness of the strange beauty and perfection of materials and have little to do with Pop Art.

Notes

1. A phrase coined by Lawrence Alloway in the early fifties to describe the strong forerunner activity in this direction by Eduardo Paolozzi, Richard Hamilton and others in London. Its subsequent usage cannot, however, be made his responsibility.

The value of Alloway's consistent insight into this movement, incidentally, cannot be overestimated.

2. Ruscha is the first artist in the movement to have published, in an edition of one hundred copies, a book entitled *Twenty-Six Gasoline Stations*. A series of photographed images, it should be regarded as a small painting.

3. See Alan R. Solomon's perceptive introduction to the catalog of "The Popular Image Exhibition" at the Washington Gallery of Modern Art, 1963, for a statement on Rauschenberg's and Johns' contribution.

4. Dine, who occupies a halfway position between assemblage and the new art, had a one-man exhibition at the Martha Jackson Gallery, New York, in January 1962. It was Bengston's dealer, Irving Blum of the Ferus Gallery, Los Angeles, who gave the first one-man exhibition in July of 1962 to Warhol, a critical artist in the new movement who made a clean break with his Campbell's Soup Can series.

Art is Love is God*

The California assemblage movement stems from one artist, Wallace Berman, who in 1947, with very little formal art training, began to draw with bizarre, naïve and vulgar American surrealist overtones. In these drawings he projected all the underground vernacular of the jazz world and the dope addict, sometimes reconstructing portraits of jazz musicians such as Joe Albany and Charlie Parker or erotic fantasies with overtones of magic realism mixed with bebop and surrealism. In 1949, while working as a laborer distressing imitation American period furniture, he moved naturally into assemblage sculpture by combining together waste odds and ends lying around the factory. Later, he was to add photographs, drawings and word images or to combine these diverse elements into a tableau.

Berman is the major link to the existential and surrealist poets, dramatists and writers, and he established assemblage in California as a poetic art with strong moral and spiritual overtones. He will often employ the legend ART IS LOVE IS GOD, but has no simpering holier-than-thou attitude. The spiritual overtones in his work are very genuine and real but tempered by an incredibly raw and existential wit which is expressed with great simplicity and directness. There is a strange and compelling mixture of awareness and ingenuousness in Berman that almost defies verbalization. A completely unobtrusive artist (there is no mention of him in the Museum of Modern Art's encyclopedic compendium on the Art of Assemblage), his first and only exhibition took place at the old Ferus Gallery in 1957. Despite being given the opportunity to withdraw one item, he refused, and was arrested, convicted and fined for inciting lewd and lascivious passions, the exhibition being abandoned and much of the work destroyed. He has not exhibited again, preferring to work on *Semina*, a printed container or album of diverse images – poems, photographs and drawings. With a small hand press he is able to print without the limitations of the professional printer, risk of censorship or the need to domesticate his art. The restrictions of bulk and storage disappear as do the bonds of creating objects to be exhibited

* First published in *Artforum*, March 1964.

or sold. (He gives them away to friends.) The first issue of *Semina* was in 1955 and there have been seven more since, each edition approximately two hundred in number. He prints his own work, often mixed up with poets or artists he most admires (Berman was the first to print the work of Burroughs).

It is difficult to determine if Berman structured *Semina* in admiration of the album format – a container of diverse elements – or out of the sheer necessity of bypassing the problems and expense of binding or even because of a notion that in creating things in a beat way, they have a charm of their own. Probably it was a mixture of all three, but it allowed him to place a matrix of images in an envelope in random order, the images inevitably changing sequence at every inspection. As William Seitz has written, "... Identities drawn from diverse contexts and levels of value are confronted ... metaphysically and associationally (and modified by) the unique sensations of the spectator."

Berman has had a strong influence, directly and indirectly, on a number of artists, in particular George Herms, Ben Talbert, John Reed, Bruce Conner, and (to a much lesser extent) Edward Kienholz as well as a whole stream of younger artists. Talbert's work picks up on a particular aspect of Berman concerned with the toughest form of vulgar narrative, the highly erotic issues of pornography. As such, Talbert's work is virtually unexhibitable and, consequently, hardly known. Herms is an acolyte of Berman and in close accord with his spiritual overtones – he invariably marks his work with the legend "LOVE." Reed was a proto-Pop artist of junk who drifted into Berman's orbit and then disappeared. Conner came in from Kansas to the Bay Area where Berman and Herms were living at that time. Up to then he had painted and worked in an essentially flat form of collage. His meeting with Berman was to induce a decisive change – he adopted the nylon stocking as a container and veil, to work in the most ethereal of poetic symbolism. Kienholz had developed independently, using a more painterly procedure, later collaging lumps of wood and objects onto his surfaces. Berman's exhibition at the Ferus Gallery (which Kienholz directed at that time) indicated the answer to his own problems. Berman is a highly skilled photographer and as such is never dependent on found images. His ability and skill in this direction was to influence all these artists with

the exception of Kienholz, who almost never uses photographic images. Conner, for example, made a number of very interesting movies by collaging newsfilm, comic, and shot sequences. California assemblage, as a result of Berman's influence, is completely autonomous, full of rich narrative and the closest development to a true surrealist root in the American vernacular.

Mondrian at Santa Barbara*

Mondrian was an obsessive visionary idealist. He could not bear the thought of art for art's sake, nor for art to be (merely) morally uplifting. He wanted it to serve a greater purpose – to bring man, art, and environment into a Utopian harmony. In 1926, in "Pure Abstract Art," he wrote: "... In our disequilibriated society whose atmosphere thoroughly reeks with old age everything drives us to seek pure equilibrium: it alone will sustain us with the indispensable joy of living. To this end, pure abstract art's 'painting' is not enough: the expression **must be realized in our material environment**, and by this means prepare the realization of pure equilibrium within society itself. Only then will art become life." Given these words, combined with the knowledge of his earlier close connection to de Stijl (and in particular to Van Doesberg, who became an architect in order to further amplify these ideals), it is not surprising that his art is often connected to function and the function of visual space. However, Mondrian, despite his urge to bring man and his surroundings into a state of greater physical and spiritual harmony, was never a functional artist. Not only does his break with Van Doesberg and de Stijl attest to this, but it can be firmly asserted that whenever there was conflict of his esthetic with his dreams of a better world for mankind, the former won.

Many European artists were to be optimistically sucked into integrationalist notions. The Bauhaus, of course, became a prime factor in the dissemination of these ideas, but as early as 1917, Malevich and the Russian Constructivists had already moved in this direction, and this despite Malevich's extraordinary book *The Non-Objective World*, abounding in statements asserting the supremacy of pure feeling in the creative arts. Nevertheless, he and others were to eventually subvert the original radical impulses of abstract art into a framework of environmental function or integration with science.

If Malevich, and others, go from freedom to group synthesis, Mondrian did exactly the opposite, as shown not only in his paintings but in a change of emphasis in his writings shortly prior to his death.

* First published in *Artforum*, March 1965.

In 1942 he states, "... In the deep future, the realization in tangible reality of pure plasticism will replace the work of art. But to achieve this, it will be necessary for us to direct ourselves towards a universal conception of life and to release ourselves from the pressures of nature. Then we will no longer need paintings and sculptures, because we shall live in the midst of realized art." He adds, however, "... At the present time art is still of the greatest importance because the laws of equilibrium are demonstrated by it in a direct manner independent of individual conceptions."

Viewed in the light of this change of emphasis, Mondrian emerges from scrutiny not as a dispassionate purist, but as a Subjective Hero. Thus, despite notions to the contrary, Mondrian's surfaces are in no way renunciatory, or, for that matter pristine, particularly in works from the early thirties to his death in 1944. A very pronounced brushwork is an important compositional element of his painting. Soft and delicate but somewhat irregular, it is used directionally, in support of or in contrast to the black grids. It is also used within the black, and runs directionally along. Likewise his color, although ritualized at first sight, has little connection to the optical primaries, except in the broadest sense of being a red, blue, or yellow. If it be granted that a true blue is without yellow or red, and likewise a true red is without blue or yellow, his color completely lacks this order of exactitude. Apart from being succulent in quality, his blues are of the rich, pasty, natural order of tubed cobalt and ultramarine, perhaps intermixed and modified. His red (cadmium?), is tinged pinkish by the addition of white. Generally, application of several coats of the same color gives resonance and strength, as well as body. In addition to the whites are subtle variations of distilled blues, grays and subliminal pink tints, each lying within its own rectilinear space between the black grids. In other words, the black of the grids and the colors – with the exception of yellow – are re-echoed in a subdued way within the general areas, in much the same manner, for example, as in Guston, although the procedure is different and the range more delicate. The black of the grid is never matte; in later works it is often a shiny, syrupy, enameled surface. Bearing brushmarks, the crossing of black over black at the junctions of the grids forms additional rectangles. The white and off-white areas are raised

to form channels for the black grids to lie within, there being a very perceptible change of depth of surface. The facture and execution of Mondrian's paintings, then, is personal, subjective, non-mechanical, unique, unrepeatable and could not have been done by any other person according to his directions. (Against the objection that frequent restoration makes close examination suspect, examination under ultra-violet light establishes that although many paintings evince consider-able restoration around the outer edges, and occasionally within, with the exception of a few yellow areas, it is the whites that have been repaired, and then only in small areas. Varnishing, presumably by dealers, adds, to some extent, to the reflective qualities or sheen of surface, but not enough to detract from the substance of the above remarks.)

The paintings in the current exhibition at the Santa Barbara Museum of Art, the largest to be held in the United States, clearly reveal the poor condition of Mondrian's work painted after the thirties. In many of these paintings an extensive network of small cracks has developed within the white and near-white areas. In a few paintings semicircular cracks have begun to curl and break away from the main body of paint; this has necessitated gluing back into position and subsequent retouching. The current condition of his work cannot be attributed to neglect, for it is too widespread. And his early work, with very rare exceptions, is in excellent condition. It is reasonable, then, to assert that with the possible exception of Klee (who experimented continuously with new media) no other artist's work in the history of modern art has suffered so distinct a deterioration in so short a time. Given the apparent simplicity of his approach, and his usage of conven-tional materials, it is obvious that Mondrian, in his overwhelmingly compulsive search to realize his esthetic, neglected, to an extraordinary extent, the technical aspects of his painting. This brings him closer to Pollock than Purism.

This basic conflict in Mondrian's painting is important: the net effect of the brushwork and the glossy tracks serve to distract from the unity of surface. Given the nature of his writings, the obsessive manner in which year after year he laboriously and endlessly honed his esthetic, combined with his enormous visual sensitivity, it seems

difficult to believe he had a low threshold of awareness of the powerful effect very small, subtle changes can make on the tonality of a picture. Nor is it sufficient to postulate that he was not as aware as he could have been of improving his technical means. Admittedly, despite his enormous sophistication, Mondrian was a clumsy artist, almost, it would seem, perversely so. Herein lies the answer. Perfection and imperfection lie side by side within his painting, mutually contradicting one another – the razor-sharp edge of the black lines contrasted against the suffused surfaces. This conflict between means and ends transmits a psychic tension his disciples refined out of their art by subordinating search to system and technical refinement. In Mondrian, this duality serves as a check against ritualization and virtuosity and enables his work to transmit the drama of search and struggle without making a spectacle of it. (Without any strictures against the Santa Barbara Museum of Art, the installation of the exhibition served to throw into relief the condition of Mondrian's paintings. Mounted on a continuous ribbon of clean white paper stretched from the baseboard to a high picture rail, this sanitary surface distended every defect. A neutral gray ground might have been preferable.)

Another aspect of Mondrian's art is the manner in which he continuously plunges and backtracks; he employs a process of regression and re-establishment, setting up a system only to destroy it, eliminating at one point, only to reintroduce exactly the same thing at a later date. For example, his Cubist work is contained within a black grid which is eliminated in the *Color Planes* of 1917, re-used throughout the twenties and thirties and finally eliminated in his very last paintings. Again, in his work of 1917 (despite entitling earlier facade paintings *Compositions*), he eliminated all references to the everyday world and produced purely non-objective work, only to reintroduce a sense of ambience in his later works, as in *Place de la Concorde* of 1938–43 and *Broadway Boogie-Woogie* of 1942–43. He went from complex images to simple images, and backward, many times over. (The same approach is apparent throughout his earlier work.) He continuously contradicted himself for the purpose of expansion.

The earliest cohesive work of Mondrian is a series of paintings entitled *Farm Near Duivendrecht*. They appear to have been started in

1905 and extended over the next three or four years. Seuphor, in his book *Piet Mondrian*, lists nine such paintings. Robert Welsh, currently re-examining the early work, speaks of twelve, and a number of drawings. (Until Welsh delved once more into Mondrian's work, it had been taken for granted that Seuphor's book was a pretty complete catalogue raisonné. Welsh, however, speaks of another two hundred and fifty unlisted works.) Considering the paintings previous to, during, and after this series, they are an extraordinarily speculative body of work. Painted in the studio from sketches, they are bridge pictures that prefigure much of his later development. The three broad elements – farm buildings, trees and sky – are treated in a considered manner, first by the reduction of all forms to contour, which is then filled in, and second, by the emergence of overall flatness which results from this process. Mondrian was to use this method throughout his later painting. In addition, his use of a rectilinear grid within the facade of the farmhouse, the clump of trees in front, and the flat locked-together pink, blue and yellow-tinted clouds are also harbingers of a later handling of subject matter and structure.[1] A painting of 1909, *Dunes 1* reveals connections to Pointillism; but more to the point is Mondrian's diminution of subject, substance and presence by the establishment of an equivalence between the figure and ground within an overall structural method that prefigures the eventual grid system. By this time, that is, before he went to Paris sometime around 1912, essential elements of his development were beginning to emerge, and this despite a considerable amount of investigation of Monet, Munch, and other sources of modern art. (Constantly fed by his own passionate idealism, he was never to be a narrow-minded sectarian. Much later, for example, he was to write approvingly of Dada. He also contributed an article entitled "Het Neo-Plasticism" to Schwitters' *Merz* magazine, number 6 of 1923). In an extraordinary painting entitled *Composition in Pink, Blue, and White* of 1912 – a study of the facade of a Parisian church – painted on cardboard with oil from the dense, separate islands of freely applied paint bleeding into the ground, he reduced his colors to blue, red, and yellow, the very same colors (but employed in a more diminished manner) of the sky in the 1905 painting *Farm Near Duivendrecht*.

The sharpest break in Mondrian's work occurs around 1918 with

the first lozenge painting. The Cubists had first used the oval or circular format to extend the ambivalence of figure and ground. A circle, having neither top nor bottom, denies weight and provokes spatial ambiguity and intangibility. A circle within the square format of a canvas, however, remains essentially a point of focus, echoing, in a distant manner, perspective, the focal organization of perceived objects in the everyday world. Mondrian cut away the non-functional corners, creating his first truly all-over paintings in dynamic equilibrium. By accentuating horizontal and vertical asymmetrically disposed lines within a diagonal grid he was able to invent hitherto unknown relations. From this moment onward he was to evolve an art distinctly his own.

Mondrian worked intermittently over the next fifteen years on a small number of these lozenge shapes, reverting in between to the traditional rectilinear format. The last of the series was in 1933, but he reverted to the lozenge in a small number of paintings in 1943, a year before his death (as in the unfinished *Victory Boogie-Woogie* of 1943–44). Quite apart from this format variation, demonstrating in a typical manner his process of regression and re-establishment, a comparison of two paintings, the first completed in the middle twenties, and the second a decade or so later, reveals a considerable change of emphasis in Mondrian's evolution.

In *Composition with Blue* of 1926, he employs a segmental type of space, the configuration, two rectangles, subliminally completing itself in the mind of the observer outside the lozenge beyond the canvas. In effect this painting traps a segment of reality. Mondrian locks his composition into position by the creation of a tenuous but tangible pivotal point, emphasized by the fragment of blue in the crossed black grid. His deployment of the diagonal lozenge shape provokes an acute turning movement, stressed (and perhaps set into motion) by the imbalance of the composition, which is simultaneously denied by the optical fluctuations of the black and white, then amplified by the subliminal completion of the rectangles outside the canvas. In short, he sets up a process of flux, with the result that the tangible slips from the grasp of the mind to be replaced by the intangible.

In *Composition in White, Red, and Yellow* of 1938, he eradicates the segmental type of space in his earlier work. The lines and colors that

hitherto arc-ed off the canvas into space are now wrapped around the outer edge of the canvas. (This obviously cannot be seen in reproductions, and only with some difficulty in the actual paintings, since the edges are taped to within a quarter of an inch of the picture surface to hide the tack-heads.) This destruction of the outside pull metaphorically makes of the painting not a fragment of an esthetic cosmic reality, but a self-contained reality.

Mondrian's sense of edge is very unique. It has tremendous importance in his work, finally becoming an intrinsic element. He appears to be the first artist to give it this sense of dominance. Completely abandoning a restrictive frame, he fixed around the painting a small baguette. White, like the surrounding tape, it is recessed so as to assert the autonomy of edge and picture plane.

This sense of the visual importance of every element in the painting is tied to his sense of scale, and cannot be considered separately. A number of complicated factors dominate Mondrian's scale: first, the question of flatness (in the sense of destruction of perspective) and second, the manner in which he either tied his image by hingeing to an internal block-form, or to the edge. Perspective, for example, is never completely abolished in Monet; despite the scale (which immerses the viewer) of his late painting, he merely succeeded in bringing it to the surface. Similarly, Kandinsky's painting has an implied perspective, the tilted forms of his Abstract Expressionist period slithering into a segmental type of space. In destroying the center of the painting and placing it in flux, Mondrian's paintings "look" at the observer; in doing so they cannot be larger than the normal arc of vision of an observer positioned immediately in front of the painting. In other words, if the various acute formal relationships cannot be scanned comparatively and more or less simultaneously, the viewer cannot grasp the necessary relationships. The scale, then, must be small. If the hatchet-like quality of Mondrian's grids plays an essential role, minute differences, in contrast, are relatively unimportant in Monet (or for that matter, in Pollock, who also used an immersive-type scale).

Note

1. Unfortunately, the Santa Barbara exhibition shows only one of these paintings. Structured as a retrospective, the exhibition consists of works from American sources. Thus it would have been better titled "Mondrian in America," especially since the exhibition is of necessity fragmentary – no works from Europe being available due to a rival exhibition at the same time. In any event, without a more acute presentation of Mondrian with a series of works in correct sequence neither scholarly nor critical evaluation can be satisfied.

Concerning *Various Small Fires*: Edward Ruscha Discusses his Perplexing Publications*

John Coplans: *This is the second book of this character you have published?*
 Edward Ruscha: Yes, the first, in 1962, was *Twenty-Six Gasoline Stations.*
What is your purpose in publishing these books?
 To begin with – when I am planning a book, I have a blind faith in what I am doing. I am not inferring I don't have doubts, or that I haven't made mistakes. Nor am I really interested in books as such, but I am interested in unusual kinds of publications. The first book came out of a play with words. The title came before I even thought about the pictures. I like the word "gasoline" and I like the specific quality of "twenty-six." If you look at the book you will see how well the typography works – I worked on all that before I took the photographs. Not that I had an important message about photographs or gasoline, or anything like that – I merely wanted a cohesive thing. Above all, the photographs I use are not "arty" in any sense of the word. I think photography is dead as a fine art; its only place is in the commercial world, for technical or information purposes. I don't mean cinema photography, but still photography, that is, limited edition, individual, hand-processed photos. Mine are simply reproductions of photos. Thus, it is not a book to house a collection of art photographs – they are technical data like indus-trial photography. To me, they are nothing more than snapshots.
You mean there is no design play within the photographic frame?
 No.
But haven't they been cropped?
 Yes, but that arises from the consciousness of layout in the book.
Did you collect these photos as an aid to painting, in any way?
 No, although I did subsequently paint one of the gasoline stations reproduced in the first book – I had no idea at the time I would eventually make a painting based on it.

* First published in *Artforum*, February 1965.

But isn't the subject matter of these photos common to your paintings?
Only two paintings. However, they were done very much the same
way I did the first book. I did the title and lay-out on the paintings
before I put the gasoline stations in.
Is there a correlation between the way you paint and the books?
It's not important as far as the books are concerned.
I once referred to Twenty-Six Gasoline Stations *and said "it should
be regarded as a small painting" – was this correct?*
The only reason would be the relationship between the way I
handle typography in my paintings. For example, I sometimes title
the sides of my paintings in the same manner as the spine of a book.
The similarity is only one of style. The purpose behind the books
and my paintings is entirely different. I don't quite know how my
books fit in. There is a whole recognized scene paintings fit into.
One of the purposes of my book has to do with making a mass-
produced object. The final product has a very commercial, profes-
sional feel to it. I am not in sympathy with the whole area of
hand-printed publications, however sincere. One mistake I made
in *Twenty-Six Gasoline Stations* was in numbering the books.
I was testing – at that time – that each copy a person might buy
would have an individual place in the edition. I don't want that now.
*To come back to the photos – you deliberately chose each subject and
specially photographed them?*
Yes, the whole thing was contrived.
To what end? Why fires and why the last shot, of milk?
My painting of a gas station with a magazine has a similar idea. The
magazine is irrelevant, tacked onto the end of it. In a like manner,
milk seemed to make the book more interesting and gave it cohesion.
Was it necessary for you, personally, to take the photographs?
No, anyone could. In fact, one of them was taken by someone else.
I went to a stock photograph place and looked for pictures of fires,
there were none. It is not important who took the photos, it is a
matter of convenience, purely.
What about the layout?
That is important, the pictures have to be in the correct sequence,
one without a mood taking over.

This one – I don't quite know what it is – some kind of fire, looks rather arty.

Only because it is a kind of subject matter that is not immediately recognizable.

Do you expect people to buy the book, or did you make it just for the pleasure?

There is a very thin line as to whether this book is worthless or has any value – to most people it is probably worthless. Reactions are very varied; for example, some people are outraged. I showed the first book to a gasoline station attendant. He was amused. Some think it is great, others are at a loss.

What kind of people say it is great – those familiar with modern art?

No, not at all. Many people buy the book because they are curiosities. For example, one girl bought three copies, one for each of her boy friends. She said it would be a great gift for them, since they had everything already.

Do you think your books are better made than most books that are marketed today?

There are not many books that would fit into this style of production. Considered as a pocket book, it is definitely better than most. My books are as perfectly made as possible.

Would you regard the book as an exercise in the exploration of the possibilities of technical production?

No. I use standard and well-known processes: it can be done quite easily, there is no difficulty. But as a normal, commercial project most people couldn't afford to print books like this. It is purely a question of cost.

Do you know a book called Nonverbal Communication *by Ruesch and Kees?*

Yes, it is a good book, but it has a text that explains the pictures. It has something to say on a rational level that my books evade. The material is not collated with the same intent at all. Of course, the photographs used are not art photographs, but it is for people who want to know about the psychology of pictures or images. This (*Various Small Fires*) IS the psychology of pictures. Although we both use the same kind of snapshots, they are put to different use.

Nonverbal Communication has a functional purpose, it is a book to learn things from – you don't necessarily learn anything from my books. The pictures in that book are only an aid to verbal content. That is why I have eliminated all text from my books – I want absolutely neutral material. My pictures are not that interesting, nor the subject matter. They are simply a collection of "facts"; my book is more like a collection of "readymades."

You are interested in some notion of the readymade?

No, what I am after is a kind of polish. Once I have decided all the detail – photos, layout, etc. – what I really want is a professional polish, a clear cut machine finish. This book is printed by the best book printer west of New York. Look how well made and crisp it is. I am not trying to create a precious limited edition book, but a mass-produced product of high order. All my books are identical. They have none of the nuances of the handmade and crafted limited edition book. It is almost worth the money to have the thrill of seeing 400 exactly identical books stacked in front of you.

Abstract Expressionist Ceramics*

Quite neglected in most accounts of the development of recent West Coast art is the brief period during the middle fifties (roughly from 1954, when Peter Voulkos arrived in Los Angeles, to 1958) when a group of some of the most talented and inventive artists in California shared an intense involvement in ceramics. The brilliant body of work produced during this period has remained relatively little known, although it contains the germinal elements of the mature styles of many well-known West Coast artists. It also produced a considerably far-reaching revolution in ceramics itself, and constituted the most ingenious regional adaptation of the spirit of Abstract Expressionism that has yet emerged. Undoubtedly, what has prevented this work from receiving its proper due hitherto has been the hangover of an outmoded conception of ceramics as a minor art at best, a mere "craft" at least. That Voulkos, Price, Mason, Bengston, and their associates should have fed into this medium some of their most original ideas, and should have, in the process, elevated the medium itself to a new stature, was a possibility simply too unlikely to be given serious consideration.

Peter Voulkos' reputation as a ceramicist of some importance preceded him to Los Angeles. His presence attracted several other ceramicists, notably John Mason, Billy Al Bengston, and Kenneth Price, all of whom linked up with him. Mason, the eldest, was a contemporary of Voulkos and already a skilled ceramicist. Bengston and Price, although younger, were also considerably skilled in the medium.[1] Both were studying at Los Angeles City College and when Voulkos joined the faculty at Otis Art Institute to start a ceramic center, they decided to join him. In speaking of those days, Bengston has remarked, ". . . we stood in awe and admiration of Voulkos' extraordinary capacity to handle clay. He was also technically superior to anyone at that time and probably still is today. He has a quite incredible touch. Something that others have to work extremely hard to obtain, he had naturally." Price adds, ". . . it was a revelation to our lives to see how Voulkos worked. He is capable of the most intense economy of energy for the amount of time

* First published by the Art Gallery, University of California, Irvine, October 1966.

he spends on a work. Yet he does more work and spends more energy than anyone else. Voulkos is capable of an almost inhuman capacity – he made fifteen pieces to everyone else's one." As a consequence of Voulkos' vitality, there developed an extremely competitive spirit. They began to regard themselves not so much as a group with a common program, but as individual contestants. Ceramics, it should be remembered, are made in kiln loads and the production of quantities is common. But in those years, suffused with this new spirit (and reinforced by the ideal climate of southern California), they often worked fourteen hours a day, seven days a week, making as many as a hundred pots a day. Attracted by what was going on, other ceramicists of a kindred spirit soon filtered in; for example, Malcolm McClain, Michael Frimkess, and later Henry Takemoto.

Despite Voulkos' position on the faculty at Otis, he never placed any distance between himself and his younger colleagues. He continuously worked side by side with them and, as a consequence, there was always a considerable exchange of ideas. In a similar manner to the Club in New York, but without the same aura of self-consciousness, ceramics began to draw artists of a kindred spirit together in Los Angeles. Everyone was interested in what was going on, including many painters. Craig Kauffman and Robert Irwin, for example, as a mark of their interest, each entitled a painting *Black Raku* after the Japanese ceremonial tea bowls. Price made and began to give away his coffee cups as a token of camaraderie to sympathetic artists. Strictly utilitarian, each piece is highly individual; they are the prized possessions of many artists in California, who use them daily. Given the emergence of a distinctly American style of painting, the minds of these ceramicists were freed of anxiety about the future. They were aware of what was going on in the art world outside of Los Angeles, particularly in New York and San Francisco. What they needed was time to mature as artists, to seek their own path free of external pressures. The pot, they felt, was no more than an idiom and could lead in any direction. They were uninterested in exhibiting and, apart from Fred Marer (who very early on began to collect their work) and Rose Slivka of *Craft Horizons*, no one in the official art world (as distinct from the craft world) was either interested or quite knew what they were up to.[2] This

suited their purpose at the time. Given, however, the quite revolutionary ceramics produced over these years, the arbitrary consignment of the ceramic medium to what they considered to be a twilight world, that of the crafts, later caused them considerable misgivings, and even anguish.

In the history of Western art, the artist has continuously struggled to divest his activities of the tainted aura of craftsmanship and the implications of being a hired hand. What he wanted and did get was intellectual and social equality within the liberal arts. Distinguishing himself by the use of certain media (for example, oil paint, bronze, and marble), he left the employment of what was considered to be the inferior media to mechanics or craftsmen. Ceramics was one of these. The artist could use any of the minor media, including ceramics, but only for the purpose of the sketch.[3] Out of this approach arose the distinction between the "fine" and the "decorative" arts.

In modern art all conventions including this hierarchy of media have been under constant attack. What distinguishes a work of art from that of craft is qualitative. A work of art is not concerned with the utilitarian, the rational and the logical. Its purpose is expressive, that is, to aim new questions as to the nature of existence. In short, it is concerned with the esthetic experience in its purest form. To this it should be added that one of the most important qualities which distinctly separates American painting from much of pre-World-War-II European art is the question of esthetic purity. Issues concerning integration with other disciplines – for example, the integration of art and science or of art and architecture – are completely antithetical to the spirit established by the Abstract Expressionist outlook.

Since medieval times Europe can hardly be conceived of as a ceramic culture, especially in comparison to China, Korea, and Japan. Despite the admiration for many of the wares from those countries and their massive importation during the sixteenth and seventeenth centuries, until recently the basis of European art has been deeply iconographic. As Herbert Read pointed out, "... pottery is at once the simplest and the most difficult of all the arts. It is the simplest because it is the most elemental; it is the most difficult because it is the most abstract. Pottery is pure art; it is freed from imitative intention and is

perhaps to that extent less free for the expression of the will to form than pottery; pottery is plastic art in its most abstract essence."[4]

The task these ceramicists set themselves was to rediscover the essential characteristic of the medium. Obviously their first step was to free themselves of all dogma and convention. It is true that their earliest work was often extremely eclectic, but they felt the need to know the past before they could break away from it. There were few ceramics of any importance to be seen in Los Angeles; reproductions from books served as their museum. The photograph is notorious for blurring and distorting scale, and as a result, very often a shape based on some prototype from the past was blown up to an enormous size. Although they admired Bernard Leach they felt out of sympathy with his quasi-Oriental outlook and approach. They did not want to reconstruct Oriental ceramics but to create a viable approach of their own. It is true that the new and original was more admired in Japanese art than in the Chinese or Korean, and that from the seventeenth century onward Japanese ceramics had continuously demonstrated artistic daring, ingenuity and invention. But at the basis of the Japanese esthetic was the notion of "... utility as the first principle of beauty."[5] The rejection of this tradition led to a major breakthrough.

The fact that a pot need no longer act as a *vessel* assumed great significance. Being wheel-thrown, pottery is invariably symmetrical and although the Japanese Raku tea bowl, for example, is much admired for its imperfection of shape – its lack of perfect symmetry – nevertheless it is basically circular and, as such, symmetrical. Voulkos and Mason began to punch and squash forms into shapes that minimized symmetry and equilibrium. One of Mason's vases, for example, is triangular and, by using a highly organic glaze and surface treatment, each facet when viewed from a different angle presents a totally dissimilar appearance. Clay is a highly fluid and malleable material with a life of its own. Sensing the form-expressed emotion that lay at the heart of Abstract Expressionism, these ceramicists began to exploit shape and surface for its expressive potential. A free rein was allowed for imperfections arising from the natural limitations of the material. Inextricably interwoven, shape, surface, and coloration took on a highly organic quality.

The temperament of each artist soon began to play a more assertive role. Price began to explore deeply a limited range of forms and was always concerned with the linear edge formed by the outside of a pot or plate. The relationship, for example, of a plate to the supporting edge of the surface was a matter of importance to him, particularly the manner in which the negative space was formed. As a consequence of this approach, his work became increasingly considered and reductive. In contrast, Voulkos' ceramics began to assume all the qualities of an explosive release and although completely abstract they began to reveal strong anthropomorphic overtones. Mason's work, however small, gave the impression of massiveness and weight. Not only highly inventive, but extremely vigorous in conception and execution, the work of all these artists began to owe little to the past. Each step made not only fortified their confidence, but opened up, with increasing rapidity, new avenues to be explored. Probably the most decisive shift by Voulkos was in constructing wares of multi-part form. Dependence on the repertoire of shapes inherited from functional vessels ceased, synthetic forms could henceforth be created. Although it took time to exploit this idea, it nevertheless led towards a more sculptural concept. Another important move by Voulkos was the use of epoxies for joining parts together; this was followed by the employment of epoxy paints side by side with glazes. In this manner the esthetic concept of "truth to materials" was abandoned and by this use of paint the way opened for the development of polychrome sculpture on the West Coast.

The peak of the ceramic development was undoubtedly between the years 1956 and 1958. During this period grew the first radical movement totally to revolutionize the whole approach to ceramics. What was done in those days is now mainstream.

Notes

1. *Craft Horizons* was one of the most adventurous magazines in the United States. It followed with great insight and knowledge the development of ceramics in California. A special issue in 1956 was devoted to California, and as early as 1961 it published a heavily illustrated article written by Rose Slivka on the ceramic sculpture linking the new approach to Abstract Expressionism.
2. The situation is aggravated by the fact that the Museum of Modern Art in New

York, an extremely influential institution, apart from showing painting and sculpture, also exhibits architecture, photography, and commercially designed objects. It will show a teapot of fine design but, following earlier guidelines, nothing that fits into the category of the crafts. This is left to the Museum of Contemporary Crafts. Thus the Museum of Modern Art perpetuates the distinction of art and craft, but allows commercial design into an institution devoted to high art.

3. Reuben Nakian's ceramics, for example, follow these guidelines. All of his major work is in metal.

4. Read, Sir Herbert, *The Meaning of Art*, New York, 1951, p.41.

5. Soetsu, Yanagi, quoted by Bernard Leach, *A Potter's Book*, London, 1940, p.8.

Jim Turrell *

James Turrell was born in Los Angeles, California, in 1943; he currently lives in Santa Monica, California. Turrell's images are projected from a slightly modified, but standard, high-intensity projector positioned on the gallery ceiling. No attempt is made to conceal the projectors, and as a consequence of the intensity of the projected light image, it is not necessary for the gallery to be in absolute darkness. His monochromatic images consist of simple geometric configurations, for example a square or a rectangle. In some instances, the overall geometric shape is modified by the removal of a smaller, either similar or dissimilar geometric shape from one corner. In any event, each image is unique. The borders are crisply defined, and the internal field of the image is usually flat and without divisive incident.[1] The overall size varies from configuration to configuration, but the majority approximate eight feet at the largest dimension. The white images have a slightly discernible bluish cast and the colored images are tinged a definite blue or pink. The position on the gallery wall of the whitish images is indeterminate. The colored images, on the other hand, assume a more definite position; the projected color-plane is read as a tangible surface effect and thus appears to be more objectified.

Turrell's images are not only static, non-repetitive and absolute, but they are also highly subjective. His art corresponds to the notion discussed by the sculptor Robert Morris: "... The better new work takes relationships out of the work and makes them a function of space, light and the viewer's field of vision." Turrell's means, however, are purely pictorial. In other words, he uses luminosity not as a sculptor uses material to create three-dimensional form, but illusionistically, that is, in a similar manner to a painter who uses paint on canvas.

Each image is focused upon the wall surface of the gallery by projection and variously positioned. For example, some images are positioned equidistantly across one of the internal angles of the wall and others directly onto the plane of the wall. Those images focused upon one plane of the wall usually rest on, or slightly above, floor level

* First published by the Pasadena Art Museum, September 1967, in the exhibition catalog *Jim Turrell*.

or crisply butt up to the angle of the adjoining wall, or are placed in both positions. Each image is a self-contained entity and activates an arc of the gallery in its own particular manner. Thus it is possible to place several images in a gallery and have them apprehended as specific works with an individual character.

The intensity of the projected light dematerializes the wall surfaces enclosed within the boundaries of the image and the unlighted wall surface abutting the image. Walking close to the wall, however, dissolves the physical-object qualities of the image and the observer becomes aware of the actual disposition of the wall surface and that the image is merely reflected light. An awareness of the transient qualities of the image does not detract from the effectiveness of the work. In fact, it serves to intensify the idea that the image, although an illusion, can nevertheless be experienced as something tangible. The manner in which light is made physical and objectified in these images demonstrates that volumes can be engendered without references to structure, and further, that transparency can be engendered without conventional employment of material.

The tangibility of the image is increased by the manner in which it modifies the lighted wall as well as the surrounding space of the gallery and, more than that, the ambient space, that is the space beyond or outside the gallery. In the first instance, the definition and the brilliance of the image makes it difficult to determine the position of the wall; and the wall appears to lie somewhere behind the plane of the image. If the observer looks into the image it appears to penetrate the wall. On the other hand, when the wall is focused upon, the position of the image then becomes less determinate. One is called upon to make simultaneous decisions as to where the image lies and where the walls lie. This is due to the fact that the viewer is involved in a space in which the "painting supports" have been enlarged to become congruent with the wall surfaces.

In the second instance, it is first necessary to differentiate between the viewer's awareness of space, or the space a viewer can perceive or imagine, and the actual space of the gallery. In other words, the viewer when looking at one of these images is not only forced to modify his awareness of the fixed position of the wall and image, but he also

becomes aware that the image refers to an exploded space. This sensation is enhanced and increased by the very intangibility of the light. When a light image is projected under the circumstances given, the constant modification and fluctuation of the observer's spatial sense tends to expand the awareness of the physical limits of the gallery.

It must be added that in addition to the powerful modification of the observer's space created by these images, they also have considerable iconic power. This may not be clearly demonstrable, but the compelling sensuousness of the light and its exhaustive brilliance is almost hypnotic. Furthermore, an apprehension of the means used does not rationalize the total effect but adds to its vividness and mysteriousness.

Note

1. Except for *Afrum*, an image projected across the corner of the gallery. Although the projected field for this image is flat, the corner line of the gallery is highlighted as a consequence of reflected light.

Cézanne's Watercolors*

Paul Cézanne is widely thought of as a painter of extraordinary importance. He was also a compulsive watercolorist who used the medium throughout his career to create a rich body of work. Some four hundred watercolors in all are known, but the largest number date from the latter part of his working life, that is, from 1890 onward. However, because of Cézanne's indifferent and sometimes irascible attitude toward his art, not all his watercolors have survived. Vollard relates that when Cézanne was painting his portrait, he became enraged over the painting's lack of progress, seized ten watercolors pinned up on the walls of his studio, and destroyed them. Renoir returned from L'Estaque in 1882 with a magnificent watercolor Cézanne had abandoned among the rocks, and the painter Borély records how he observed in 1902 some twenty watercolors carelessly thrown upon the floor of Cézanne's studio. As for the rest, several watercolors passed into collectors' hands during Cézanne's lifetime and a few were acquired by artists, notably Renoir and Degas. A considerable number evidently passed into Vollard's hands when the dealer purchased the contents of Cézanne's Paris studio in 1897.

Cézanne included several watercolors with his oils at the third Impressionist exhibition in 1877 but none are known to have been exhibited thereafter until Vollard's retrospective exhibition of Cézanne's work in 1895. In 1905, sensing the importance of the water-colors, Vollard gave them a separate exhibition.

The early watercolors are few in number, generally small in size, and invariably signed. Painted upon a toned or grayish paper, the translucent watercolor medium is often highlighted with fairly thick touches of white gouache. It was not until Cézanne had absorbed Impressionism under the tutelage of Pissarro that he began to exploit a purer watercolor technique by employing transparent layers of liquid color upon a white or relatively white ground. Radical to the technique of Impressionism was the notion of employing pure color upon a white ground as against the traditional toned or dark ground. Moreover, in

* First published by the Pasadena Art Museum and the Ward Ritchie Press, Los Angeles, November 1967.

contrast to Cézanne's extremely laborious method of oil painting, in the watercolors he used a spontaneous and uncorrected touch which plays a highly expressive role, especially in the later works. Unsigned and undated, the later watercolors vary widely in complexity, subject matter, scale, and handling: they range from the slightest of color notations superimposed upon a few sparsely rendered pencil lines on a broad expanse of white paper to astonishingly complex works saturated with color.

Cézanne's watercolors cannot be approached without some discussion of his position within the history of art. His work was savagely attacked and bitterly misunderstood in his lifetime. In contrast, Claude Monet, the father of Impressionism and the contemporary most admired by Cézanne, from mid-career onward basked in the highest esteem. Soon after the death of each artist their reputations were reversed; Monet's declining to a low ebb and Cézanne's soaring to exalted heights.[1] In the process, Cézanne became all things to all men. Eliciting the most extraordinary degree of uncritical adulation, Cézanne was apotheosized on two counts: 1) as the father of modern art, its prophet and legislator, "the primitive new way"; and 2) as the only true heir of the Renaissance and Baroque masters. Whatever the truth of either view, the two positions do not fit together comfortably. If Cézanne is indeed "the primitive of a new way," his art can hardly be valued on the basis of its traditional look, and those attempts that have consistently been made to reconcile such conflicting views are a detriment to a fuller understanding of his art. The issue has been further confused by those who have placed too great a reliance on Cézanne's writings or his fragmentarily recorded statements and, in particular, his stated ambition to recreate "the art of museums." It is Cézanne's gifts as a painter and not his theories – however apt or interesting they may sound – that have placed him in the forefront as a painter.

Cézanne's desire to make of Impressionism something solid and as enduring as the art of the French classic masters of the seventeenth century is well known. But his early poetry and painting very clearly indicate his sensibility as being distinctly rooted within the French nineteenth-century Romantic tradition. However much he desired to emulate the classic tradition, this approach to art can now obviously be seen as completely foreign to his temperament. In his desire to

discipline his art and give it a more formal structure, he became an inverted Expressionist; the fervor of his brushstrokes, let alone the agonized impurity of his drawing, is indicative of his inability to renounce the passionate and highly emotional basis of his art.

Cézanne's dominant position within the hierarchy of modern art has been challenged in the last decade by a rehabilitation of Monet's reputation.[2] This rehabilitation is the result of the emergence of a radical new style of painting in post-World-War-II American art which has questioned many assumptions concerning the nature of pictorial structure, and particularly those structural aspects of Cézanne's art focused upon by the Cubist painters. Although it was primarily Barnett Newman's emphasis on the significance of Monet's late painting and, in particular, the *Waterlilies* that led in the first place to a revival of Monet's reputation, subsequent developments in American art have also stressed the importance of Monet's earlier and more typically Impressionistic painting, for example his serial views of cathedrals and haystacks. The immense scale of the late Monet's *Waterlilies* and their emphasis on surface and color as pictorial entities in themselves make much of Cézanne's oil painting look extremely traditional. But any comparison of Cézanne and Monet leads one to the realization that the core of Cézanne's radical vision springs more from the open and dispersed quality of the watercolors and less from those aspects of his work, particularly in his oil painting, that hark back to the seventeenth century. If, in the past, Cézanne's watercolors have been admired more for their charm than their urgency as works of art, this no longer holds true.

The growth of Cézanne's reputation was due in the first place to his acceptance by the Cubist painters (and conversely Monet's decline began from exactly this point). In no small degree it was Roger Fry in his critical capacity who was subsequently responsible for the expansion and enhancement of Cézanne's reputation. By rigorous application of the Swiss scholar Heinrich Wölfflin's proposition that evaluation should attempt to come to grips with "those things which constitute the value and essence of a work of art," Fry drew the viewer's attention to the plastic and architectonic elements of Cézanne's art; and in the process was the first to extract art criticism from its entanglement with moral,

sentimental, and anecdotal details. Much of what Fry has to say concerning Cézanne stands. But in order to give weight and gravity to Cézanne's art he overemphasized its traditional aspects. Finally, given the current renewal of Monet's reputation, Cézanne's art can no longer be considered as antithetical to Impressionism. It needs to be viewed as a segment of a larger development in modern art shaped jointly with Monet. By flattening the picture as a consequence of de-emphasizing the groundline and by omitting the horizon, both Monet and Cézanne threw overboard the traditional central focus and began to hang the picture from all four sides of the canvas. Monet pioneered this effect at a great scale with a strong emphasis on color surface. Cézanne reached toward this sense of two-dimensional flatness by dissolving the contours of masses into the surrounding space, particularly in his watercolors. Cézanne's discoveries led to the Cubist structure and finally into the art, for example, of De Kooning and Kline. Monet's art, on the other hand, became the genesis for Pollock and the field painters, in particular, Newman, Still, and Rothko, with such artists as Guston and Hofmann, for example, straddling both aspects. Thus Monet's and Cézanne's art are the two main poles from which Abstract Expressionism ultimately sprang and which sensibility both these artists fed in equal measure.

While admitting the fineness of Cézanne's watercolors, writers on his art have for the most part tended to regard them as a diversionary impulse. They are thought of as a substitute for oil painting when the difficulties he experienced in expressing himself in oils became burdensome through low spirits or lack of progress, or as an easy medium to employ when inclement weather or physical incapacity interfered with his plans for major work. Thus the watercolors have been considered not only as secondary, but also as having a private quality and consequently not intended for public viewing. This private quality, however, not only reveals the innermost workings of Cézanne's mind and thus brings us closer to his thoughts, but it also is an essential determinant of modern art's freedom to develop without recourse to public solutions. To a considerable extent Impressionism made a strong break with the Beaux-Arts or academic tradition, which still lingered on in the work of Delacroix or Courbet. But the most advanced outlook in the latter part of the nineteenth century was, however, present in a series of water-

colors which Cézanne apparently valued little. Cézanne therefore was the forerunner of an art that was later to become fully involved in a direct kind of personal investigation which required no public support for its outlook or content.

Although the watercolors most of the time share a common subject matter with his oil paintings, they were seldom preparatory to the oil paintings. His watercolors exist in their own right and cannot be viewed as part of a systematic workshop procedure beginning with the sketch and developing through intermediate stages to the finished oil painting. He rarely, it would seem, used watercolor in preference to oil but he treated each work, whether in oil or watercolor, as a distinct and separate entity, as something complete in itself though he frequently returned to the same motif later. For example, apart from the numerous oil paintings of Mont St. Victoire, there are also extant some twenty watercolors of the same motif. This impression of the uniqueness and independent quality of his watercolors is re-enforced by the largeness of scale of many of the landscapes and still lifes which often reach or exceed two feet at their greatest dimension, and which by virtue of their large size and complexity appear to strain the resources of the medium. Despite the small scale of many other works and their apparently sketchy appearance, the intricacy of Cézanne's disciplined formalism elicits a sensation of completeness. As Roger Fry first pointed out "... even in the watercolors where only the key phrases are written down they are felt to be setting up rhythms in every part of the surface."

The application of paint in Monet's and Pissarro's Impressionist painting was by way of small dabs, dots or commas of pigment, until an evenly dispersed crust was built up with the image suspended therein. Cézanne accepted many of the basic tenets of Impressionism, and in particular Monet's polarization of color, but he re-introduced line and clearly delineated broad strokes of colors. Superimposed one upon the other, these clearly articulated color shapes leave a perceptible record as one brushstroke overlaps another; they support and participate within the numerous linear rhythms of painting. In the watercolors the boundaries of these color shapes are subsumed by the re-echoing shape of the white ground which becomes a positive plastic element. The white ground of Cézanne's watercolors acts reciprocally; it is an

empty yet active surface – sometimes it seems flat, and at other times, especially when the shape is linearly contained, it seems to jump forward or, when marginal, it has a lateral displacement. This interlocked and reticulated maze of color, line, and ground in Cézanne's work created a new kind of space – one that projects toward the spectator rather than recedes into the interior – and conflicted with the traditional use of artistic perspective. Though the motif in many of the watercolors is treated flatly and without perspective, Cézanne obviously agonized over this effect and continuously set himself the task of reconciling this new spatial effect with a three-dimensional representation of his motif.

Painted in layers of semi-transparent watercolor, Cézanne's dematerialized color is locked into the shape of his broad brushstrokes, with the color accents balanced so that none holds the eye more than others. Cézanne did not effect to the same extent the kind of color concordance which in Monet often becomes overwhelming. Although he sometimes tied himself into the local color of his motif, at other times he departed radically from it; but either way his stepped and overlapping layers of translucent color always maintained their separate identity because of the scale of each mark. Only rarely does Cézanne's palette of red, blue, green, and yellow extend throughout all his watercolors. Some works are restricted to touches of only two colors; in others he employed the full range of his palette: touches of red next to cold green, and touches of orange or ocher next to blues.

Cézanne's regard for the old masters is often reflected in his oil paintings by compositional details taken from a particular artist that caught his fancy. It is true that there exist a number of watercolors freely based on the compositions and subject matter of artists Cézanne admired, for example, Manet's *Olympia* and Delacroix's *Medea*, but in large measure the watercolors are free of influences of this nature and are composed directly and untraditionally. This is not to infer that Cézanne's compositional procedure is casual, but the watercolors reveal that the range of his explorations was remarkable and, moreover, that he was not so systematically tied to classical geometrics or relationships to the framing edge as has been previously thought. It is his use of color as a direct exponent of form, and his reconciliation of part with

part, and part with the whole, that is a greater source of nourishment to his art. The forms in Cézanne's watercolors range over any point of the picture plane; some compositions are centrally positioned and almost rigidly symmetrical, as for example, *The Fountain of the City Hall Square at Aix-en-Provence* of 1895–1900. In this watercolor a centrifugally organized and densely compacted group of leaves is positioned to the extreme right of the paper. In most of the watercolors there is a high degree of crop, and whenever a motif is used several times, as for instance in the large number of views of Mont St. Victoire, Cézanne seems to make a point of strongly varying his viewpoint. The motif is sometimes viewed from above or below, or from either side, or the distance from the motif is varied. In the various watercolors of the Rocks at Bibemus, his position in relationship to the motif is often identical, but each is composed differently. For example, in one watercolor the group of rocks is not quite centralized but extends all over the paper and is composed flatly without foreground, background or horizon. In another watercolor of the same subject, although his position in front of the rocks is identical, the rocks intrude from two edges and part of the paper is blank.

Throughout the watercolors a high degree of format variation can be observed. In Cézanne's oils the rectilinear canvases, whether used horizontally or vertically, incline toward squareness and are therefore proportioned more regularly. In contrast, in the watercolors many vertical and horizontal compositions are elongated and consequently nearer in shape to a double square.

In addition to compositional variety, Cézanne's subject matter is extremely wide and ranges in the watercolors over landscapes of many kinds, architecture, still lifes, flower pieces, plant and drapery studies, isolated figures, and self-portraits as well as groups of bathers in a landscape setting. One surprising late work is of a coat thrown over a seat of a chair; it rivals in expressiveness the well-known portrait by Vincent Van Gogh of a pair of worn boots. Besides the *Coat over a Chair* there are several other watercolors that incline toward a similar degree of expressive handling, in particular those of skulls and the impetuously handled *Boy with a Red Vest* (1890–96). Except for the watercolors of idyllic scenes of bathers, which are structured around the human

figure, his numerous landscapes, like those of Monet, are devoid of people. Without human presence to give scale, they seem to exist in a world apart.

Although Cézanne frequently painted directly from his motif, he sometimes composed from his imagination as he did, for example, in the many watercolors of bathers. But even when working in front of the motif (and despite the veracity of his eye which often has been proved correct by comparison with photographs of his motifs), Cézanne never submitted himself to the capriciousness of nature. Although he wrote, "I feel sure that all pictures by old masters depicting subjects out-of-doors have only been hesitatingly done, for they do not seem to me to have the true and, above all, original aspect which nature presents," nature is hardly the subject matter of his art. With the exception of a rare watercolor, such as *Trees in the Storm* in which a group of barely recognizable trees is lashed by the wind, his landscapes exist without movement or temperature, and without describing the texture of vegetation, hardness of rocks, or the density and weight of the earth. Radiant in color, dreamlike and impalpable in substance and without intimation of the passage of time, his landscapes are rendered vital not by their conquest of nature but by their arcane qualities. Little wonder the surrealists were to claim him as one of their own.

In many of the late watercolors, especially the bathers, Cézanne's brushstrokes became dominantly calligraphic and curvilinear. Thus, unlike his more slowly executed works which maintain a look of improvisation, the rich baroque rhythms and the spontaneous calligraphy of the various watercolors of bathers elicit a sensation of an increased tempo of execution. It was Roger Fry who first advanced the notion that the increased thinness and fluidity of Cézanne's oil painting and the looser and freer brushstrokes were a direct consequence of his increased use of watercolor, particularly in the latter part of his life. The more open spacing of the brushstrokes of his late oil paintings left the white ground of the canvas showing through in various places. Moreover, the white interstices remaining between adjoining brushstrokes formed integrated accents. This effect not only added to the elusiveness of Cézanne's surface, but more important, it finally helped destroy traditional notions of finish. The immensity of Cézanne's

achievement in watercolors and the dazzling range of possibilities he explored in this medium may appear to be of less importance when weighed against many of his best works in oil. But even if Cézanne valued the watercolors less than the oils, the one could not have been arrived at without the endless daring explorations contained within the other. And if the watercolors are less realized than the oil paintings, because of the manner in which they reflect the conceptual range of Cézanne's mind, they have an importance far beyond the seeming slenderness of the means employed.

Notes

1. Roger Fry claimed Monet's painting as "aimed almost exclusively at a scientific documentation of appearances" and consequently as "equivalent to abandoning art." Lionello Venturi wrote Monet off as "the victim and gravedigger of Impressionism": and Sir Kenneth Clark not only speaks of Monet's cathedral series as a "disastrous" choice of subject matter, but he also asserts: "If decadence in all the arts manifests itself by the means becoming the end, then the last works of Monet may be cited as a text book example."

2. This has served to enforce a realization that however much Cézanne "restructured" Impressionism, he never – as so often has been claimed in the past – destroyed the validity of Monet's contribution.

Kurt Schwitters*

Two innovations are central to advanced art in the twentieth century: first, the introduction of nonobjective or purely abstract imagery; and second, a revolutionary approach to the use of artistic materials and media. Thus an "image" is no longer a simple reflection of the seen world; and the traditional hierarchy of media has been challenged and leveled. An artist may now employ any kind of material technique, traditional or otherwise, provided it suits his expressive purpose. Kurt Schwitters' work encompasses both these innovations. His commitment to the consequences of a radical exploitation of media is apparent by 1917, is full-blown by 1918–19, and is consistently maintained thereafter throughout his working life.

Until recently, Schwitters' essential contribution has often been misunderstood. There has been a wrong emphasis upon the "ephemeral" nature of his materials – his use of odds and ends of used printed papers and other discarded urban artifacts. While it is true Schwitters made art out of trash or inconsequential materials, and drew attention to the inherent irony of using them for this purpose, he fully committed himself at the same time to the exploitation of the absolute qualities of those materials. The *actuality* of printed paper and its variety of textures played an important role in his art as important as any more mentalistic or poetic qualities. The sheer novelty of Schwitters' material was at first shocking; it was an assault upon the viewer – a by-result of his assault upon dead tradition. But with the widespread acceptance of new media in post-World-War-II art, the scandal of his materials has vanished and no longer distracts one from the inventiveness, variety, and vigor of his abstract compositions.

The twentieth-century crisis of media emerges in the Synthetic Cubist period of Pablo Picasso and Georges Braque. Picasso undoubtedly influenced Schwitters, but it must be borne in mind that Picasso's work can be regarded as the climax of a nineteenth-century view. He was never committed to abstraction; he fills his paintings and sculptures

* Written with Walter Hopps. First published as the introduction to *Kurt Schwitters: A Portrait from Life*, ed. Kate Trauman Steinitz, University of California Press, Berkeley, 1968.

with referential elaboration, which more often than not detracts from the essential qualities of his work. Although he and Braque introduced the collage technique into the realm of high art, and used it to extraordinary effect, they used it only sparsely in the context of the total body of their work. Neither artist employed it as a major medium, nor envisaged it as such. Nor did Picasso, who also introduced the technique of assemblage, exploit it to any marked degree. Picasso in fact did very little assemblage. This crisis in media, however, became widespread and far-reaching, and was later taken up in all the major center of European art; but the crucial figures, apart from Picasso and Braque, finally turn out to be Max Ernst, Marcel Duchamp, Kurt Schwitters, and of course Jean Dubuffet. Max Ernst is undoubtedly a critical figure in the development of collage, but only in graphics. As with Picasso, the major body of Ernst's work, both in painting and sculpture, was resolved within the traditional means of oil paint on canvas and cast bronze. In point of fact, it was Duchamp and Schwitters who mounted an attack and forever fired away at the customary and expected in regard to materials. Duchamp is the preeminent example of the didactic revolutionary among artists. Duchamp made each of his works, step by step, a special lesson. Never repeating himself, he made of inconsistency an unbreakable law, First and foremost he is an instigator of essential ideas in art and is the source for much that comes later. Since he was preoccupied with essences, he necessarily limited the quantity of his production; and indeed it seems that he was almost trying to push his art below the threshold of visibility. This propensity alone sets him apart from Schwitters, who had a taste for abundance.

Picasso is often thought of as the most prolific artist since Rubens; yet Schwitters nearly equalled him in this respect. Because Picasso often worked at a very much larger size than Schwitters, there is a tendency to think of his production as greater. Picasso has lived longer than Schwitters, who died in 1948; but Schwitters created multitudes of works. A catalogue raisonné of his purely visual art, at least for the present, is an impossibility. Moreover, since a large part of his *oeuvre* has been lost from view or destroyed, it is more than probable that no adequate gauge of the total body of his painting and sculpture will ever be developed.

Schwitters' mature work is marked by a militantly abstract pictorial organization. Employing a wide variety of images, or parts of concrete objects – for example, typographic elements from printed matter, or scraps of paper, cloth, wood, bones, or metal – he positions these disparate elements into the basic pictorial structure of his Merz paintings and collages in a completely synthetic, arbitrary, and abstract manner. While it is true the figurative or referential elements he employs maintain their singular identity and carry over some of the mood and character of their nonart origins, it is important to note that Schwitters never links his various elements, whether recognizable object or not, into any kind of narrative framework.

Schwitters' notion of employing a stream of highly disassociative imagery was influenced by the poetry of the Sturm group of artists, especially that of Stramm, Walden, and Bluemner. He was friendly with Chagall and wrote a poem on him as a token of his admiration; but however unreal or dreamlike the juxtaposition of Chagall's imagery, it is fitted into a narrative event. Schwitters, in contrast, treats his various elements in the same detached and formal manner as he would a square, a circle, or any other drawn or painted geometric figure. Moreover, despite his basically Cubist framework, he never employs any kind of unifying logic of position or relationship of one object to another as found, for example, in a typical Cubist painting by Braque or Picasso. In a still life by either of these artists the elements and represented objects are always connected or interlocked into an inherently logical spatial relationship derived from the seen world. In comparison, from 1919 onward, the parts and modules of Schwitters' composition seem amazingly disjunctive. And unlike Paul Klee, who poised his individualistic range of imagery in a vague and generalized landscape format, Schwitters purges completely from his art even vestigal spatial references to the seen world.

Schwitters' disjunctive manner of handling imagery appeared confused and disordered to many of his contemporaries and was a tremendous hindrance, especially earlier in his career, to recognition of the excellence of his work. Schwitters' forms range over any point of the picture plane; structural and pictorial climaxes freely occur near the edge or at any point he wills. He sometimes uses a centrifugally

organized composition with elements whirling off a vaguely positioned center (especially in his best early work). These compositional procedures differ sharply from the conventional Cubist organization. Moreover, the axis in Schwitters' work is often tipped or strongly tilted; and he does a great deal of cropping at the edges. This latter procedure tends to emphasize the perimeter of the format, increasing the scale of the internal module and giving the composition an "allover" effect: thus it is that a Schwitters collage or painting frequently appears to be less a self-contained entity than a part from some larger whole.

Operating throughout Schwitters' work is a palpable sense of agglutinization: of creating structure by a series of accretions. Collage lends itself to a high degree of spontaneous manipulation. Forms may be glued together or one on top of another, and the position of any part altered with great rapidity by tearing or cutting and re-pasting. There is never any evidence in Schwitters' work of the use of a master plan with a point-by-point addition of detail. He apparently starts from the smallest part of his module and, by a purely spontaneous additive process, formulates his overall image. Despite the smallness of many of his collages, Schwitters manages to obtain a startling range of effects and a tremendous degree of thematic richness. He not only seems incapable of repeating himself, but also gets enormous variety of theme from work to work.

Schwitters' radical approach to the materials of art, and that of his contemporaries, is only one aspect of the twentieth-century rebellion against any stricture, esthetic or otherwise, which serves to inhibit free expression. The growth of an intellectual climate that began to challenge compulsively the rational basis of art is a product of this search for greater intellectual freedom. The immediate impulse for the attack sprang from the lack of a viable artistic procedure fully capable of encompassing states of paradox, absurdity, and irrationality as part of the nature of human experience. It seemed critical to many artists to prick the bubble of pomposity that had long surrounded the making of art, and at the same time to make as clean a break with the past as possible. As a consequence, the long tradition of the high seriousness of art was assailed. Dada is clearly a manifestation of this impulse, aiming as it did at more open-ended sense of what is possible in art. Thus it would be a mistake to regard Dada as a surge of nihilism, or the

Dadaists as cynically indifferent to what was going on in the world. It was their very anguish that drove them to outrage audiences, their need to shock people out of apathy into awareness. However destructive their art at first may have appeared, it turns out they were highly constructive activists. Dada opened the pathways, technically and expressively, to an extraordinary new range of possibilities. By provoking spontaneous manifestations of absurd streams of consciousness, Dada made it possible for formal or intellectual play and the notion of spontaneous and automatically derived compositions to become part of the means of art.

Very pertinent to Schwitters' art is this operational program of free play, the idea, in creating, of being able to indulge the most spontaneous fancy. A compulsive pleasure principle operates in his work; it is obvious that art to be *his* art had to participate in the very quick of life. Schwitters was in no sense a recluse who isolated himself from existence by building an imaginary world, nor was he a programmatic idealist; he absorbed and transformed every life experience, even the most random and trivial. Schwitters' art, however, cannot be judged to be less than totally serious – as witness the breadth of his interests, the vivacity of his mind, and his extraordinary ability to "make it new," never turning his past achievements into stale formulas.

The way Schwitters suddenly burst forth into maturity is astounding. It can justifiably be claimed that Schwitters is the only modern artist to arrive at a sophisticated style without preliminary stages of some duration and crudeness. His early work (of which there is little) gives no hint of the abrupt change that was to take place in 1918. Exhibited in 1917, his first drawings and paintings gave every indication that he would remain within the more structured side of German Expressionism. Within a year he had completely reformulated his esthetic. Without hesitations or dry periods, he consistently maintained a high level of pictorial achievement until his death in 1948. It would appear that Schwitters never agonized over his work; he completed each piece to the best of his ability, then put it aside and got on with the next. Moreover, he had a compulsive drive to work at the most rapid possible rate. The steady stream of his production was interrupted only by various

journeys in Europe and his enforced exile from Germany to Norway, and subsequently to England. In spite of being uprooted, and very often having to face difficult working conditions, he continued to produce. There are various changes of emphasis in Schwitters' work which can be charted, but it should be noted that once he adopts a particular device or working procedure, though it may be dropped for a while, its use is liable to reoccur at any later time. By 1919 he was working well into the area of collage, often with an admixture of oil paint and flat pasted material. A number of 1918–19 collages show stylistic affinities to Max Ernst, but it would be difficult to prove any direct influence. It may very well be possible that those collages antedate similar work by Ernst. The early collages are strongly Synthetic Cubist in their organization and employ a matrix of figures cut from newspapers, magazines, and advertisements. In 1919 also appear the first purely abstract collages that employ textured and printed papers without figurative elements. These are not the first purely abstract works by Schwitters; a number of drawings dated 1917 and 1918 appear to be tentative explorations into a totally abstract world.

Schwitters, it should be noted, emphatically regarded his collages as paintings and not drawings:

> I call small compositions that I have pasted and occasionally overpainted 'Merz-drawings.' In reality the expression 'drawings' is not sufficient because these small works are, essentially, painted, that is, colored and flatly formed. But by some chance this mistaken expression happened to creep in quite early and now this word cannot be changed very easily. But please regard the small 'Merz-drawings' as paintings.[1]

Schwitters' Dada activities began in 1919, when he conceived and named his own special direction as Merz. In speaking of the origin of the word "Merz," Schwitters wrote:

> I called my new way of creation with any material 'MERZ.' This is the second syllable of 'Kommerz' (commerce). The name originated from the 'Merzbild,' a picture in which the word 'MERZ' could be read in between abstract forms. It was cut out and glued on from an advertisement for the KOMMERZ UND PRIVATBANK. This word 'MERZ' had become a part of the picture through being attuned to the other part of the picture, and so it had to stay there. You will understand that I called a picture with the word MERZ the 'Merz-picture' in the same way that I called a picture with 'und'

the 'Und-picture' and a picture with the word 'Arbeiter' the 'Arbeiter-picture.' When I first exhibited these pasted and nailed pictures with the 'Sturm' in Berlin, I searched for a collective noun for this new kind of picture, because I could not define them with the older conceptions like Expressionism, Futurism, or whatever. So I gave all my pictures the name 'MERZ-pictures' after the most characteristic of them and thus made them into a species. Later on I expanded this name 'MERZ' to include my poetry (I had written poetry since 1917), and finally all my relevant activities. Now I call myself MERZ.[2]

Schwitters' Merz paintings incorporated all kinds of three-dimensional objects – lids of tin cans, coins, cigarettes, parts of children's toys, and string. These objects, it would appear, were at first chosen for their qualities of flatness, and were pinned, nailed, or glued closely adjacent to painted or collaged forms. From 1921 onward, in marked contrast, the objects used are larger and thicker and very often dominate the work completely. Pieces of wood or wooden objects fixed to the surface project forward and bite deeply into the observer's space. When flat elements are used, they are very often positioned to run over the edge of the picture support and consequently bite into the surrounding wall space. At times, the connective Cubist architectonic scaffolding is absent; isolated pieces of wood or objects are arbitrarily positioned within a flat, extensive field, the Cubist structure being implied rather than actually present. Many of these works are very pure examples of assemblage.

Although operating from a basic commitment to an architectonic structure derived from Cubism, Schwitters' work at times manifests an Expressionist quality. In some of his early work, and to a larger degree after the thirties, his handling of texture and color has an eruptive force. He eschews, however, the excesses and exuberance of the high-pitched emotional color that characterizes German Expressionism. His color is somber, dry, and Cézannesque, and his work is remarkably removed from the typical lugubrious spirit of German Romanticism. Schwitters' work is more architectural than fluid or lyrical. There is a dry and quick edge to his art, but with no touch of heavy-handed efficiency and no compulsive mechanical quality.

The diversity of Schwitters' works in the twenties is astonishing. Dating from the early 1920s, but little known, are a number of small

Abstract Expressionist paintings made by dabbing, smearing, or rubbing oil paint onto paper. With no form of visible linear structure, texture is exploited as image. Constantly linking these diverse aspects of Schwitters' art is his free and playful exploitation of materials and techniques. Typical of this approach are a number of drawings made by impressing a single word onto paper with a rubber stamp.

As early as 1920, Schwitters conceived and began to work on a large-scale, three-dimensional architectural sculpture, the *Merzbau*. The first of three such structures he built in his lifetime, it was destroyed during 1943 in an Allied bombing raid on Hanover. This original *Merzbau* preoccupied Schwitters for some sixteen years, and finally extended upward through two stories and downward into the basement of his house. The purest form of environmental sculpture, it completely engulfed the spectator within a cavernous maze of smooth, cubed forms that varied extensively in shape, size, and proportion. Schwitters maintained throughout this enormous work an appearance of spontaneity, haphazardness, and freedom from planning.

In 1923 Schwitters began publication of his magazine entitled *Merz*. Six issues were published in the first year; these included his own writing as well as contributions by Arp, Van Doesburg, Hannah Höch, Picabia, Mondrian, Tzara, Hausman, and Man Ray. In 1924 another six issues were published with contributions by Arp, Gropius, Lissitsky, and Tzara. *Merz* 10 was devoted to the Bauhaus, and *Merz* 11 to typography. (Schwitters became a notable and influential contributor to the shape of modern typographic design.) *Merz* 12, a children's book entitled *Der Hahnepeter*, was a collaboration with Kate Steinitz. As a result of the magazine and many other activities that took him on lecture tours to various European cities, particularly in Holland, Switzerland, and Germany, he became well known.

One consequence of Schwitters' close friendship with Van Doesburg and his intimate contact with de Stijl was a major shift of emphasis in his own art. From 1924 a strongly Constructivist mode is discernible in Schwitters' work: his forms tend to become simplified, more geometric, and the modules larger. Yet he never completely abandons his own style. Side by side with more formalized works, extremely free ones can be found.

Another very discernible break in his work begins in the thirties and reaches a climax in England. A heavier patina of surface effects, particularly the use of irregular textures and ragged edges, once more begins to pervade his work. The outlines of shapes become freely expressive, and many different kinds of loosely applied textural effects begin to dominate. Although this direction can be seen in his earliest work, in England Schwitters pursued this sense of accidental and random surfaces with renewed vigor and to great effect. The third *Merzbau*, which he worked on in an old barn at Ambleside, in the Lake District, also displays a heavy use of textural effects. In England, in the forties, Schwitters also began overtly to personalize his work. There is, for example, a collage dated 1944 which includes a magazine reproduction of a photograph of Sir Herbert Read. The basis of Schwitters' art is so rigorously abstract that he always had difficulty in encompassing the human figure. Now, suddenly, in various works – in particular, a collage taken from an American comic strip depicting a group of figures reaching out toward a girl – he begins to have new thoughts about ways of using figuration within the context of his approach to art. Pointing up this concern of Schwitters for re-establishing the use of the figure within the discoveries of modern art is the fable he wrote entitled "The Story of the Flat and the Round Painter." First published in the mimeographed newspaper of the camp in which he was interned at Douglas, on the Isle of Man, at the beginning of World War II, the story postulates that although it may no longer be possible to paint "round figures round in the air with round brushes" it is now possible for "painters [to] paint plain, flat figures with flat brushes on flat canvas." Unfortunately, Schwitters' death cut off his further exploration of this notion.

Though Schwitters was completely in touch with what was going on elsewhere, and not in any sense cut off or isolated, his intense sense of individualism evidently drove him to resist assimilation into any major center of art. And while he was in no sense a provincial artist, it is obvious that during his immediate flowering his contribution within the avant-garde of European art was seen as something fragile, or less ambitious than that of other major figures. It is impossible to gauge, of course, to what extent Schwitters' art would have been crushed or

deflected had he come directly under the influence of such figures as Picasso or Braque; but essential to Schwitters' position was his refusal to be absorbed by any movement he admired, whether Cubism, Dada, or de Stijl. He was, in effect, a one-man movement with an extraordinary ability to synthesize what seemed – at least, at the time – very disparate and antagonistic views.

One of the reasons for Schwitters' lack of celebration is that during his lifetime he had no energetic and articulate champion of his work among the art theorists. For so detached an artist as Duchamp, there was always a Tzara or a Breton or any number of well-qualified supporters in the background who vociferously campaigned for his art. Schwitters remained aloof, particularly from Huelsenbeck and Ball, as well as from the intellectual leaders centered in Berlin, who tended to regard Hanover as a provincial outpost. All of this is not to imply that Schwitters was totally misunderstood, or disregarded – he was ardently admired by a number of important artists, in particular Arp, Van Doesburg, Lissitsky, and Tzara – but, as Kate Steinitz points out, Schwitters preferred his independence.

It is strange that Schwitters' art has had little influence in Germany. It is true, of course, that the continuity of Germany's art, if not its total life, was completely disrupted by Hitler. None of the great artists who emerged from Germany prior to the rise of Hitler and the subsequent destruction of German intellectual life actually survived the war to have direct contact with a new, postwar generation. German art had to be completely rebuilt, and by the time this reconstruction began to take shape, echoes of what had occurred in French art or in the New American Painting became the principal influences. Moreover, given the present mood of Germany there is very little room for the simple, democratic, good-natured art of Schwitters to take root. Current German art is split into two modes with very little between. The interest of a younger generation is fixed either upon a new start by the use of a rigorously pure and clean abstract imagery, or upon a highly introspective, tortured art, reminiscent of Kafkaesque nightmare. A sense of pride in a national art heritage has emerged most strongly in postwar Germany, unleashing a strong drive to re-embrace the the major figures who operated from Germany and who were important influences in

twentieth-century art. So far, the primary focus has been on the Expressionists, although Schwitters has not been overlooked. His memory was honored in the city of Hannover in 1956 with a major retrospective exhibition organized by the Kestner-Gesellschaft; and in 1960 his work was chosen to represent Germany at the Venice Biennale.

Although Schwitters had no direct influence on postwar British art, his work is well known and admired in England. To a certain extent Schwitters laid the groundwork for the development of Pop Art in England, particularly the notion of creating art out of the common and vulgar materials of urban life – though British Pop Art is not committed so extensively as is American Pop Art to the employment of banal urban imagery. Schwitters also prefigured the manner in which many British Pop artists organize their paintings. It is his sense of juxtaposing fragments of disconnected images derived from the mass media that seems to inhere in their work. On the other hand, Schwitters' radical approach to media holds little interest for the British Pop painters, who with rare exception tend to be quite traditional in their approach to media and rely mainly on oil paint and canvas with occasional touches of collage.

As a consequence of various developments in post-World-War-II art in the United States, particularly the use of abstraction in assemblage and new ideas of interrelationship between life and art, Schwitters' work now seems highly important to the widest range of American artists. Schwitters' entire sensibility is devoted to and steeped in an expression of the urban life-style synthesized in all possible media. In other words, Schwitters' art can be seen as a multimedia focus on the essence of the life modern man has erected around himself, for better or for worse. In this sense Schwitters anticipates the work of Jasper Johns, Robert Rauschenberg, Claes Oldenberg, and Louise Nevelson, to name only a few. And in another sphere, Schwitters' multivalent sense of media, combined with his notion that art need be confined neither to traditional manifestations nor to a rectangle on a wall, is an important tenet of the new current of Happenings. Schwitters' prototypical theater of the absurd was basically esthetic, and participated in social and political polemic hardly at all – in contrast to many other Dadaists. This is true despite Schwitters' efforts to create an art free of estheticism; indeed the word was probably anathema to him. Schwitters

was accessible, and offered clues, to a younger generation of American artists such as Allan Kaprow or Robert Whitman and others operating in the area of non-literary theatrical events.

Schwitters' use of a rigorous empirical abstraction elicits the esteem of the widest range of younger, more reductive abstract artists. His sculpture is of great relevance to current manifestations of this aspect of art. It may be remarked that Schwitters' sculpture does not provide, in the conventional sense, notions of sculptural grandeur or of grand ambition; that in fact his sculpture was trivial in its imagery. This would obviously be incorrect when applied to three-dimensional environments, such as his Hanover *Merzbau*, which surely, had it survived the war intact, would have been one of the grand monuments of twentieth-century sculpture. Schwitters' smaller sculpture, however, is no more trivial than his smaller collages. Primarily because of his open-ended approach and exploitation of materials, his small sculpture has great relevance to current work in sculpture. His sculpture is in fact an initial foray into an area of art that flowered enormously within a couple of decades after his death.

Apart from Schwitters' concern for media and his breaking down of inhibitions concerning the inherent value of various sculptural media, he found ways of utilizing almost any material in an extraordinarily innovative fashion. In this respect he is very different from Duchamp, who in his ready-mades tended to accept the object or objects as a whole. Schwitters' form sense is much more eccentric. When he built either his open-form small sculptures from wire, for example, or his solid small sculptures from wood or plaster, the shape they assumed was dependent on the inherent properties of the material. In other words, there is no tendency in his work towards the use of an overlay of biomorphic form, or any kind of applied Cubist armature. The same may be said of his large three-dimensional agglutinized environments – the three successive *Merzbaus* he built in Germany, Norway, and England.

Within the pulse of Schwitters' art there is a uniquely integrative quality. He was reluctant to draw an arbitrary line between life and art. Thus the accidents of life or any unexpected turn of events became sustenance to him; he used anything he came across. For Schwitters,

relatively speaking, there was no such thing as the right or wrong material, or a good or a bad experience; he found methods of encompassing within his art whatever he encountered in life. He felt, so it would appear, that art could be pervasive and inclusive – a window onto life.

Notes

1. See exhibition catalog, *Kurt Schwitters*, Los Angeles: UCLA Art Galleries, 1965, p.9. From *Merz* 20, *c.* 1927.
2. *Ibid.*

Serial Imagery: Definition*

As nature becomes more abstract, a relation is more clearly
felt. The new painting has clearly shown this. And that is why
it has come to the point of expressing nothing but relations.

— Piet Mondrian

Abstract art or non-pictorial art is as old as this century, and
though more specialized than previous art, is clearer and more
complete, and like all modern thought and knowledge, more
demanding in its grasp of relations.

— Ad Reinhardt

Serial Imagery is a type of repeated form or structure shared
equally by each work in a group of related works made by one
artist.[1] To paint in series, however, is not necessarily to be Serial.
Neither the number of works nor the similarity of theme in a given
series determines whether a painting or sculpture is Serial. Rather,
Seriality is identified by a particular inter-relationship, rigorously
consistent, of structure and syntax: Serial structures are produced by
a single indivisible process that links the internal structure of a work
to that of other works within a differentiated whole. While a Series may
have any number of works, it must, as a precondition of Seriality, have
at least two. Thus a uniquely conceived painting or sculpture *cannot*
be Serial.

There are no boundaries implicit to Serial Imagery; its structures
can be likened to continuums or constellations. Though often painted
in sets, that is, in a limited number that satisfy a given condition,
Serial Images are nevertheless capable of infinite expansion. There is
no limit to the quantity of works in a Series other than what is deter-
mined by the artist. Once established, a Series may be kept open and
added to periodically in the future. The question of the number of works
in any given Series is relative to the artist's intentions and working
procedures, and may involve a variety of approaches (as will later be

* This text forms the section entitled "Definition" in *Serial Imagery*, published by the
Pasadena Art Museum and the New York Graphic Society, September 1968.

discussed). Serial Imagery furthermore ignores the rational sequence of time. Series can be cut off at any point (cf. Kenneth Noland, Morris Louis, Frank Stella, Ellsworth Kelly); re-entered later (Stella); or continued and extended indefinitely (Josef Albers).

Central to Serial Imagery is the concept of *macro-structure* – that which is apprehended in terms of relational order and of continuity, but not in terms of distance, number or magnitude. The following example will make this relationship clearer. If the number one is combined with a comma and given the status of a self-contained unit (representing a painting), and repeated thus,

$$1,1,1,1,1,1,1,1,1,1,$$

all the units are interchangeable. The units are presented lineally and without hierarchy of order; each unit is similar and each is of equal importance. In the same manner the macro-structure of a Series is self-evident irrespective of the number of works in the Series.

Equally essential to Serial form is the *consistency* of the postulates, that is, that no two contradictory propositions can be deduced from any collocation of units. Hence, if the units are positioned irregularly,

$$1,1,1, \quad 1, 1, \quad 1,1, \quad 1, \quad 1,1,$$

the rhythms may vary but the macro-structure in each sub-group is identical to that of the whole.[2] Thus the macro-structure is not dependent on interval or distance; each unit remains interchangeable and has the same rank as the others, without disturbing the continuity of the macro-structure. This interchangeability of the units and their lack of hierarchical order is more clearly revealed if the units are arranged symmetrically, as follows:

$$1, 1, 1, 1, 1, 1, 1, 1,$$
$$1, 1, 1, 1, 1, 1, 1, 1,$$
$$1, 1, 1, 1, 1, 1, 1, 1,$$
$$1, 1, 1, 1, 1, 1, 1, 1,$$
$$1, 1, 1, 1, 1, 1, 1, 1,$$
$$1, 1, 1, 1, 1, 1, 1, 1,$$
$$1, 1, 1, 1, 1, 1, 1, 1,$$
$$1, 1, 1, 1, 1, 1, 1, 1,$$

Such an arrangement, which can be read up and down, diagonally, or back and forth in any direction, demonstrates (if only by analogy) the inherent capacity of Serial structures to interact and to reinforce, by juxtaposition, each other's presence and qualities. Meaning is enhanced and the artist's intentions can be more fully decoded when the individual Serial work is seen within the context of its set. In earlier or non-Serial art, the notion of a masterpiece – of one painting into which is compressed a supreme artistic achievement – is implicit. However, with Serial Imagery the masterpiece concept is abandoned. Consequently each work within a Series is of equal value; it is part of a whole; its qualities are significantly more emphatic when seen in context than when seen in isolation.

The foregoing is not to say that a Serial painting or sculpture lacks autonomy. Each single work in a Series must be complete in itself and therefore *may* be shown in isolation. Furthermore, in some Series the appearance of the paintings, if they are exhibited as a set, will be affected by the sequence in which they are hung. This is especially so in the work of Albers (though the degree and type of change that takes place varies from artist to artist). Albers is so precise in his handling of color – itself a highly *imprecise* material – that the emphasis and tonality of his paintings are subject to considerable variation according to their juxtaposition.

In mathematics there seem to be at least four possible Serial forms. Referring to the Dedekind-Cantor theory of variables, Edward V. Huntington states:

> ... With regard to the existence of first and last elements, all Series may be divided into four groups: 1) those that have neither a first nor a last element; 2) those that have a first element, but no last; 3) those that have a last element, but no first; and 4) those that have both a first and a last.

The implications of definitions 1) and 4) may be illustrated with Gertrude Stein's strikingly Serial poem: "Rose is a rose is a rose is a rose."[3] As Miss Stein relates in her autobiography,[4] she made a monogram of the poem, which she used on her notepaper:

In this form the poem has a first and a last member, whether it is written in a line or designed as an emblem, and would fall under definition 4) above. Yet in discussing the poem Miss Stein either deliberately or inadvertently misquotes herself and renders the poem "... a rose is a rose is a rose is a rose."[5] If "is" is added to either side of this revised form, and the poem recast as an emblem, the parameters of the structure are sufficiently altered to make the difference critical; the poem then conforms to definition 1) and in its duration becomes similar in structure to a continuum – that is, non-linear. (It is also perfectly symmetrical in its parts, having seven members in each quadrant.[6])

All contemporary usage of Serial Imagery, whether in painting or sculpture, is without either first or last members. Obviously, at one point, there had to be a beginning – the first painting or sculpture made – but its identity becomes subsumed within the whole, within the macro-structure. The same principle applies to the last member. At any given point in time one work in a Series stands last in order of execution, but its sequential identity is irrelevant and in fact is lost immediately on the work's completion. The basic structure of Serial Imagery, then, can be likened to a pack of cards, in which every card is the Ace of Spades; all cards are of equal value and all imprinted with the same emblem, which may or may not vary in size, color, or position.

Setting the question of Albers aside for the time being, it can be said that the first use of Serial Imagery in recent painting is shared by two artists, Ad Reinhardt and Yves Klein. Klein's Serial painting (begun about 1957) is marked by the systematic use of one canvas size and one grainy textured color. Among Klein's Serial works the similarity of color together with the low textural level of organically textured paint grain, while it slowed down scan, was insufficient to defeat an inherent tendency towards inert uniformity. Reinhardt's use of Serial Imagery, on the other hand, though also basically entropic as an enterprise, is more important for a number of reasons. Reinhardt's Serial usage predates that of Klein, and unlike the overtly systematic look of Albers' art, Reinhardt's Serial forms imply *the use of a structure whose order is inherent but concealed.* In various paintings (as far back as 1955) Reinhardt employed as a structural principle a series of symmetrically positioned forms that repeated the framing edge. At times he united four square canvases to form a larger square. This modular division of the overall format was further reiterated by the horizontal and vertical squares symmetrically placed within each segment. His early systematic use of symmetry served to purge his painting of an outdated rhetoric, which he campaigned against equally in his systematically reiterated writings.

Reinhardt clearly is a key figure in the evolution of Serial Imagery in the United States, as Klein was not. If, apart from the inherently entropic tendency of his painting, any deficiency could be isolated it would be his manner of paint application, which never sufficiently

de-activated the internal time-flow of the structure. His method of facture, consisting of a layer-upon-layer application of flat paint over a pre-existent image, left traces of a "local" time-track. In his last works, however, the black overlay of paint fused more into a one-to-one relationship with his structure. As the paintings got blacker they got more and more neutral. The formal importance of Reinhardt's painting therefore resides in its quality of indetermination, its neutral emptiness. This indeterminate quality would not be remarkable in itself if it were not allied to an emphasis on symmetry and macro-structure: that which raises no claim to stand for the work in its own right, but which controls the development of the individual painting within a Series. What Reinhardt set into motion was the idea of a network of choices and limitations which were preformed but not logically apparent on the surface of the picture or within the whole Series. Until now it has always been assumed that Reinhardt was only repeating one painting rather than painting a Series. On the other hand Reinhardt's work also proved that once the hierarchical links are solved and ironed out it becomes increasingly difficult to achieve contrast, that is, to give each painting a positive identity without reasserting rank or becoming over-bearingly redundant. Nevertheless, his painting was an important step in the Serial direction and of great importance to a later generation.

It was Stella who made the first moves to exploit Serial depositions of a higher order. In the manner of Reinhardt, Stella (in his first Series, in 1959) also employed black, but with a linear element tracking across the picture plane. These lines were formed by leaving ragged edges of unpainted ground between the abutting areas of black. Stella reversed Reinhardt's process of paint application; instead of making an image and then painting over it, allowing it to bleed through, Stella obliterated most of the painted ground and left the unpainted parts to form the image. In this way he obtained a greater fusion of image and facture, without leaving a time-trace. By varying the linear image he asserted the individual identity of each painting within the overall system.

It is important to note that the organization of Stella's paintings begins in the center, and spreads outward by his use of various kinds of symmetry. Rather than echoing the rectilinear shape of the canvas within the field, as Reinhardt had done, Stella asserted the thickness of

the stretcher bar as a modular element that controlled interval-width between the lines in the internal structure of the painting. However, instead of imposing the framing edge as the unifying structural principle, Stella took the basic module and extended it outside the framing edge by 1) making the stretcher bar equal in thickness to the internal module, and 2) repeating the ground color with the unpainted portion of canvas that covered the stretcher bar. It is only coincidental to his system that the internal modulations and the stretcher thicknesses are the same. In this manner Stella was able to employ a wide variety of images that have no one-to-one relationship with the horizontal and vertical elements of the framing edge; the vectors of his internal imagery are consequently disparate and energetic. (This structural process involves an absolutely different syntax from that arising from Synthetic Cubism, which systematically reiterates and plays against the internal boundaries of the framing edge.)

It is useful to return to Gertrude Stein's poem "Rose is a rose is a rose is a rose" in order to amplify Stella's moves. To Miss Stein, nouns were of great importance. In systematically repeating the noun "rose" she took advantage of its innate capacity to evoke multi-levels of meaning and image. The subject of her poem might very likely have been Francis Rose, a minor Surrealist painter with whom she was extremely friendly. As the poem was read it might have conjured up a succession of images something like this: Rose (Francis) is a rose (flower) is a rose (color) is a rose (perfume) is a rose (gem) is a rose (compass card), etc. In Reinhardt's Serial Imagery the threshold of difference between each painting is so low as to finally deny difference, though it is true each painting occupies a different space. Stella, on the other hand, created a unique identity for each painting by using a simple, bilaterally symmetrical network of images, which, in effect, were variants of the same image. In this way he preserved an absence of hierarchy; each image was equal in rank. Each image at the same time asserted its own identity with its own evocative potential, so to speak, in the manner of Miss Stein's rose. Moreover, Stella's paintings can be positioned in random order; the time-flow is non-sequential.

Although Piet Mondrian's art employs systematic elements of equal value that are interchangeable, they contain an obvious linear

time sequence and a first and last number. This is apparent because his facture becomes more refined in time and each painting is self-consciously dated on the front. In this sense Albers' art is nearer to Stella's; the duration between Albers' paintings is compressed, and the time-flow more nearly reversible. Music, poetry, and dance, by the very nature of their form, can only flow forward in time. It is impossible to play music, to read poetry or to dance backward. In one form or another Claude Monet, Alexei Jawlensky, Marcel Duchamp, Mondrian, Albers, Klein, and Reinhardt have all proved in their Serial investigations that it was possible to make time relative and to reverse its flow. But it was Stella, who was soon to be joined by Noland, Louis, Andy Warhol, Larry Bell, and somewhat later, Kelly, who began a sophisticated dialog involving the non-sequential possibilities of Serial forms that rapidly led to a new plateau of achievement.

Inherent to the earlier use of Serial Imagery is a lack of extension or progression; whatever the quality of Mondrian's and Albers' achievement, their art reaches a plateau and stays there. Obviously, they become more adept in time at using their system, but their art nevertheless remains circumscribed by a non-expanding esthetic. They refine rather than expand the system further. Part of Stella's remarkable achievement was his discovery that the inherent non-atavistic tendency of Serial art – the inability of the artist to regress to a more primitive spatial notion so long as his system was maintained – could be accelerated and made to leap forward rapidly. Stella began exploring the nature of Serial Imagery vertically as well as horizontally by altering the parameters within each successive Series. The parameters of each Series are not only varied but often reinforced in complexity. For instance, within one series Stella may repeat the same shape in different colors while, at the same time, progressively altering the initial shape. Stella discovered that the permutations – the typical, possible distributions which are strategically central to Serial order – can be varied at will. That there are no limiting rules to this strategy is reminiscent of Wittgenstein's remark: "Language is a 'game' the rules of which we have to make up as we go along."[7]

Stella's moves toward a discrete quantification of the parameters was first marked by a realization (in the *Black* Series) of well-defined

and clearly distinguished *units*, articulating themselves by means of reciprocal effect, each one limiting and defining the nature of its fellows. Thus a situation of cross-incidence and cross-reference, of reciprocal relativity and multi-polarity, became his most essential means. And in order to judge the fruitfulness of each new step within a particular new Series it became necessary for Stella to anticipate the entire route ahead.

Noland and Louis, who soon joined Stella in the Serial enterprise, have a much more romantic outlook; such pre-plotting is clearly antithetical to their esthetic. To be sure, Serial Imagery, though systematic, does permit unknown variables. As Anton Ehrenzweig has observed, the artist obviously "cannot anticipate *all* the possible moves that are open according to the rules which [he is] still making up," but he "*can* handle 'open' structures with blurred frontiers which will be drawn with proper precision only in the unknowable future" [my italics].[8] Both Louis and Noland are much older artists than Stella, and their painting habits were formed by the esthetic of an earlier generation. It is to their credit that once they entered the Serial dialog they performed brilliantly, though often with perceptible hesitancy because of their disinclination to plot and anticipate their primary moves. After Noland's first extraordinary Series of *Targets* (which were done in 1960–62 and are among the finest explorations of Serial Imagery), his hesitation and wavering became apparent; yet in the later *Chevron* Series and others that were to follow he reasserted his Serial direction with great clarity and extraordinary verve.

Stella's earliest investigations involved shape; in contrast, Noland's earliest concern was color. As the ensuing dialog developed Stella and Noland were to exchange interest, Noland later exploiting shape as well as color and Stella adding color to his explorations. Louis' central focus was on color throughout. These artists, as well as Bell (in sculpture), were to discover that Serial Imagery directly attacks all conscious means of ordering the micro-structure; the internal order can become random, providing the parameters of the macro-structure are systematically maintained. Louis discovered this in his pouring technique, and was then able to paint without envisioning the complete field. Provided Louis could delineate in advance where he was to pour the color, and

could maintain the family of color and similar intervals within each distinct Series, it was not necessary for him to view the whole potential field; each area of the painting could be added to part by part.

Given the overriding control asserted through the macro-structure and the drive to create an individual identity for each discrete unit, a corollary of the Serial process would then be the development of an infra-structure that surfaces and magnifies buried qualities. Stella, for example, in his second Series, as a final necessity brought about by the logic of the internal configuration, began to notch out the shapes of his canvas; this idea was made possible by the reciprocity of the parts to the macro-structure, which in its topology lies outside the boundaries, or apart from the boundaries, of the framing edge. Stella's intention it would seem was not to create objects or to objectify his canvas as much as to make the individual work's presence within a Series *resonate*, to give each unit more visual energy, thereby reversing the entropic process; in other words to give each painting a supra-identity.[9] John Cage has used a similar procedure in musical performances: in order to give clarity and brilliance to the sound emitted by a particular instrument, he removes it from the ensemble and places it within or at some point on the perimeter of the audience, where it waits its turn to be heard in the prescribed sequence of play.

It must be remembered that in Serial Imagery the exhibition space becomes a component. Only when paintings of a Series are exhibited together in a gallery space do the parameters built into the paintings and their reciprocal quality begin to operate. By permitting the paintings to bite into the wall space, and the wall space to bite into the shaped canvas, Stella added another reciprocal parameter to his system; he emphasized the space by forcing it and the painting to become attached. Moreover, when his shaped paintings are hung on the walls, the walls act like sound boxes echoing the interior shape and amplifying the exterior shape. The intervals between paintings, as the intervals in music, become positive elements. The more eccentric the overall shape of the canvas the greater the contrast between interior and exterior forms (as, for example, in Stella's 1966 Series of highly idiosyncratic shaped canvases with contrapuntally shaped colors). Stella not only orchestrates the color and the shape so they simultaneously assert and

deny one another; but when these paintings are strung along a wall the intervening spaces intensify the differences between canvases. (Noland's attenuated diamond shapes also set up a series of highly repetitive and assertive diagonal rhythms when exhibited adjacent to one another.) In addition to resonating the individual unit within the Series and extending its identity, Stella's art tests both the structural parameters of Serial Imagery and the extent to which they can be stretched.

Too little in recent criticism has been written on the nature of color as it is experienced in the work of Stella, Noland and Louis, other than to note its *optical* quality. All our experience of color, of course, is optical; yet Albers for one – perhaps more than any artist over the last twenty years – has set out to render our perception of color more precise, specifically by focusing on a limited range of particular colors. He has in a sense blatantly revealed the purity of color as an optical phenomenon; he has magnified the tensions color is capable of inciting in the eye, and he has made the viewer sensitive to color as a purely perceptual experience. His single-minded, haunting enterprise has been to lock color and structure into an absolute one-to-one relationship. Color to Albers has never been a decorative element. No artist in recent times has rendered more precisely than he, or permuted so intensely, the possible range of color experience, without denying its subjective or psychological overtones. It should be added that while Albers has always insisted his approach to color is intuitional, that fact has for the most part been ignored.

Central to Serial Imagery, as has been previously stated, is the controlling influence of the macro-structure, within which (provided the parameters are systematically observed) a high degree of randomness in the use of infra-forms is possible. Applying this principle to the use of color in Serial forms, it is necessary for an artist only to maintain the same family of colors in order to proceed with an extraordinary degree of freedom – a freedom, moreover, that has not previously been possible. The moment Louis, to take one example, began a systematic use of Serial Imagery the whole nature of his color enterprise changed. In his Series of *Stripe* paintings the effect of pouring the different but adjacent stripes of color onto the unsized ground was to give these

vertical elements a lateral displacement in time and space. In other words, by pouring only once rather than several times to form each single stripe within a typical cluster, Louis left no record of the flow of time. An additional effect of pouring one stripe adjacent to another and letting the stain spread from one to another was to induce a homogenized surface. The stain acted somewhat in the manner of mortar, which fills in to give brickwork a monolithic appearance despite visual evidence of the brickwork's modular origins. This method enabled Louis not only to achieve what Albers had practised for years, but to bring added complexity and randomness to the process.

On the other hand, turning to the *Target* paintings by Noland, it is evident that the most crucial parameter of Noland's macro-structure is the *center* of the painting rather than the framing edge. Noland's color structure depends on the most rigid and absolute use of symmetry. In most of the clear-edged *Target* paintings it is of no consequence whether the top is marked; the paintings may be hung any side up without altering the appearance of the image. Noland's use of a jig of some kind to brush in the forms ensures the rigidity of his symmetry and its lack of perceivable variations. Presumably by choice, Noland varies the interval and distance between the concentric rings of colors. However, once he has set up his system he could probably position the color more randomly if he wished.

The result of this system of control by a macro-structure in the work of Louis, Noland, and Stella is that for the first time color can be fully orchestrated. The intervals, cadence, and textures of the colors begin to assert themselves in a form similar to music, with the individual colors vibrating and resonating. In Louis' *Stripe* paintings the colors virtually form visual chords. And unlike music, color need not be read forward (linearly) but can be scanned from any point in any direction, allowing the rhythms as perceived by the eye to vary to an extraordinary extent. As a result color in these paintings takes on a role it has never been permitted to assume in all the long history of art.

Within the development of Serial Imagery, Andy Warhol's art proves to be highly idiosyncratic. Warhol was to take the inherent entropic tendency of the earlier phase of Seriality and (like Beckett and Genet, two outstanding figures in recent literature whose life-style

Warhol in various ways so remarkably echoes) turn it into a positive factor. Perhaps no single image in the second half of the twentieth century is so daring in concept and so beautiful in appearance as Warhol's helium-filled Series of floating aluminum pillows, which change position and relationship to one another with the slightest breath of air. In their form they represent the most perfect visual analogy of a continuum the human mind has conceived: identical, manufactured objects remorselessly stamped out by a machine, which when filled with gas and clustered within a space, become more organic in their relationship than the interweaving strands of a Pollock painting.

Larry Bell is the only sculptor of consequence to emerge in the sixties who deploys Serial Imagery. Bell was originally a painter, and his sculpture has a presence that betokens still another aspect of Serial forms. It has been shown that Serial Imagery is concerned not with the notion of masterpiece, but of process. Process implies progression or advance within a steady rhythm – in other words, continuity and productivity. Process is not a closed system arising out of a unique esthetic; it is not concealed in highly charged psychological factors. Process is a system that can be decoded and adapted to any personal use. Once a process is understood, an artist can enter into the dialogue at any point. It is choice of "realm" that is important and not uniqueness of "subjects." Hence Bell's crucial act was that he decoded the Serial system and made his own entry into the process, while working out of Los Angeles and without ever having been to New York or knowing any of the other artists concerned. More than any art in the past, the dialogue of Seriality is taking place in public; it is a gallery and not a studio art.

From the critical viewpoint, the employment of Serial Imagery raises a number of issues. Serial forms reveal very easily the complexity of the artist's decisions and the nature of his enterprise as a whole. Once several artists use a similar system or process they substantiate each other, both to the audience and to themselves. Each artist, of course, is engaged in an endeavor to make the best art of his time; but the dialogue is so public and the system so flexible that the rate of each artist's response is greatly accelerated. Furthermore, the more eccentric any work within a given Series is, the more easy it would seem for the

critic to judge it; however, due to the extreme mutuality and interdependence of each painting in a Series, judgments as to the quality of any one painting are difficult, if not pointless. How is one to decide which Mondrian is *the* masterpiece? It is impossible to discuss at any meaningful level the relative importance of any one of his paintings over another. Judgments of this nature have to be foregone. In Mondrian's mature work it is necessary to deal instead with the nature of his informing *structure*: how is it more clear in his later art and less clear in his earlier art? Indeed, except for Mondrian's last works there is *no* inherent system of progression in his art. Moreover, one cannot say which Monet *Cathedral*, which Serial Reinhardt, which *Black* Stella, which Noland *Target*, which Warhol *Campbell's Soup Can*, which Serial Kelly, or which of the later Bell boxes is best. Such a judgment is meaningless; at best it does no more than exercise a dubious connoisseurship.[10] The crucial factor is again the choice of realm, the way each painting fits within the chosen structure: that is, whether the postulates of each painting are consistent with the others in such a way that no two contradictory propositions can be deduced within a Series. Thus criticism must address itself to the largest entity. The task of the critic is not to say which work is good or bad or best; his task is to ask what is there and what is the nature of the experience. Only then, if he wishes, can the critic venture an opinion of its value. In fact, simply to describe this experience is to in some way evaluate it.

Central to the work of all the Serial artists is the endeavor that has marked art since earliest times: the attempt to describe with the structure of art our perception of the space we inhabit. This undertaking informs all art, whether music, poetry, painting, or sculpture; each generation of artists refines, explores, augments or completely restructures our intellectual, psychological and perceptual awareness of the human spatial domain. In modern art there are two main streams of this evolution, one via Monet, the other via Cézanne and the Cubists.[11] Both dealt with simultaneity in different ways. Monet's Serial enterprise (as has already been pointed out) structured simultaneity by the use of a macro-structure, and can be spatially likened to a continuum. The Cubists, on the other hand, dealt with notions of simultaneity within the framework of one painting. Their structure and its topology

can be likened to a Möbius strip, which has no top or bottom, no inside or outside; all are interchangeable within a common framework. It took Cubism to assert Cézanne's notions, but Monet's were fully formed at the outset and were reiterated time after time in his art from 1891 onwards. Monet was painting serially through the years of Cubism. Yet it was not until nearly eighty years after the *Cathedral* Series that we see Monet's discoveries begin to be realized by other artists. Josef Albers, who was born three years before Monet's first advanced Serial venture began, is the living link between Monet and the new painters. It is to be hoped Albers' art will now be more clearly recognized for its potency.

There are sufficient indications in the emergence of Serial Imagery over the past decade in the United States that the rhythms attendant upon the Serial style ritually celebrate, if only obliquely or subliminally, overtones of American life. In various ways, Serial Imagery reveals a local color that identifies the ambience of its origin. Serial Imagery is particularly fitted to reflect its contemporary environment, because of the open and unplanned nature of its internal dialogue, its highly systematic yet flexible process of production, its high degree of specialization, and its narrow, deep focus on a single issue. Its redundancy is a positive act that continuously affirms the power and continuity of the creative process. Taken together, the approaches of the artists mentioned above in no small measure evoke the underlying control-systems central to an advanced, "free-enterprise," technological society. Esthetically, of course, the paintings are no better or worse for our recognition of this quality.

Notes

1. Serial Imagery, Seriality, Serial structure or form, etc. is used interchangeably throughout this text, and refers to forms linked by a macro-structure. The use of the word series, on the other hand, refers to a more simple grouping of forms in any kind of a set.

2. Interestingly enough, the logic of syntax common to Western languages does not permit the cataloging of simultaneously important entities in a non-hierarchical order. In Western usage, ideas or objects are invariably enumerated in ordinal sequence: 1), 2), 3), etc. The Chinese, on the other hand, prefix equally important items: 1), 1), 1), etc.

3. The poem as set forth here was originally one line of a longer and more complex poem, "Sacred Emily," from Gertrude Stein, *Geography and Plays*, Four Seas Press, Boston, 1922, pp.178–88.

4. Stein, *The Autobiography of Alice B. Toklas*, Literary Guild, New York, 1933, p.169.

5. *Ibid.*

6. In fact Miss Stein does consciously play with the form of this poem, giving it three different beginnings and hence three different structures. She introduces it with "Rose," "a rose," and "is a rose" all in the same passage. *Ibid.*, p.169.

7. Ludwig Wittgenstein, *Philosophical Investigations*, Blackwell, Oxford, 1963, par. 83.

8. Anton Ehrenzweig, *The Hidden Order of Art*, University of California, Berkeley, 1967, p.42.

9. Ellsworth Kelly had also much earlier struck upon this idea, but his was more a process of dismounting the canvas from the wall by making parts step out onto the floor and into the observer's space. In his case it was to lead to the development of a number of remarkable sculptures.

10. Ezra Pound's comment is highly appropriate: "I reject the term connoisseurship, for 'connoisseurship' is associated in our minds with a desire for acquisition. The person possessed of connoisseurship is so apt to want to buy the rare at one price and sell it at another. I do not believe that a person with this spirit has ever *seen*".

11. Mondrian and Albers draw upon both traditions.

Andy Warhol: The Art*

The most publicly celebrated figure to emerge from Pop Art is Andy Warhol. Claes Oldenburg and Roy Lichtenstein may well have received more serious consideration from the official art world, but to the American public-at-large Andy Warhol *is* Pop. Not that Warhol is taken any less seriously by the art world; his paintings are sought after by collectors and museums and command prices as high as those of his colleagues. But the focus on Warhol has been more on Warhol the celebrity than Warhol the artist.

True, Warhol's attitude may have encouraged this reaction. He is notoriously evasive about his art and seemingly indifferent to interpretation. The same cannot be said of Oldenburg or Lichtenstein, for much of what they have to say about their work is intensely illuminating. But Warhol's super-cool attitude and ability to incite the wildest of edge of publicity has undoubtedly influenced the reception of his art. He has not, of course, been entirely silent. An implicit sense of irony, even outright mockery, feeds through his few casually recorded remarks. But if Warhol misleads us the fault is more ours than his, for underneath the campy mask he so carefully presents to the world there is obviously a first-rate mind at work. Whether or not he casts himself in the role of anti-hero, feigns indifference or (for whatever reason) provokes our sense of disbelief is not the issue, for ultimately judgement as to what is significant in the art is pivotal to the work itself. Pop is a cultural phenomenon, and like any other style it must eventually fall on its merit, as art. Within the Pop style Warhol has produced an important body of work. The time has now arrived to selectively sort through his art and to examine the nature of his contribution.

Of the several artists who were to emerge as the leading proponents of Pop Art in the sixties nearly all were professionally trained painters; many had years of serious endeavor behind them, even if in other styles. Some may have worked from time to time in jobs outside of their chosen career in order to support themselves, but their knowledge of art was extremely sophisticated. Warhol is possibly the only exception. Yet once he made the decision to switch from commercial art to painting,

* First published in *Andy Warhol*, New York Graphic Society, 1970.

the rapidity of his transformation was startling. From the beginning of his painting career (sometime toward the end of 1960) Warhol has employed a banal and common imagery. His ability to intuit his entry into the art world with an imagery that shortly afterward was to prove extremely critical within the development of American painting was the token of his uncanny knack to incisively and speedily touch the heart of critical issues.

It is impossible, however, to discuss the origins and development of Pop Art – and especially the use of banal imagery so central to the style – without first remarking the influence of Jasper Johns and Robert Rauschenberg. Both painters unleashed into the art ambience various alternative proposals to Abstract Expressionism, chiefly by opening up painting (once again) to a greater range of imagistic content. Rauschenberg and Johns employed a type of imagery that evokes the ordinary, the commonplace of everyday life, and thus jointly freed banal imagery for use by a later generation of artists. Warhol was undoubtedly aware of Johns's and Rauschenberg's art (as were many other painters) but his direct use of comic-strip imagery as in *Dick Tracy* (1960) and *Nancy and Popeye* (both 1961) was an unexpected extension of their vocabulary – so much so that Roy Lichtenstein, on first seeing Warhol's comic-strip paintings at Leo Castelli's gallery at about the same time he brought in his own (in the spring of 1961), remarked in amazement at the similarity of Warhol's work to his own.

Warhol's first works are clearly exploratory and derive much from Abstract Expressionism as they connect to Pop. Though the cartoon imagery and the style of drawing obviously refers to the original models, the paint is loosely applied and dribbles in the "approved" Abstract Expressionist manner. In *Del Monte Peach Halves* (c. 1960–61) – a harbinger of the forthcoming Campbell's soup cans – the fruit can is more or less centrally positioned, with the image and subdivided background very loosely painted. In contrast, *Nancy* appears to be a literal blow-up from a frame of the well-known cartoon. In short, these paintings veer between reworked images and absolute duplications.

The most decisive move apparent in Warhol's body of paintings that follows (from 1961 to 1962) is the rejection of paint handling. This decision again sharply connects his work to Lichtenstein's. It is aston-

ishing that the two should simultaneously strike the notion, especially since they were the only artists to do so among the many involved with Pop imagery at that time. But, while Lichtenstein persistently and unwaveringly narrowed his style, Warhol at this time worked his way through many ideas with great rapidity, dropping each idea immediately once it was dealt with. If Lichtenstein proceeded with greater clarity and apparent purpose, it was for obvious reasons. He was a much more experienced painter than Warhol (his first one-man exhibition was held in New York in 1952); he had a greater theoretical grasp of his aims. Characteristically, once Lichtenstein narrows down a range of imagery suitable to his esthetic purpose he systematically plugs the gaps. However, both artists during this period selected images which, though different, nevertheless reflected corresponding ideas. In addition they sometimes lifted their images from similar sources, especially newspaper or yellow-page phone book advertisements. For instance, Warhol's 1962 painting *Before and After* is subdivided into two side-by-side images that sequentially reveal the silhouetted head of a woman, identical except for the reshaping prominent aquiline nose to a pert *retroussé* accomplished by cosmetic surgery. Lichtenstein's *Like New* (painted about the same time) is a hinged diptych that also uses a sequential image. On the left-hand panel is a piece of woven cloth with a large cigarette burn in the centre; on the right is the same piece of cloth in impeccable condition after reweaving. Obvious, too, at this time is a shared vein of humor – both artists' imagery is often simultaneously funny and devastating. They relish thumbing a nose at the art world by choosing an outrageous sub-esthetic range of subject matter.

Warhol's body of painting clearly underwent three principle stages of development: 1) he would select an image and rework it informally; 2) he then began hand-painting selected images to simulate mass-production; and 3) he finally dealt with mass-production directly through the use of various reproductive processes. The transition from one stage to another is not always clear, for there are occasional lapses.

Within the second category are the paintings derived from newspaper pages; match covers; dance step diagrams; paintings-by-numbers sets; stamps; single and multiple images of glass labels; money; S & H stamps; single and multiple airmail stamps and Coke bottles; and most

famous of all, single, multiple, and serial images of Campbell's soup cans. With the exception of the Campbell's soup cans, which came last, the sequence and order of these works are difficult to establish.[1] Throughout this period Warhol made numerous drawings either related as preparatory to the many images enumerated above or as proposals that were never painted: a record cover, a baseball, and others.

In these works there is a heavy amount of lettering, which he later discards. (Lichtenstein also gave it up, but he initially did a lot more with it than Warhol.) Warhol drops lettering entirely after the Campbell's soup cans, concentrating instead on the punch of his visual imagery. Also missing in much of this early work is a sense of brutality and morbidity common in later work. In short, in the earlier subject matter the possibility of the imagery being charged is there, but the temperature is low. The "charge" at this point is still below the surface. Nor is it a question of these works being painted by hand, though this is partially a factor; due simply to choice of imagery and inertness of handling, they lack the grotesqueness and sense of horror transmitted throughout the later work.

Within this group of paintings the highly varied "Do It Yourself" images are the most offbeat. Taken from hobby shop color-keyed painting sets, these banal images are transformed by Warhol into strange paintings that are themselves supremely banal metaphors for paintings. Though the color is literal, its lyricism is sharply at odds with the banality of the image. The "Do It Yourself" paintings pose the question: can a painting be made that looks mechanical but is not? The numerous numbers (that, in the hobby sets, indicated which areas were to be painted which colors) are of mechanical origin, printed onto transfer paper and affixed to the canvas surface by the application of heat. They mark the first suggestion of Warhol's finding the means to eliminate the use of the hand from his painting.

Some of the most important paintings from this second period, at least as far as Warhol's esthetic evolution is concerned, are the images of complete front and back pages from the *New York Mirror, Post,* or *Daily News.* Newspapers inherently suggest the use of mass-production and reproductive processes, especially the photograph, which appears in large scale on the cover pages of these newspapers.

Implicit in these paintings are Warhol's later charged images of disasters and public personalities who make the news. But most important are the associations they contain of the manner in which the newspaper consistently touches the pulse of life. As a medium the newspaper is central to what Lawrence Alloway has described as the communications network of the urban environment. Once gathered, written, edited, composed, printed and distributed, news – like the paper it is printed on – becomes stale within a few hours of its production, and then is immediately disposable. What is topical one moment is dead the next, only to be replaced by the next headline or next piece of sensationalism, sandwiched between a constant barrage of messages to consume.

The newspaper image presents, in a very forthright way, the issue of duplication, which is never quite raised in the work of Lichtenstein, who deals only with the reproduced process itself through the use of Benday dots. With Warhol one senses the use of the chosen image as a whole, as an entity, especially in the later photographic images. The imagery that Warhol finally selects is in the range of charged, tough notions that in Rauschenberg's work, for example, become transformed by painterly handling. Warhol's imagery is transformed in much the same manner that Lichtenstein transforms the comic-strip, but the crucial issue is that the transformation is not immediately apparent. More immediate to the viewer is that the painting looks as disposable as the original it is modeled from: something to be thrown away, or the cheapest kind of advertising, of no value except as a message to sell. This is exactly what infuriated Erle Loran as well as many others of the art audience. What these viewers failed to sufficiently consider was the power and ironic efficiency of the various concealed formal devices operating in the paintings: critical alteration of the contexts of the images, changes of scale, suppression of paint handling, compositional inertness, etc. But if Johns takes the American flag and with his formal innovations and painterly touch magically rehumanizes it, Warhol on the other hand, almost by choice of imagery alone it seems, forces us to squarely face the existential edge of our existence.

The money, Coke, airmail and S & H stamps, glass label, and Campbell's soup can paintings enforce the issue of multiplicity of the image itself, which as a motif is endlessly repeated. Two important

formal innovations edge into these paintings. First, the actual against the simulated use of an anonymous and mechanical technique, the second, the use of serial forms. Several of the money paintings were silk-screened, as were the modulated rows of images imprinted on the surface of the Whitney Museum's *Green Coca-Cola Bottles*. (However, though Warhol even much later never entirely removes hand touches from his paintings, it is not until he uses the blown up photographic image taken from newspaper or other sources that he becomes crucially involved in photomechanical and silk-screen printing processes.) And with the Campbell's soup cans which are the last of the hand-painted images, he shifts very decisively into the use of serial forms.[2]

Central to serial imagery is redundancy. The traditional concept of the masterpiece as a consummate example of inspired skill that sets out to compress a peak of human endeavor into one painting is abandoned in preference for repetition and abundance. Serial forms also differ from the traditional concept of theme and variation. In the latter, the structure may be the same, but the composition is sufficiently varied so that each painting, though belonging to a set, can be recognized as unique. In serial imagery, uniqueness is not the issue; the structure and composition are sufficiently inert so that all the paintings, even though they can be differentiated, *appear* to be similar. Basically, it is a question of a shift in emphasis. Theme and variation are concerned with uniqueness and serial imagery is not. Serial forms are virtually boring; there is very often a low threshold of change from painting to painting. But each painting is complete in itself and can exist very fully alone. Obviously, when serial paintings are seen together within the context of a set, the serial structure is more apparent. Serial paintings or sculptures, however, are all equal in the sense of being without any hierarchy of rank, position or meaning. They may also be added to indefinitely, at any time. This, of course, depends upon the approach of each individual artist and the manner in which he sets up (or alters) the parameters of his particular system.

Including Campbell's soup cans, Warhol's most serial paintings are those which thematically concentrate on a single image: for example, the various portraits as well as the Brillo and other boxes, the aluminum pillows, some of the disasters, and all the flowers. The power of these

images derives from their seriality: that there are not only many more than a few in any given series, but that it seems to the viewer there are many more than can possibly be counted. This has partially to do with choice of imagery. Warhol invariably selects an image that pre-exists in endless multiples. Thus his series gives the appearance of being boundless, never finished and without wholeness. Moreover, the larger the actual number of paintings in any one series, the greater the sense of inertia or input. Warhol's series, then (like the work of many other artists), speak of a continuum.

Some of Warhol's paintings seem to have affinities with the modular. This may well be true, especially for the S & H and airmail stamps, the multiple Coke bottles, the glass labels, some of the Campbell's soup can images and the Marilyn Monroe paintings. However, the use of a modular structure is not central to these works, which are hard to distinguish in essence from the more serial ones. There is never any sense of wholeness or completion, or of a holistic or unitary quality, to any of his modulated forms, which invoke endlessness and appear to be a segment of something infinitely larger. Obviously Warhol's work is hard to compartmentalize, but there is no doubt that the use of modular forms has greater power in the hands of other artists.

Crucial to Pop Art is the ironic power of its banal imagery. But it would be a mistake to think that Oldenburg, Lichtenstein, and Warhol, for instance, are attached to their material in the sense of praising it or liking it for itself. (They may like it for the purpose of their art, which is another matter altogether.) Unlike the English Pop painters, who often express a romantic view of American culture, these artists are strictly neutral; they are neither for the material nor against it. Instead they use banal imagery ironically, and consequently detach themselves from emotional attitudes about their subject matter. Furthermore, this detachment does not mean they cannot be viewed in any measure as moralizers. Without doubt, a strong vein of tragic humor pulses through Oldenburg's sculpture and drawings. Lichtenstein's images of love are full of pathos, and at the same time, ironically, his lovers (and heroes) are fully exposed in their shallowness. Warhol's images are particularly savage and uncompromising. They appear in some curious way abandoned, as it were, to public gaze; and once there they demand quite

persuasively that we face them, ourselves, and the twentieth-century landscape we cohabit.

Warhol's large, sparse, black and white painting of a single Coke bottle is a brutally baleful icon. There is nothing delectable about this painting. The sensuousness of the original glass bottle (designed by Raymond Loewy Associates) with the dark brown liquid gleaming through the container is thoroughly negated in the painting. But Warhol has a very special capacity to select images, which, when presented in a painterly context, associationally press upon the nerve-ends of certain aspects of our daily existence. It is not that Coca-Cola is so bad or so good. As a sweet, carbonated drink it is essentially no better or worse than other brands that are marketed. But what is perturbing is the ferocity of the overall effort that goes into advertising, marketing, and distributing something that is ultimately so trifling. Like so many other manufactured products, the packaging promises much, the advertising more, yet the product delivers little. Coca-Cola is prototypical of the desperate urgency abounding in a free-enterprise, technological society to bend and habituate the consumer to the producer's will, regardless of the intrinsic worth of the identical products made by different manufacturers. The shriller the advertising, the more ferocious the battle to gain and maintain a major share of the market. Unfortunately, there is more to it than this. Markets today are international, to be fought over in the same style as in America. Coca-Cola is symbolic of the new American industrial imperialism in which technology, marketing techniques and culture become irretrievably and inseparably intermixed to spawn on new territory the same manic set of goals and values.

Similarly, Campbell's soup promises much and delivers just as little. The thirty-two different soups mass-marketed each have a different name redolent of the gustatory delights of many nations and traditional good cooking – Scotch Broth (A Hearty Soup), Consommé (Beef) Soup, Minestrone (Italian-Style Vegetable Soup), Cheddar Cheese Soup (Great As A Sauce Too!), Old-Fashioned Tomato Rice Soup, etc. So much diversity within multiplicity! Though the names and ingredients may be different, however, the soups are all equally tasteless and may as well have come out of the same vat. Campbell's canned soups – Warhol seems

ironically to assert – are like people; their names, sexes, ages, origins, tastes, and passions may be different, but an advanced consumer-oriented, technological society squeezes them all into the same vat.

It is difficult to ascertain exactly what combination of circumstances led Warhol to change his imagery and technique so rapidly, radically and simultaneously toward the end of 1962 and in early 1963. Warhol's first New York exhibition in late 1962 included a very diverse range of paintings – Campbell's soup cans, Coca-Cola match covers, modular rows of Coke bottles, modular Martinson Coffee tins, at least one of the newspaper images (*129 Die in Jet*) and various portraits, in particular the modular heads of Troy Donahue, Elvis Presley, and Marilyn Monroe. In this exhibition, including at least one painting of rows of Coke bottles, all the portraits employ the silk-screen technique. The impersonal method of hand painting the images hitherto employed is subjected to a powerful transformation.

Rauschenberg and Warhol seem to have developed an interest in the silk-screen technique at about the same time (though Warhol may have anticipated Rauschenberg somewhat, in the money paintings of 1962). Rauschenberg's purpose was to find a means to alter the scale of the photographic material that he had formerly affixed to his paintings as elements of collage. Silk-screening allowed him to include the blown-up image as an integral element of the canvas surface. Warhol, on the other hand, used the technique as a device to control the overall surface of the painting. Warhol first lays down a flat but often brilliant ground color and then unifies the surface and image by repetition of the middle of the screen. The final image, however, is very arbitrary and quite unlike the impersonal handling of the serial Campbell's soup cans, from which all trace of paint handling has been suppressed. In employing the silk-screen technique, which is used in commercial art to give evenness of surface and crispness of outline, Warhol reverses the effect. In his hands the technique becomes arbitrary, unpredictable and random as the paint surface appears to be in an Abstract Expressionist painting.

In essence, silk-screen is a sophisticated stencil process. On the bottom of a box frame several inches deep and considerably larger than the image to be printed, a suitable porous material is attached (silk in the hand process and fine metal mesh in the mechanized process). The

image can be affixed to the material by a variety of means, either by hand or photomechanically. Warhol uses the latter method. All areas other than those parts of the image to be printed are occluded and made impervious to the print or a water-soluble dye. The frame is then placed on top of and in close contact with the surface to be printed. The liquid printing medium is poured in at one end of the frame. It is then stroked across the image with a rubber squeegee and forced through the mesh to print on the surface of the material beneath. Though the silk-screen process is simple, many things can go wrong. For instance, if the medium is stroked across the image unevenly, if the density of the medium varies, if the squeegee is worn or dirty, or if there is insufficient medium to complete a stroke, the image will not print evenly. Parts of the image will become occluded or the dirt will print tracks, etc. The sharpness of the image will also vary according to the pressure exerted on the squeegee, or the angle it is held at. Many of these deficiencies will often work their way into the mesh and, unless the screen is cleaned, will show up in subsequent images.

These normally accidental effects are often deliberately sought by Warhol. At other times, his images are printed more evenly. In many of the latter, especially some of the Marilyn Monroes, the nearly identical images are heightened by touches of color applied with a brush. A compelling aspect of Warhol's silk-screen images is that the transformation of the images is effected in the technique; thus it is embedded in the various processes.

The silk-screen process is capable of breeding a tremendous amount of paintings. Yet not only are Warhol's images very few; by the time the identical images are either printed many times on a single canvas, or alternatively printed on small canvases and then assembled into one serial painting, the number of his paintings shrinks considerably. In fact, the overall body of his work is surprisingly small. Since a major part of the decisions in the silk-screen process is made outside the painting itself (even the screens for color can be mechanically prepared in advance), making the painting is then a question of screening the image or varying the color. These decisions can be communicated to an assistant. Perhaps this is one reason why Warhol doesn't count how many works he ever made, or care. Those he doesn't like he can throw

away. It is not so much that he is uninterested in his own history (though that may well be a factor); his indifference arises partly because of the processes involved. It is always possible to make more, and what obviously interests Warhol is the decisions, not the acts of making.

Neither Lichtenstein's nor Warhol's painting (nor Johns's nor Rauschenberg's for that matter) is involved in edge-tension in the same manner as the field painters (Stella, Noland, Kelly). Lichtenstein's method of organizing the painting has more to do with Cubism, particularly his method of cropping the image. The actual borders of Warhol's paintings, on the other hand, are arbitrary and not at all critical. In fact, Warhol's paintings lack edge-tension. To him the edge is merely a convenient way to finish the painting. Like Lichtenstein, Warhol crops, but the final edge of the painting is determined by the repetition of the module of the screen, or the size of a single image contained on the screen. In Warhol's paintings of Elvis Presley, which reproduce the whole figure, the background is a flat silver. Either single, double or treble repeats of the figure are centered on the canvas. The top edge of the canvas cuts the head and the bottom edge cuts the feet. Because of the nature of the silk-screen process, which necessitates the unmounted canvas being placed in the press in order to be printed upon, the edges of these paintings are determined afterward, though obviously their general location may be known in advance. Very often the single images printed on one canvas are united to form a larger unit of several canvases. In any event, the edge is always positioned as an outgrowth of the margins of the image on the screen. At times Warhol will add to a screened canvas another blank canvas of the same size painted the identical color – as for instance the Liz Taylor paintings or the very large dun-colored *Race Riot*. But unlike photographs or movies, which localize space delineating subject, surroundings, background, etc., Warhol's paintings present images in a surrounding space that is felt or perceived as a continuum. This is enhanced by the fact that his portraits are without a literal background. His heads or figures are positioned on a flat-painted surface.

What Warhol's paintings lack in edge-tension is compensated by other tensions he induces in his pictorial structure, notably that of slippage. This is introduced in various ways – by the under-inked direc-

tional vector of the squeegee, or the printed overlap of the margins of the screen, or a lack of taut registration when several colors are used. Many of the large *Flower* paintings involve this form of color slippage. In addition, Warhol deliberately ensures that the color areas are larger than the natural forms they are designed to denote. For example, the red of the lips in the Liz Taylor portraits is very much larger than the lips themselves.

A strong feeling of time is also induced by the silk-screen printing method. It arises from the apparent variation of light in the modulated on serialized images. In fact, there is no actual change of light. Warhol takes the same image, repeats it, and creates in the viewer a sense of seeing a whole series of light changes by varying the quantity of black from image to image. Thus the same image runs the gamut of blacks or greys, apparently indicating different times or amounts of daylight, when in fact the viewer is perceiving a single photo printed with variety of screening effects. No other Pop artist is involved in the ideas of time, sequence, duration, repetition, and seriality to the extent Warhol is. These aspects of formal innovation are what make his work unique.

In at least one painting, *Robert Rauschenberg* (1963), time is used by Warhol in a straightforwardly literal or narrative manner. The painting was made by screening old photographs of Rauschenberg, first as a child with his family, then as a growing boy, and finally, as the artist Warhol knows. The time sequence of the images, which are repeated on the canvas in modulated rows, runs from top to bottom, the images at the bottom (of Rauschenberg the artist) being much larger in scale. Apart from this painting, Warhol's use of the time element is generally more abstract. Warhol seems to realize that his work is less sentimental or journalistic – hence of greater impact – if the painting suggests time without actually using it.

Because of the oblique time-element that Warhol introduces into the painting, each repetition of the same image seems to be unique rather than a duplicate of others. Thus the internal variations and the slippage that arise as consequences of the printing techniques give life to what was originally a static image, in particular by making the viewer think that time is moving. This, of course, is enhanced in the serial paintings by the linear qualities of the sequence of the images

from left to right and top to bottom. One reason why Warhol was readily able to drop words or written images is that his serial or modular images act in very much the same orderly sequence of parts that the structure of words evokes. The idea of movies, of course, is also inherent in the silk-screen paintings, the sequential presentation of images with slight changes first occurring in the money and Campbell's soup paintings, and particularly in the painting of tiered rows of Coke bottles that are in various stages of fullness or emptiness. Still other aspects of his painting lead toward movies – silver backgrounds of many paintings, as well as the blank silver canvases often adjoining, like movie screens.[3]

Warhol's instinct for color is not so much vulgar as theatrical. He often suffuses the whole surface of a canvas with a single color to gain an effect of what might be termed colored light. It is difficult to use any of the traditional categories in discussing Warhol's usage, which bends toward non-art color.

His color lacks any sense of pigmentation. Like the silver surfaces of the Liz Taylor or Marlon Brando paintings, it is sometimes inert, always amorphous, and pervades the surface. Though often high-keyed, his colors are at times earthy, as in one of the *Race Riot* paintings, which is covered in a flat, sickly-looking, ocherish tinge reminding the viewer of a worn, stained, and decaying surface. In other paintings Warhol moves into what may best be described as a range of psychedelic coloration. For the most part his color is bodiless and flat and is invariably acted on by black, which gives it a shrill tension. Further, the color is often too high-keyed to be realistic, yet it fits into a naturalistic image. This heightens the unreality, though the blacks he so often uses roughen the color and denude it of sweetness. However, in a number of other works Warhol successfully counterpoises two or more brilliant hues without the use of blacks.

Warhol uses public pictures of people. With rare exceptions (e.g. *Ethel Scull*) he avoids candid snapshots that reveal private or idiosyncratic information about the persons concerned. His portraits are forthright, but of people wearing composed faces. The pictures are neither reworked nor touched up. What one finally must confront is the paradox that however correct its likeness, a picture never tells the truth. Photographs of faces are supposed to be revealing of more than the physical

structure of the face. However, they rarely reveal inner truths about the person concerned. That is why the *Jackie* paintings are so powerful (and touch us deeply). Mrs. Kennedy may have been photographed during a terrible experience or ritual, but in the Warhol paintings she looks normal even in her anguish. It is only in the car crashes, when people are caught imminently facing their own death, that they wear masks frozen in terror; otherwise Warhol's portraits transmit nothing of the inner psychic tensions of the persons portrayed. They are always dehumanized by never reflecting what they feel. Thus Warhol dehumanizes people and humanizes soup cans.

Within the *Disaster* series, the auto crashes with all their bloody, smashed and mangled bodies are finally made to seem real. If one evades looking too closely at the gory details of such a photograph in a newspaper, one is compelled, on the other hand, to look at them in a Warhol painting – if only because of the contradiction between what seems at one moment to be a very abstract painting and another which suddenly becomes an image filled with the most horrific details. Or again, though no one is present, the ritualization of judicial execution in all of its morbidity is fully revealed in *Silver Disaster* by the "Silence" sign that lurks in the foreground.

The *Flowers* were first shown in 1964. They consist of many series of different sizes within two main series, one of which has green in the background, and the other, black and white. What is incredible about the best of the flower paintings (especially the very large ones) is that they present a distillation of much of the strength of Warhol's act – the flash of beauty that suddenly becomes tragic under the viewer's gaze. The garish and brilliantly colored flowers always gravitate toward the surrounding blackness and finally end up in a sea of morbidity. No matter how much one wishes these flowers to remain beautiful they perish under one's gaze, as if haunted by death.

Warhol is open to everything. And everything these days seems to consist of violence and death. Both are central to his art and his life. He doesn't censor, nor does he moralize – at least not directly in the work, though in a paradoxical manner, by choice of material. When he presents his imagery he does so without any hierarchical or extra-symbolic devices. He can be related to the absurdist playwrights and

writers, in vision if not in style. He does not share the underlying dramatic structure apparent in their work. He also has no surreal, metaphorical or symbolic edge. His work is literal throughout: those are Campbell's soup cans, and nothing can be done to alter their existence; that is an automatic explosion, and there it is as an irrevocable fact of our existence; here is a car crash, and nothing can be done to place it in another world. It is anonymous as the accident that can happen to anyone. The car crashes are as anonymous as the movie stars; they are portraits of death without even the ritual that attends the convicted killer executed in the electric chair. True, with Jackie and especially the painting of the funeral one views the liturgy, but one is well aware that this is no answer either.

It seems at first that Warhol's imagery is catholic, but this is not so; his choices are very deliberately limited. On the rare occasions when a painting fails it fails primarily because his sense of choice has let him down. But his sensitivity to exactly the right amount of charged imagery is singular.

Notes

1. In addition, there exist photographs of a series of representations of automobiles, some of details (front, or wheel and mudguards) and others of repetitive side views of the whole. These works were made as illustrations for a magazine article and should not be confused with Warhol's exhibited works.

2. For a more extended discussion of the usage of serial forms see my *Serial Imagery* (exhibition catalog, Pasadena Art Museum, 1968; book, the New York Graphic Society, 1968).

3. Though Warhol's interest in movies – to whatever degree – was very likely long-standing, apparently the crucial event that directed him into film-making was his 1963 exhibition of Liz Taylor and Elvis Presley paintings at the Ferus Gallery in Los Angeles. The attraction of Hollywood was too powerful to resist. Before making the journey for the opening of the exhibition Warhol obtained a hand movie camera and on arrival at Los Angeles with some of the factory crew he began shooting *Tarzan*. The opening shots of this movie begin on the LA freeways, and the subject is introduced by an approach shot of a "'Tarzana" off-ramp freeway sign.

Don Judd *

The body of sculpture produced by Don Judd since 1962 has served to rejuvenate the medium radically and to open sculpture to a new level of sensation and perception. Judd's art has also enforced, on a wide front, a re-evaluation of the goals of sculpture and its expressive potential. His art posits a major shift in the priorities of sculpture; the principles of order that he employs, and particularly the unified gestalt central to his art, exert so powerful an impact as to nullify the past and compel in the viewer an awareness of being faced with a wholly new experience of sculptural form.

Broadly speaking, Judd's art has evolved in three distinct phases: the early painterly and conventional wall-bound works made through 1962; the mixed body of painted wooden sculptures exhibited at the Green Gallery, New York, in 1963; and the fabricated metal sculptures created after the Green Gallery exhibition up to the present, a selection of which constitutes this exhibition.

The Green Gallery exhibition established Judd as a major force in American sculpture. To a large extent it was this exhibition that helped to break the impasse marking the condition of sculpture in New York and freed the medium to participate in the accumulated discoveries of advanced American painting. Within a short period of time aspects of Judd's approach to sculpture spread rapidly and had an obvious and widely perceivable influence in sculptors' studios in Los Angeles as well as New York, as clearly revealed in the "Primary Structures" exhibition held at the Jewish Museum, New York, in 1966. More important, perhaps, was the effect of this exhibition on the development of Judd's own work. It crystallized the nature of his own effort, speeded up his development and laid the groundwork for the sculptures in metal.

This groundwork may be seen in the series of diverse wall- and floor-bound wooden sculptures exhibited at the Green Gallery, pieces that provided Judd with a repertory of forms upon which the works in metal are formulated. The painted wooden pieces also reveal Judd's preference for an inert, symmetrical organization and a surface purged

* First published by the Pasadena Art Museum, May 1971, in the exhibition catalog *Don Judd*.

of any residual illusionism. Judd's desire to further purge all iconic or extra-cultural references is reinforced by a refusal to title his pieces. His art is rigorously and single-mindedly abstract. This abstractness is strengthened additionally by the elimination of any hierarchical parts and climactic incident, a formal quality Judd derives from advanced New York painting, particularly through his interest in the painting of Jackson Pollock, Barnett Newman, and Frank Stella. Structure, shape, color, surface are integrated in a unified relationship without the use of a base within a plain geometric form. As simple as it may seem, the floorbound existence of his sculpture reflects an important decision: it augments the inertness of the sculpture, eradicates any vestigial anthropomorphic or gestural qualities derived from the human body, and ties the sculpture to the architecture of the exhibition space. Color in Judd's sculpture is part of a whole and is used across an entire plane to fuse color and surface, to unify rather than to divide. Similarly, Judd's use of mathematical schemata in certain pieces is solely to denote order, is graspable at a glance, and devoid of any function beyond the necessity of the parts to reinforce the whole. The absence of any hierarchy of parts is extended to the traditional notions of frontality and its frame of reference originating in the human body: all of Judd's floor sculptures are without any fixed sense of front, back or sides, and the identification of any part as such is dependent on the position of the viewer in relationship to the sculpture at a given moment.

Another important aspect of the Green Gallery exhibition (particularly to the development of Judd's later cantilevered metal wall pieces) is the feedback of certain ideas from the three-dimensional floor sculptures. Judd continued making wall pieces side by side with the floor pieces, but the traditional manner in which the format of relief connects to painting (by reiterating the flatness of the wall surface) is broken in several works – notably the long, divided box-shape, which consists of a square upper and lower part, with two square holes at either end of the lower part that give visual access to the interior. In creating a shell form – fully three-dimensional yet open on the inside and cantilevered off the wall – Judd dissolves the residual connection of relief to painting and, instead, re-attaches to the architecture of the wall this more dimensional and autonomous shape.

The indivisibility and concreteness of Judd's metal sculptures are powerfully enhanced by the employment of a wide range of self-colored materials that include galvanized iron, aluminum, brass, copper, stainless steel, and a range of colored Plexiglas. In the earlier wood pieces, the surface finish of applied paint relates more to painting than to sculpture. In the metal pieces the self-colored materials erase any such vestigial connection once and for all, even though many of the pieces made from these materials are either wholly or in part sprayed or anodized with additive color. In contrast to the wood pieces and the overall severity of their matte-colored surfaces, the pieces in metal are less neutral. The variously colored metals, Plexiglas, and different techniques of applied color provide Judd with a newly expanded vocabulary of surfaces that he exploits with astonishing vigor and variety: color, texture, hardness, temperature, density, thickness of edge, opacity, translucency, and reflectiveness are selectively exploited to such an extent that the materials no longer look impersonal and take on an intensified presence within the context of the sculpture.

By Judd's contrasting one material against another, the spatial qualities of the pieces become enormously enhanced. For instance, the opaque, colored plastic liner on the inside of the open-ended, tubular aluminum boxes uniquely alters the qualities of this sculpture: in contrast to the crisply delineated austere planes of the exterior, the colored interior looks extremely sensual and spatially much larger than the exterior that contains it. And though the rigid and simple geometry at the bases of Judd's configurations can be clearly observed in his cleanly outlined perspective drawings, the severity of shape of the sculptures is softened to a surprising degree by these uniquely sensate touches. Very often the materials take on different qualities with time: many of Judd's earliest metal pieces are made of galvanized iron, a common enough industrial material with little esthetic appeal, at least in its raw state; yet the mottling effect of the galvanizing process and its idiosyncratic range of patterning on the hard, bright and metallic surface weathers in time to a rich matte gray. Thus despite the simplicity of the geometry, Judd's personal vision and the manner in which he handles his finishes very often transform the materials of his sculpture to evoke a feeling of sheer sensate beauty.

Very evident in the sculpture in metal is an augmenting process – an intermingling with the ambient space – though this quality varies in degree from sculpture to sculpture. In the stacks which are cantilevered off the wall, the floor and ceiling form the top and bottom members of the sculpture; the intervals between each part of the sculpture and the floor and ceiling being equal, the wall, floor and ceiling thus become subsumed into the sculpture. Several other of Judd's sculptures are equally demanding on the spatial context. Among these are the series of fifty-seven sheet-metal tubes piled to form a horizontal honeycomb shape against a back wall, the whole contained by two side walls. Clearly the complexity of Judd's involvement with the architectural ambience of the exhibition space varies from piece to piece and is a considered aspect of his sculpture. By modulating and opening his forms, Judd varies radically the size of his sculpture, and it ranges, without loss of scale or significance, from the small to the extremely large.

The use of various sheet metals and Plexiglas and the fabrication of his sculpture according to his requirements by a sheet metal work-shop (Bernstein) are purely a matter of convenience, and have no overt iconological significance, such as reflecting the coercive force of science on art or similar postulates. Judd's use of sheet metals and a fabricating workshop is entirely for practical reasons: it speeds construction, over-comes structural and weight problems inherent to wood, yields more information on skin thickness of closed forms and, finally, achieves durability to the extent that the sculptures can be displayed outside. Sheet metal extends the structural possibilities of the pieces and also helps enforce the unitary gestalt of the sculptures: technique and form become more reflective of each other than in the wooden pieces.

Plexiglas plays an important role in the ordering of many of Judd's pieces. It presents an ambiguous, colored surface that is closed to the touch yet open to the eye. Thus, apart from any structural function, the material can be used to delineate a planar surface and simultaneously give visual access to the interior. This duality of purpose is successfully exploited by Judd in a number of pieces. For instance, a number of single, rectilinear floor boxes with transparent, colored Plexiglas top and side panels have square openings in the opposing metal ends

connected across the box shape by metal tubing. The tube provides a view through one axis of the box, and the Plexiglas (which also delineates three planes of the box) provides a view of the interior and the floor, thus creating a second viewing axis. In yet another piece Judd raises the question of frontality: the piece consists of six square stainless steel wall boxes with the sides inset with colored Plexiglas; the boxes are spaced slightly apart and positioned horizontally along the wall. The sculpture thus appears to be unyieldingly frontal – that is, until the viewer moves to either extreme end and glances through the Plexiglas into the tunnel formed by the modulated row of six boxes. The primacy of this experience is perceptually overwhelming: what are the front and the back in one position become the sides in another, and conversely, what were the sides in one position now become the front and the back. In short, the concept of frontality in a wall-hung sculpture is completely subverted.

Because of its reduction of form to primary shapes and its anti-historical bias, Judd's sculpture (along with that of other contemporaries) has often been referred to as "minimal." So-called minimal art is thought of as being cool, impersonal, and reductive. Judd's art, however, is not concerned with minimalization, but with a meaningful re-energization of the sculptural vocabulary. Judd has studied art history as well as philosophy, and his writings on art are well known. For several years in the first part of the sixties he actively contributed as a critic to several art journals, but like most American artists he shies away from any rigidly expressed theoretical position or dogmatic assertions on his own art. Judd's approach to sculpture is entirely empirical; he isolates his own concerns by a process of rejecting those values that he feels are no longer viable.

A crucial element of Judd's approach to sculpture is the rejection of all forms of illusionism or of any device that represents, symbolizes or acts to deter or prevent the **direct ordering of the viewer's perceptions** other than by the sculpture itself and its ambient situation. In other words, there is a drive to concretize sensation – to make it immediate – not a consequence of an image, metaphor or mediative device. Though abstract, Judd's art is intensely human, of this world, and not by any means as impassive or inert as its structure at first sight

suggests. Certainly the rhythm of his art is very different from and less emotionally inflected than much recent art, but its capacity to interact with the ambience and the human perceptual apparatus at a one-to-one level suggests the opening up of art to a meaningful order of experience, one that actually exists within the framework of our existence. In this sense, it would seem that Judd's art is compellingly of our time and committed at the highest level to life itself and its future.

Fragments According to Johns: an Interview with Jasper Johns*

In the following interview, Jasper Johns discusses his lithographic series *Fragment – According to What*, made at Gemini G.E.L. in 1971. The interview took place in Los Angeles in 1971.

John Coplans: *I understand the six handprinted lithographs are fragments from the painting* According to What *(1964). If I remember correctly, the painting consists of several linked panels. How many are there?*
 Jasper Johns: Six, I believe – either five or six.
So each print relates to one of the panels of the painting?
 No, not really, because *Hinged Canvas* and *Leg and Chair* relate to the same panel. *Bent "Blue"* is from the lower part of the lettering. *Bent Stencil* is from the lower part of the center of the painting. *Coathanger and Spoon* is from the lower right side of the painting. *Bent "U"* is just an element of *Bent "Blue."*
How did you transfer these images from the paintings to the prints?
 I used photographs. The leg, the bent stencil, the letters, and the coathanger all derive from photographs I had specially made. A lot of the perspective of things in the drawing of the prints is derived from photographs, so in certain situations I thought it easier to use the actual photograph than to avoid it.
You did say the complexity of the letters "blue" would have been a horrible task to render in drawing?
 Well, actually I couldn't have done it because in the original painting they are fake. I can tell you what happened: I had aluminum letters cast for the painting – red, yellow, blue – and it was my intention to bend all the letters of the word blue. I took them out on the terrace and began hammering at them, and I couldn't make them bend because they were too thick and resistant. So I had to send them back to the man that made them, who also couldn't bend them. He had to saw into them, then bend them and fill in the joints with solder, so the letters are not literal, they suggest something they are not. All of the letters – red, yellow, and blue – are painted

* First published in *The Print Collector's Newsletter*, vol. III, no.2, May–June 1972.

backwards as a mirror image; then between the painted image is a hinge carrying the three-dimensional bent letters.

You've used the words red, yellow, blue a lot in your paintings.

I've used all the primary and secondary colors as words.

What are the elements of Bent Stencil *in the actual painting?*

They are just circles in squares. The squares are treated as value, a kind of progression from white to black; the colors are a spectrum progression – yellow to orange, then it skips. To explain that: yellow, green, blue, violet, red, orange are right out of the spectrum, but adding and subtracting – yellow plus blue equals green; minus yellow equals blue; plus red equals violet; minus blue equals red; plus yellow equals orange; plus black equals brown; minus orange equals black; plus white equals gray; minus black equals white; The only place where there is any disturbance in the order is with the brown, which always seems to me to be a separate color. Then the value scale went from white through gray to black, and then from dark to light again by adding a violet.

The prints refer to …?

The piece of metal attached to the painting is the template I used to paint all the circles; when I got to the bottom I bent it and attached it to the lower part of the painting.

The drawing in Coathanger and Spoon *is quite different from the painting.*

It is as though the coathanger was positioned flat against the surface, traced onto the canvas and then bent away. So the gray represents the tracing of the coathanger before it was bent, and the black is the coathanger bent backwards.

The spoon is on a piece of wire attached to the canvas?

No, it's on a piece of wire attached to the coathanger, but loose, swinging in the air.

What about Leg and Chair?

The first time I used this kind of element was in Japan, in a painting called *Watchman* (1964), in which I did a section of figure seated in a chair. It was used with the realistic or imitative surface shown forward. After I finished the painting, I invited various people to come and look at it. My Japanese friends all went up against the

painting to look behind to see how it was made. So when I made this painting, which I already had in mind, I turned it the other way to show the back of the cast, as it were, or the inside of the cast rather than the outside.

Where does the title According to What *come from?*

I made it up. Recently I found something on this wording. I think the note appearing in my sketchbook goes like "somewhere there is the question of seeing *clearly*, seeing *what*, according to *what*." And that's where the title came from.

The hinged canvas is at the bottom of According to What, *face to the painting and signed on the back. I presume the print is of the image concealed on the inner face of the hinged canvas. Does the* Hinged Canvas *lithograph correspond pretty much to the original image?*

Yes, fairly exactly. In the painting the canvas is hinged and drops to the floor. The print simultaneously shows the hinged canvas closed and open. On the face of the canvas is the shadow of Duchamp.

But in the original painting everything is flat – there is no illusion of perspective.

Yes, but in the print I just made the image symmetrical, so the top is the same as the bottom.

And the reference to Duchamp?

Duchamp did a work which was a torn square (I think it's called something like *Myself Torn to Pieces*). I took a tracing of the profile, hung it by a string and cast its shadow so it became distorted and no longer square. I used that image in the painting. There is in Duchamp a reference to a hinged picture, which of course is what this canvas is. Beyond that I don't know what to say because I work more or less intuitively.

And the black splattered blob to the side of the Duchamp profile with the trickle coming down?

I sprayed that with a spray gun.

But does that have a particular reference?

The painting was made up of different ways of doing things, different ways of applying paint, so the language becomes somewhat unclear. If you do everything from one position, with consistency, then everything can be referred to that. You understand the devia-

tion from the point to which everything refers. But if you don't have a point to which these things refer, then you get a different situation, which is unclear. That was my idea.

In the original painting you applied paint by brush. Are there so many different ways of applying paint?

It's applied through a stencil, it's applied with the idea of an image of Marcel, it's applied with air – with spray. I think this is also the first painting that I let drips go sideways – I turned the painting to let this happen. It has squares and circles of paint, is shaded and unpainted and all that kind of thing. I tried to involve the paint in the area of thought that moves from representation to material or dimensional objects, and tried to make them all equal, more or less.

Were the shadows ever a concern to you?

The shadows change according to what happens around the painting. Everything changes according to that. Everything changes according to something, and I tried to make a situation that allows things to change.

Back to the prints. Did you try any other aspects of the painting and not use them?

No, I didn't. What I did was to take those things which are elements and are more or less lost in the painting, and made these details the subjects of the painting.

You dropped the use of the wide range of color as used in the painting.

The prints are all in various cold and warm grays.

What is the portion of a comic on the top right-hand corner of Bent "Blue"?

In the print each image is different – that area is a monotype.

Of the sixty-six numbered prints in the edition, each is different?

Yes, each is a different fragment of newsprint – comics, want ads, sports, all kinds of things.

One would never deduce that from a single print.

You would never deduce it from looking at one print because you tend to think that the prints are all the same.

Are any of the other prints different in this way?

No, only *Bent "Blue."*

And all the prints employ the same range of color?

Yes, except in the newsprint in *Bent "Blue,"* which is a direct transfer from the newspaper.

What is the multicolored arrowed line on Bent "U"*?*

Just to indicate the line at which the letters are bent.

It also repeats the colors red, yellow, and blue as used in the lettering on the painting. I notice the double arrowed line across Coathanger and Spoon *also repeats the colors.*

In both situations it represents a line which is turned back. The words "hinge" are also in spectrum colors. I use the spectrum colors at every point where a part has the ability to turn in a different way.

Why did you cross out your signature on Hinged Canvas *with blue lines?*

Well, I didn't cross it out. The cross was there before I signed it, but I planned to sign it that way. I have deliberately taken Duchamp's own work and slightly changed it, and thought to make a kind of play on whose work it is, whether mine or his.

Why did you cross out the printed matter in Bent "Blue" *in the same way?*

In a sense to say it is of no importance, because in *Bent "Blue,"* that area is constantly changing, so it's not too important what's there. But obviously it's of great importance what's there, because that is what is there. But it could be anything else – that or the next image.

Apart from color, did you use as great a variety of techniques in the lithographs as in the paintings?

No, what I did in the prints was to get rid of color and replace it with a gray field – gray, gray-violet and that kind of thing. Where I've used color, like red, yellow, and blue, the colorful elements generally would be those normally without color – as an indication they are directions, for instance, to bend something.

Some of the prints are also signed in different colors. Hinged Canvas *is signed in purple,* Leg and Chair *in blue,* Coathanger and Spoon *in green. Do you have any general remarks on the prints – something that came to mind as you were making the lithographs?*

Without exception, the prints are highly representational. In every case, objects are represented, so they are very conventional illustra-

tions. But in making what is a detail in the painting – and is often lost – the subject of each print, I made it more obvious, I think. What I did then was to print them in such a way that the suggestion of other things happening occurred. One of the ways I chose to do this is not to center the printing on the paper. Only the subject is centered, so the printing runs off the paper without margins. In every case they bleed, and this suggests they are fragments of something else.

Roy Lichtenstein*

Until recently, the history of American painting has been concerned with delineating the changing shape of the American consciousness within stylistic forms that originated in Europe. Yet at the same time, in the search to intersect art with life and felt experience, the American use of imagery has of necessity been distant from its European origins and has persistently revealed distinctly American overtones. To the sophisticated eye of John Ruskin in 1856, the disparity between the European original and the American counterpart was sufficient to provoke a complaint about the ugliness of American painting (a transgression, paradoxically, that a more enlightened generation of American painters a hundred years later consciously sought to emulate). But in matters of culture, and especially painting, Europe led and America followed. American painting looked out-of-date, clumsy, naïve, and homespun – an altogether maimed version of its model.

To the vanguard painters in New York in the 1940s and 1950s, who formulated Abstract Expressionism and thereby lifted American painting out of its provincial status, the essence of their challenge lay in nullifying the traditional impotence of American artists in the face of European superiority. To break the stranglehold of European art became the overriding task. A process of absorption and denial opened painting at its most meaningful level to the American experience. Disavowal became transmuted into a source of regenerative vitality, a procedure not uncommon in modern art. The rejection of European sophistication of touch in favor of painterly spontaneity and directness (often equated by epigones with painting in a numb, brutal, or ugly manner) opened the way to a viable expression of the American consciousness.

Inevitably, however, the radicality of one generation required refurbishing by another, and the question once thought answered by the Abstract Expressionists was reasserted in Pop art, which once more raised the issue of the American identity – this time, however, in figurative painting.[1] And if the Abstract Expressionists enforced the

* First published in *Roy Lichtenstein* by Praeger Publishers, New York and Washington, 1972.

issue of an American identity by exploiting the expressive potential of paint itself, the Pop artists, in contrast, made ugly and brutal American images and thrust them down the throat of the public. Roy Lichtenstein, Claes Oldenburg, and Andy Warhol project a range of imagery from the very heart of the American civilization, an imagery so powerful, so persuasive, and so different from the European experience that the result appeared as outrageous to the viewer as had the thought of Jackson Pollock's picking up a can of commercial paint and throwing the contents over the canvas.

Inherent to the imagery of Pop Art, and particularly of Lichtenstein's painting, is a built-in challenge to the exclusiveness of European traditions. Lichtenstein's images menace sacrosanct values and in a remarkable way expand our consciousness of civilization and culture. His art is a reminder that the goals of civilization and art as we face them in America are mutually incompatible; through imagery derived from the contemporary American vernacular, he exposes the true relationship of one to the other, and to reality. Lichtenstein stated in an early interview, "I want my images to be as critical, as threatening, and as insistent as possible." Asked "About what?" he replied, "As visual object, as paintings, not as critical comments about the world." But, as Nicolas Calas so correctly asserts, "Only a work which touches upon a myth whose validity is accepted could be threatening."[2] Thus, in Lichtenstein's "reproductions" of Monet, Cézanne, Picasso, and Mondrian – the giants of European art – he punctures the myth of their invulnerability once more; not, however, by the long-drawn-out battle for mastery so typical of the older generation of American painters, but by absorbing the European old masters in one stroke by parody. Lichtenstein converts their images into vernacular forms reminiscent of the comics and thereby re-creates the workings of a consumer civilization with its built-in capacity to coarsen everything it touches. He further rams home his point by painting, for example, his vulgarized version of a Picasso still-life (*Still-life*, 1964) on plastic – a cheap, synthetic industrial material with a glossy and sanitary surface.

Lichtenstein's drive to adapt his art to a popular, more immediately accessible iconography reflective of contemporary life is long standing and derives from a constant interest in the use of a purely American

symbolic subject matter. He remarks that from 1951 onward his images were "mostly reinterpretations of those artists concerned with the opening of the West, such as Remington, with a subject matter of cowboys, Indians, treaty signings, a sort of Western official art in a style broadly influenced by modern paintings." In a 1954 review of a one-man exhibition, Fairfield Porter discerningly intuited the manner in which the painting Lichtenstein was then doing prefigured his Pop style:

> He uses the modern manner that is at hand. He retains ... the child's way of using things ... for the purposes for which they were not intended. The sophisticated manner is applied to the corny ... He notices relationships that are not supposed to be noticed ... He transforms the meaning of things through his private and irreverent imagination.[3]

Between 1957 and 1961, Lichtenstein abandoned figuration for Abstract Expressionism. To viably merge pictorial and formal energy with an American iconography, however, demanded the invention of a completely new style. In the comics, an American invention, Lichtenstein found his inspiration. Vernacular in imagery and derived from the heart of the culture, the comics persuasively reveal American civilization in its most uninhibited form. Moreover, the comic image is endemic to the consciousness of the vast majority of Americans and, in spite of their varying origin and background, it has stimulated a shared awareness that is almost wholly independent of race, creed, age, or sex.[4]

Central to Lichtenstein's art is his use of stereotyped situations. The comic images painted between 1961 and 1965, which are abstracted from the original narrative context, reveal by skillful selection standard modes of behavior of the average American adult. Lichtenstein's use of irony is formidable and includes the rendition of violent emotion in a mechanical style. His images look as pre-packaged as a cliché; the events depicted appear to be crucial but their critical quality is only sham. In revealing the trite situations of everyday life, his images also point up a consistent absence of crisis in so-called dramatic situations, emphasizing that everyday American life is composed of petty people enamored of petty problems – of people continuously preoccupied with taking care of themselves. The men and women Lichtenstein selects to depict are trapped in stupid situations, vassals of a system beyond their everyday control. His art points up the constant irritation of life in an

advanced consumer society, of the accumulation of intolerable situations that finally makes the texture so unbearable.

Lichtenstein's rendition of images derived from the comics is blatant: they are without ambiguity, forthright in preserving the style of the original. The situations depicted are not without humor, and even tragedy dissolves into farce. Many images focus on romantic love or the mock heroics of men at war. Lichtenstein's lovers and heroes are full of pathos and at the same time, ironically, fully exposed in their shallowness. They reveal themselves to be programed: each responds to a given situation with standard modes of behavior typical of the American culture, whether it is the girl who has quarrelled with her lover and is about to tearfully drown (*Drowning Girl*, 1963) or the pilot who has shot down his comrade by mistake (*Tex*, 1962). The viewer ultimately discovers his own indifference to the imminent death of the girl or the agonizing situation of the surviving pilot. Problems he should care a great deal about suddenly appear ridiculous. This capacity to trigger in the viewer a realization of his own disquieting lack of concern is part of the content of Lichtenstein's paintings – skillfully structured double entendre.

Lichtenstein's use of lettering in the comic images is extensive and permits him to generalize experience, yet to load it with a specifically charged sentiment. The balloons and captions play an important iconographic role except in situations that are obvious and therefore require no further elucidation. The use of words makes the imagery concrete and points up what the viewer might miss or fail to perceive by not immediately catching the intended irony. A viewer would certainly understand the consternation of the girl on the telephone if the painting *Oh, Jeff ... I Love You Too, But* (1964) had no lettering, but the inclusion of the encapsulated legend "Oh, Jeff, I love you too, but ..." immediately throws the image into a romantic context of unrequited passion. In a rare exception, the irony takes the form of an "in" joke. *Mr. Bellamy* (1961) depicts a uniformed naval officer; a "think" balloon is captioned: "I am supposed to report to a Mr. Bellamy. I wonder what he is like." Mr Bellamy refers to Richard Bellamy, at that time director of the Green Gallery, an avant-garde New York gallery well known for first exhibiting the work of many important young artists.

124

It would not suffice for Lichtenstein's intended irony simply to title his paintings in a more traditional way. This can be clearly seen in the painting *Cold Shoulder* (1963) in which the lower part of the balloon is shaped like a series of icicles; though the girl is saying "hullo," the use of the icicle shapes indicates that in reality she means "goodbye." Thus, the letters do not as much repeat what is going on as expand, extend, or explain the meaning of the depicted situation. Furthermore, Lichtenstein not only treats the balloons as a communication device but also uses them as esthetic elements. The balloons are therefore important as shape. Lichtenstein follows the conventions of the comics in his usage: a think balloon (usually indicated by a series of bubbles that connect it to the "thinker") encapsulates unspoken thoughts, a narrative balloon encloses spoken words. But Lichtenstein never mixes the two forms together in one painting, as the Cubists do.

Though lettering is extensively used in Cubist collage, Lichtenstein is the only painter in the history of Western art (apart from Warhol, who used words in a few early paintings) to concentrate so exclusively on the integration of words and figurative images in a narrative way. Strange that it is so unique a contribution considering the long history of word usage in calligraphic form in Oriental art. It is also ironical that Lichtenstein's inspiration derives not from a form of high art but the pulp comics.

A curious facet of Lichtenstein's painting is that once he began quoting cartoon images, he found it necessary to work his way out of the very clumsiness he originally sought. There are two early phases to his cartoon work – the first, in which he accedes to the vulgarity of the comic image, and a second, wherein object replaces subject and in which he begins to probe his means and thereby transforms his style. In the first phase, the images are densely and softly composed and, though he more or less "quotes" the facture of the comics, the impulse to classicize his paintings by building form out of standard pictorial parts (inherent in the comic technique and subject treatment) is only implied or loosely carried out. Lichtenstein began to clarify his vision and means in 1962, when he dropped color altogether for the use of rigorous black-and-white images of objects derived mainly from advertising art. In his search for a revised lexicon of form, he chose simple

objects – a golf ball (*Golf Ball*, 1962), a man's sock (*Sock*, 1962), a piece of fabric before and after the reweaving of a cigarette burn (*Like New*, 1962), an automobile wheel and tire (*Tire*, 1962). In his second phase, purging his imagery of all sentimentality by emphasizing the diagrammatic, Lichtenstein brought to bear his experience as an engineering draftsman; he created with a cold factuality and lack of idealization a series of almost melodramatic images of modern life. Inexpensive, mass-produced objects are ironically presented as things of beauty in their own right, and carried into this new reality by an exaggerated degree of isolation and magnification, as if in close-up view. The objects float in the center of the field in a flat, undefined space. The banality of the objects themselves and their very anonymity is married to a rigorous sense of abstraction – a new architecture of boldness and clarity defined by the starkness and simplicity of the parts.

Lichtenstein has stated: "The meaning of my work is that it's industrial, that's what all the world will soon become. Europe will be the same way soon, so it won't be American; it will just be universal." Emphasis on the technological – and also the built-in capacity of an industrial civilization not only to extend itself infinitely but also to reshape culture – led Lichtenstein to formulate a style in which the component parts and the precision of finish of the painting ironically apes the subject matter. Though in fact each work is completely dependent on Lichtenstein's own sure and meticulous touch for its vitality and painterly sophistication, the process of facture is concealed and the painting's appearance simulates the anonymous and mechanical finish of machine-made objects.

Obviously, Mondrian and Léger provide a precedent for this development: Mondrian, perhaps inadvertently, by having standardized his formal elements into simplified component parts, including the primary spectrum of color that Lichtenstein uses; and Léger by his overt interest in the mechanization of painting, which – as a result of a highly developed system of preplanning – included the stripping down of his vocabulary to component and interchangeable parts, as well as the use of a machinelike precision of finish. The idea, of course, of a painting's being completely planned in advance is a classical one. But Léger's and Lichtenstein's usage is reflective of a different intent, that

of stylistically mirroring mechanical standardization and repetition. Lichtenstein often enlarges his sketches, and transfers them onto a canvas by using a projector. The art world overlooked, or was forgetful of, this classical European method of organizing a painting because of Abstract Expressionism's compulsion for spontaneity, and accused Lichtenstein of degrading high art by importing the techniques of commercial art into painting. In actuality, however, it is not so much the preplanning as the high degree of manipulation in the process of paint application and continuous adjustments that lead to a compelling unification of the shapes and the pictorial field in a Lichtenstein painting.

Lichtenstein's assertive use of Benday dots to enhance the mechanical look of his art, similar to his use of words in narrative sequence, imprints his paintings with his own unique identity. In the painting of a woven piece of cloth before and after repair (*Like New*, 1962), the image is most exclusively built of Benday dots: subject, object, and technique are formally unified. The Benday dots become a recognizable and sophisticated component of Lichtenstein's painting, and in the later paintings of landscapes as well as in the haystacks and the Rouen Cathedral series, the images are impacted in a surface of colored, overlapped dots. Thus, the dots, in replacing dabbed brush marks, become a metaphor of mechanization and plenitude. The superimposition of the dots in a well-regulated overlapping pattern in any given area creates in the interstices a variety of different white textures and optical patterns, which Lichtenstein employs as an ironic reference to optical art and, perhaps even indirectly, to the compulsive practice of the Pointillists. In those paintings devoid of black arabesque outlines the demarcation of one shape from another is achieved by lineally grouping the dots and changes of color. The dots are applied through a screen, often by an assistant (a further reminder of the classical studio process), and the superimposition and impingement of one color upon another causes pronounced optical color interaction.

In contrast to both his earlier comic-strip paintings and his more recent paintings, Lichtenstein's centralized images of objects in black and white (1962–63) look extremely formalistic; they represent an apparently necessary compositional experiment that Lichtenstein finally dropped (but not without extended the method to include images in

color of various foodstuffs – a piece of dressed meat, a wedge of pie, a hot dog, and so on). It is the diagrammatic aspect rather than the use of color in these works that visually persuades. The formal discoveries inherent in this group of paintings led to the two provocative images quoting Cézanne: *Man with Folded Arms* and *Portrait of Madame Cézanne* (both 1962). Both images derive from outline diagrams by Erle Loran explaining Cézanne's compositional methods.[5] The drawings fascinated Lichtenstein, if for no other reason than the attraction of outlining a Cézanne when the artist himself had noted that the outline escaped him. To make a diagram by isolating the woman out of the context of the painting seemed to Lichtenstein to be such an over-simplification of a complex image as to be ironical in itself. To be sure, all of Lichtenstein's images pre-exist in a flat form and are therefore "reproductions of reproductions," but by making paintings of these two images Lichtenstein raised a host of critical issues concerning what is a copy, when can it be a work of art, when is it real and when fake, and what are the differences. Lichtenstein's attitude was as startling to the art audience as Warhol's painting of soup cans, which provoked similar questions; both artists challenged the art establishment – Warhol by ironically humanizing mass-produced products, and Lichtenstein by dehumanizing a masterpiece.

The highly magnified close-up view crucial to the formal qualities of the black-and-white object paintings was extended by Lichtenstein into the comic images he painted thereafter. He intensified the emotive charge of his images by fusing object and narrative, simplified color, and high degree of image cropping. This paring away of the unessential led Lichtenstein to a sharper confrontation with the outside world, to a wider range and sharper focus in his use of stereotype. Because of his interest in revealing habit patterns Lichtenstein, unlike Léger, never paints a whole figure – and has not since his earliest paintings. It is not that Lichtenstein avoids painting the whole figure because it is too complex but, rather, that the whole figure is *too specific, too anecdotal* for his purpose. Too much detail weakens the focus and the power of the image to immediately and recognizably signal the desired content. Thus, Lichtenstein crops away until he gets to the irreducible minimum and compresses into the format the exact cliché he desires to expose.

Lichtenstein's technique is similar to his imagery: he reduces the form and color to the simplest possible elements in order to make an extremely complex statement. In short, he uses a reductive imagery and a reductive technique for their sign-carrying potential.

In comparison with the earlier comic images, Lichtenstein's later images of women (beginning in 1963) look hard, crisp, brittle, and uniformly modish in appearance, as if they all came out of the same pot of makeup. They cry more often, and the tears seem not only to be larger but to well at slighter provocation. The hair becomes a strong compositional element, rippling and contorting rhythmically in decorative arabesques around the mask-like faces. Lichtenstein's recent use of color is strong, assertive, and clear. Apart from black and white, his palette consists almost entirely of the Mondrianesque primaries of red, yellow, and blue (and very occasionally green); however, Lichtenstein rarely uses more than two colors in combination, and the black lines surrounding or crisply dividing the forms significantly magnify hue. Very often a head is cropped to such an extent that the hair flows outside the borders of the format, as, for instance, in *Sleeping Girl* (1964). In other paintings of women the hands are used for qualities of gestural expressiveness, to reinforce the iconography of the image, sometimes by enhancing the sense of pathos or the sense of helplessness of the woman's defeat in the face of a given situation.

Lichtenstein's use of heavily cropped hands in isolation dates from 1961, when he completed several finished drawings of hands in action performing various tasks. These hands become surrogates of the human body, signalling information by their actions – as, for example, in a frontal view of a hand threateningly pointing an extended index finger, in which the foreshortened view of the thumbnail and the finger look like two eyes within an angry head (*Finger Pointing*, 1961). Others reveal a cropped hand treating a cropped and naked foot (*Foot Medication*, 1962), and two cropped hands outlining the shape of a foot for mail-order shoes (*Mail Order Foot*, 1961). In many of the comic-strip paintings executed in 1962 and thereafter, the object and the detached hand are united in cropped images (sometimes with a consumer item) performing a household task (*Spray*, 1962), or as in two images of impending violence: the cropped and gloved hand of a Western gunman

about to draw a holstered pistol (*Fastest Gun*, 1963), and an even more reduced and cropped-away image of a curled finger about to pull the trigger of a pistol (*Trigger Finger*, 1963).

An interesting facet of Lichtenstein's art is that many of his images exist as finished drawings, complete in themselves. The drawings are of two types: finished works that are not necessarily extended into paintings and sketches that are developed into either drawings or paintings. Lichtenstein is concerned with the development of an image independent of technique. Thus, an image will surface in a painting, drawing, print, or sculpture, and it will not necessarily be repeated in another medium – it is the delineation in the image itself that is of peculiar fascination to Lichtenstein.

Although the comic format presents stereotypes of subconscious desires and yearnings, and reeks of erotic fantasies and anxieties, Lichtenstein's dispassionate treatment cools the imagery to such an extent that his art is peculiarly devoid of Surrealist qualities. In contrast Claes Oldenburg dilates the eroticism of his already erotic subject matter; his art is tied to Abstract Expressionism and Surrealism, and he uses scale as a Surrealist device. Oldenburg's art is about sexuality, but Lichtenstein's aseptic treatment renders his images asexual. Andy Warhol's scale, like Oldenburg's, tends toward the environmental, and by constant repetition (as in the Brillo boxes) it implies great expanse without the use of a large format. Lichtenstein's does not. Both Warhol and Oldenburg are typically alienated existential artists. Everything Warhol paints is autobiographical; his work is as much about himself as the culture. Lichtenstein's art, however, is devoid of direct personal feelings; his style is anti-the-artist-as-hero; thus, he reflects society rather than directly mirroring his own anxieties. Nor is Lichtenstein's style anonymous, as is so often claimed. It is as full of character as Pollock's; only Lichtenstein's seemingly mechanical technique is anonymous. Nevertheless, Lichtenstein, Oldenburg, and Warhol do share one marked trait; an irrepressible vein of humor – a sense of the absurd, even – that threads their choice of imagery: Oldenburg takes cognizance of the constant reference to London's River Thames as an open sewer by proposing to anchor opposite the Houses of Parliament a sculpture of a giant ballcock;

Warhol impudently fills the gallery with replicas of Brillo boxes; Lichtenstein makes a painting of an Abstract Expressionist brushstroke in 1966 that looks like a piece of bacon, provoking thereby the obvious thought of "bringing home the bacon."

Though Lichtenstein has evolved out of American art, his painting is formally the product of European art, a distinctly American subject matter notwithstanding. He still acknowledges the framing edge as the controlling compositional device, and modulates his forms to the canvas; he crops compositionally and works in a relatively small size. True, there are large paintings – the ruins of a temple (*Temple of Apollo*, 1964), the Egyptian pyramids (*The Great Pyramid*, 1969), as well as a large brushstroke (*Yellow and Green Brushstrokes*, 1966) and several large modular modern paintings – but on the whole he only works at mural scale when the subjects are larger. The oppressive nature of the monuments, for instance, would be undermined if they were painted in a small size. Thus, large paintings are more the exception than the rule in Lichtenstein's work. What counts is that Lichtenstein composes internally (the way artists have composed with the edge throughout the history of European painting), but he is interested in balance rather than symmetry, and that he generally uses a hard-soft, left-right manner of equalizing forms. His principal drive is toward internal balance and completeness within the picture frame, and the size of his paintings tends to be fairly ordinary except for a few essays into monumentality. Though a few of his works are on plastic or enameled metal, Lichtenstein uses a traditional technique, and his habit of progressing from the rough sketch to the finished work (and his use of assistants) is entirely European.

For Lichtenstein to have carried off his art despite a traditional approach, and to have done so without wavering, represents an extraordinary challenge successfully met. Again, part of his strength that he worked in oil on canvas, without drawing upon a new technique such as the silk-screen process employed by Warhol. Nor was Lichtenstein strongly influenced by Jasper Johns or Robert Rauschenberg, who from the beginning were basically assemblagists and involved in all manner of collage techniques. Lichtenstein is a serious intellectual painter who instead wants to revolutionize painting within its traditional media.

Of course, both Rauschenberg and Johns fed into the art ambience a common, everyday imagery, but Lichtenstein's ties to these artists are more reflective of shared culture than influence. Only one painting (and its two variations), the school composition book (*Compositions*, 1964), appears to be related formally with Johns. Yet, given its chronological position in Lichtenstein's development, the connection seems to be the result of coincidence rather than influence, despite Johns' precedence in his paintings of the American flag. On the other hand, having had his art described so consistently as a direct response to Johns' influence may have led Lichtenstein to make a painting that ironically and openly reflects Johns' art, as he has done on occasion with other contemporaries.

Unlike Warhol, who explicitly acknowledges the influence of Duchamp, Lichtenstein can only have been influenced by Duchamp in a convoluted way. The series of paintings of the backs of canvases (variously numbered *Stretcher Frame with Cross Bar* and *Stretcher Frame*, 1968) are obviously a Duchampian gesture but arise out of Duchamp's general influence in New York rather than a direct influence. Moreover, the canvas backs are much more characteristic of Lichtenstein's mode of mockery through use of a public image than of Duchamp, whose irony is private and arcane. Lichtenstein's iconography is always forceful and striking; his imagery is one of signposts and not at all esoteric. Culturally, Lichtenstein's images are at the same level as the Seven Wonders of the World – pure stereotypes. The painting of an empty desert landscape with a fragment of a classical column cropped to the left edge (*Landscape with Column*, 1965) is beautifully abstract. Its imagery and irony, however, are direct and immediately refer the viewer to art history and the extraordinary claims based on remote, battered, and tiny fragments from the past; the image laughs at archaeology, too.

Throughout Lichtenstein's art there is a discernible mixture of metaphor: his art oscillates with contradictory activities and references. Several of the brushstroke paintings, which whimsically mock the Abstract Expressionist style, recall De Kooning's art. The background of the label in the school composition book and its fragmented black-and-white forms obviously refer to Pollock; the form of the waves in *Drowning Girl* are reconstructed to recall Hokusai as well as the

biomorphic forms of Arp and Miró; the cluster of semi-circular marks on the face of the subject of *Golf Ball* echo Mondrian's plus-and-minus drawings. But in Lichtenstein's references to the art of the 1930s, he reworks a style in depth. The original thirties style hovers between pure abstraction and figuration. In parodying the style, Lichtenstein first expunges every specific reference to a particular artist's work and reconstructs it in a general way with the intention of exposing its idiomatic character. Thus, Lichtenstein's "thirties" paintings are extremely varied; they swing from what appears to be outright abstraction in some paintings to a parody in others of the style's overt amalgam of man and machine. Though the images have been absorbed and converted, they ironically appear to be more characteristic of the thirties style than a genuine work of the epoch.

Lichtenstein cannot be considered an abstract painter. His "abstract" thirties-style paintings are re-creations in much the same manner in his "fake" Mondrian (*Non Objective I*, 1964), except that they are more distant from the originals. Accordingly, it is necessary for the viewer to recognize Lichtenstein's parody of the Modern style and realize that the style itself is the subject and not abstract art. Similarly, though the Mirror paintings, many of which mimic round or ovoid mirror shapes and the reflective surface of mirror glass, are abstract (in the sense that all the internal parts are composed abstractly and look abstract), they are nevertheless mirrors and must be so recognized. Lichtenstein, it would seem, is not willing to paint an abstract painting; he is primarily a subject painter who refuses to work without a seen image, Still, part of the fascination of his art is the remarkable quality of abstractness adhering to the paintings *despite* his imagery.

Lichtenstein's body of sculpture is small, for he works in three-dimensional form only from time to time. His sculptures of explosions (*Desk Explosion*, 1965, and *Explosion II*, 1966) are flat and consist of overlapping planes of enameled steel. They derive from the painting of a similar image, *Varoom* (1963), which in turn is an isolated fragment of an explosion taken from the cartoon war images. Lichtenstein's intent is to give – again, in an ironic manner – permanent shape to ephemeral form. Another series consists of monolithic columns of piled coffeecups. In these sculptures he creates an image of used restaurant ware, trans-

forming what is crude, dirty, and messy into something pristine and beautiful. The cups are polychromed in what seems to be a highly contradictory fashion; the superimposition of dots and shadows is based on the stereotype manner used by commercial artists to represent shadows and highlights on highly reflective surfaces. Thus, the sculptures simultaneously reflect the presence and absence of light in a natural and illusionistic manner. A later body of sculpture dating from 1967 is in the thirties style. Mainly of brass and glass, the forms are linear, open, and diagrammatic. Though these sculptures are three dimensional, they primarily employ profile rather than volume and play upon the highly conceptual mode of contemporary sculpture.

Lichtenstein enforces the degree of abstraction when there is no obvious quantity of social comment inherent in a work, and generally it can be said the more abstract his imagery, the weaker the iconographic charge. The charge is low in the thirties sculpture and in the landscapes, both of which are without the raw human emotions and situations so central to Lichtenstein's art. These are neither as powerful nor as successful as many of his images, though perhaps they are more subtle. Composition becomes critical when no sense of irony is held in abeyance or is absent, and the most successful landscapes – those capable or riveting the attention – are compositionally the best.

Lichtenstein very rarely relies on formal qualities alone to carry a painting except in his late paintings or mirrors and the backs of canvases. These two series, as well as many of the thirties Modern-style paintings, reflect Lichtenstein's growing ability to work viably after having absorbed the over-all development of sixties art, by working with modular units, the shaped canvas, and serial imagery. Perhaps the biggest change of all is Lichtenstein's recent desire to employ a mute image. The Mirrors no doubt derive from his interest in thirties furniture, but he works very intuitively by continually experimenting with images: the shadows of the bars appeared to be the only part of the canvas-back pictures he could successfully manipulate to any degree, but the fracturing of light on the surface of a mirror proved to be an extraordinarily adaptable and manipulable form, rich in potential. In view of the degree of refinement that has taken place more recently in his art, it is possible the Mirrors would have been less

successful had Lichtenstein painted them in 1965, at the time of his first use of reflections in his coffeecup sculptures. The Coffeecups are too closely related to the comic-strip and advertising images and consequently project the crudity so essential to his art at that time. In Lichtenstein's recent work, there is evidence of a marked degree of change, flexibility, and subtlety, partly as a consequence of sixties painting itself, partly as a result of his own internal development.

Lichtenstein's art is compellingly open to the modern experience and the twentieth-century social landscape. Pop art as a style and Lichtenstein's art in particular operate in an uncharted iconographic territory – a new world without rules and guides. Up to the seventeenth century, the iconographic limits of art were closely defined and the artists were free to function only within the limits of a given text. The world is Lichtenstein's text: there are no circumscribed patterns for his art to follow, nor any defined borders. Fortunately, Lichtenstein is an open person; he seeks and takes from everywhere according to necessity. His imagery is public, overtly of life and daily experience, its only restriction the necessity to be large in its cultural horizons or limits to succeed. Because of its openness, Lichtenstein's art is very experimental; yet it has, however, an obvious mainstream.

Lichtenstein's art reveals a wonderful sense of design, composition, and abstraction. These qualities, allied to an interest in making an art that people can understand – of realism, social ideas, and even vulgarity – expose our world in a remarkably straightforward way and reflect many of the manners, morals, and attitudes of our culture. But, though Lichtenstein deals with mass attitudes, it is the man himself, his individualism combined with a quiet and serious need to portray the truth, that makes his art unique and of major consequence.

Notes

1. It is only in the painting of another, younger generation of abstract artists, particularly Frank Stella and Kenneth Noland, that American artists began to work in a sophisticated nonobjective style without direct European influence or naïve American overtones.

2. Nicolas Calas, "Roy Lichtenstein: Insight through Irony," *Arts Magazine* 44, no. 1, September–October 1969, p.29.

3. Fairfield Porter, "Lichtenstein's Adult Primer," *Art News* 52, no. 9, March 1954, p.18.

4. For an estimate of this audience, see Pierre Couperie and Maurice C. Horn, *A History of the Comic Strip*, Crown, New York, 1968, pp.147–53.

5. Erle Loran, *Cézanne's Composition*, University of California Press, Berkeley and Los Angeles, 1946.

6. The anonymous appearance of Lichtenstein's style has often misled the critics, including this writer.

Primitivism and American Art*

> Do not tell me only of the magnitude of your industry and
> commerce, of the beneficence of your institutions, your free-
> dom, your equality: of the great and growing number of your
> churches and schools, libraries and newspapers; tell me also
> if your civilization – which is the grand name you give to all
> this development – tell me if your civilization is *interesting*.
>
> — Matthew Arnold

First published in 1938, no better account of modern European art's collision with primitive art exists than Robert Goldwater's *Primitivism in Modern Painting*, though a parallel study of the more recent American development over the past quarter century still awaits the scholar's care. Goldwater was quite unique. He was the only American art historian and general man of ideas – art critic, editor, teacher, African traveler, curator of exhibitions, and museum director – to involve himself passionately and at first hand in alien cultures, particularly African, to demonstrate a widely ranging scholarly interest in European and American art, especially of the nineteenth and twentieth centuries, and to write on the most recent art as well.

Goldwater's age, period of activity, and thinking coincided almost exactly with the emergence of the first wave of major American painters in the mid forties. The earliest important painting by these artists – notably Adolph Gottlieb, Arshile Gorky, Barnett Newman, Jackson Pollock, Clyfford Still, and Bradley Walker Tomlin – reveals a strong correspondence to the ideas documented in Goldwater's book and could have provided an epilog to it. This one sees in the overt use of imagery of signs or symbols derived from, or reflecting, primitive sources (Pollock, Gottlieb, Tomlin); the more generalized use of a biomorphism with a strong Surrealist touch and influence (Gorky, Newman, Rothko); or as with Still, the shadowy traces of primordial presences or beings.

The *Magazine of Art*, edited by Robert Goldwater from 1947 to 1953,

* First published by the Museum of Primitive Art, New York, October 1973, in the exhibition catalog *Robert Goldwater: A Memorial Exhibition*.

was a review entirely different in character from the European type of consciously arty "little review," and represented another feature that led to this revised attitude toward the primitive. The magazine's pragmatic editorial approach and content proved to be crucial intellectual boons to the artistic community.

Nor should the climate of the American art ambience of the forties be forgotten: first, an awareness in terms of the immediacy of art lacking high culture or civilization; second, the awareness of not possessing a strictly Western culture. If the art then prevalent consisted of a transplanted and mongrelized regionalism, this was equally true of the constituent elements of the population – a melding of diverse and transplanted races and cultures seeking a unified identity within the locus of a dead or dying aboriginal past. Though never explicitly commented on, the myth of the frontier – in the sense of filling a cultural void, of pursuing a future, of being one's own man – decidedly flavored the thoughts of these artists. In 1948, Newman wrote, "We are freeing ourselves of the impediments of memory, association, nostalgia, legend, myth, or what have you, that have been the devices of Western European painting. Instead of making cathedrals out of Christ, man, or "life," we are making it out of ourselves, out of our own feelings." Again, in the same year: "The artist in America is, by comparison, like a barbarian. He does not have the super-fine sensibility toward the object that dominates the European feeling." And Still, in 1952: "We are now committed to an unqualified act, not illustrating outworn myths or contemporary alibis. One must accept total responsibility for what he executes. And the measure of his greatness will be in the depth of his insights and his courage in realizing his own vision."

The rejection of Europe, or the European past, and the belief that the form of their art was necessarily to be conditioned by some potency in terms of spirit, led these artists to value experience normally thought of as remote from their culture, which would provide, in Newman's words, "a counterpart of the primitive art impulse." Obviously, Goldwater's book provided a significant clue, and was well known to the several artists discussed. The tenor of their openness to non-Western art and their focus on a pre-"cultivated" art is not merely a persistence of Jungian consciousness, but a reflection of the terrain pioneered by

Goldwater. Part of the contribution he made was to de-emphasize the anthropological context of the primitive, thereby legitimizing it as the proper subject for the nascent American art. Newman's naming the American artists as "barbarians" should not be taken at face value; it was a metaphor of vigor as against decadence, of the new versus the old and tired. Nor were these artists interested in the naïve or the crude as aspects of the primitive. Indeed, in the preface to the revised edition of his book, issued in 1967 under the title *Primitivism in Modern Art*, Goldwater clearly warns the reader to be under no misapprehension: that "however much or little primitive art had been a source for modern art, the two in fact have almost nothing in common." The attitude of these artists toward the primitive must be grasped contextually, as part of their difference from a Renaissance philosophy. Obviously, we now openly admit to and value our own "uncivilized" past with an enlightenment hitherto inconceivable. Picasso, for instance, as a key figure in modern art, bridged the old attitude and the new. He used his interest in primitive art as a strategy to attack taste – the look and surface of art, and the manner in which matter or material is put together. The same may be said of the Expressionists, who also affected the look of primitive art. But it is questionable if Picasso was deeply absorbed with the spirit of primitive art, as to some extent the Dadaists and Surrealists were, more specifically for its prerational content – its links to the art of the mad and of children. What fascinated Newman, on the contrary, was its metaphysical content.

In this country, in the three past decades, our best artists have shared views about primitive and Western culture unlike those of Europe. And being American gives Americans a mythic sense of placelessness within history that is absent from European consciousness, and absent from the younger European artists, except where they have picked this up within an adaptation of American culture. Americans have invented their culture, not inherited it. In their rhetoric they see themselves as a new race that can view the culture of the world at large, and in a way that few Europeans see Europe itself. Relevant to the latter point is Erwin Panofsky's account of his reaction as a German art historian viewing Europe for the first time from an American vantage point: "Where the European art historians were conditioned to think in

terms of national and regional boundaries, no such limitations existed for the Americans ... Seen from the other side of the Atlantic, the whole of Europe from Spain to the Eastern Mediterranean merged into one panorama the planes of which appeared at proper intervals and in equally sharp focus." Though there were important exceptions, the cultural/historical makeup of the best of American art over Goldwater's lifetime included a full but non specific consciousness of the European tradition of art, and two other ingredients that acted as forces to reassess this consciousness: 1) to a greater extent than in any other art ambience, an equally strong attachment to the art of non-Western cultures; and 2) an intellectual curiosity that has an extraordinarily finely honed sense of its own immediate resources. Through a synthesis of these three attitudes, American art laid its foundations.

By "a full but nonspecific consciousness of the European tradition of art," I mean without the kind of referential attachment to historicism found in Robert Motherwell's painting. Motherwell himself has stated how he approaches the blank canvas, makes a mark, and knows exactly its relationship to something that Matisse did. "I draw and dream of Rimbaud," he has said. Motherwell's approach to art is equivalent to Eliot's approach to poetry. His art is full of references to, and interpolations of, European culture that Newman, Rothko, and Still avoided like the plague and completely expunged from their art – not out of ignorance, but from their insight of necessity. Other American artists have maintained an equivalent referential attachment to primitive signs or the vaguely totemic, for instance Gottlieb and Louise Nevelson. Newman, Rothko, and Still soon rejected the more characteristic European usage of primitivism. Their subsequent art deals with less referential and more abstract, though no less atavistic, usages that continued to mediate aspect of American art.

Newman wrote at various times on Pre-Columbian, South Seas, and Northwest Coast Indian art. His comment on Kwakiutl hide painting is his clearest denial that the meaning of his art depended upon the formal ordering of visual elements, "the meaningless materialism of design." Rather, he sought shape as "a carrier of the awesome feeling he felt before the terror of the unknowable." Thus shape in primitive art, the entire plastic language, "was directed by a will towards metaphysical

140

understanding." Though Newman spoke for himself, these thoughts are equally characteristic of Rothko's and Still's art.

The wholly abstract and flattened, nonreferential means employed by these artists provided them with a surface freed from literalness, with which to form a total image of their own making. With the exception of their materials (oil paint on canvas), the techniques and the approach of the Renaissance – the art of the West between the fourteenth and seventeenth centuries – and its myth, meaning, process, and iconography are entirely dead for these artists. Their painting process and will to art is dependent upon a state of mind prepared for whatever kind of demonology or sense of mystical revelation they are capable of asserting. It is amazing that their seemingly simple imagery doesn't dissolve into bathos. Light, dark, and mark deal not with emptiness but with a great expanse of space and matter. Somehow they manage to indicate and catch in their art the vastness of experience – all experience – as the most threatening wilderness. Their working methods are entirely primordial in approach: a complete belief in the inspirational, of going back as deeply as possible into the subconscious state of the mind and searching deeply. All three artists are meditators. Further, their art is couched in transcendental terms. Rothko wrote, "The most important tool the artist fashions through constant practice is faith in his ability to produce miracles when they are needed." For them, that their painting could happen is an emblem of miracle.

Robert Smithson: *The Amarillo Ramp**

A song of the rolling earth, and of words accordingly,
Were you thinking that those were the words, those upright
* lines? those curves, angles, dots?*
No, those are not the words, the substantial words are in the
* ground and sea*
They are in the air, they are in you.
 — Walt Whitman, "A Song of the Rolling Earth"

Robert Smithson was a problem from the beginning. When exhibited in the Jewish Museum's "Primary Structures" exhibition in 1966, his sculpture looked eccentric compared with the prevalent notion of the Minimalist style. Smithson's adoption of the spiral motif contrasted strongly with the inert and self-contained icons of Minimalism – the circle, triangle, rectangle, or square. His spiraled *Mirror Project for Aerial Art Project*, 1967, for example, and even bulkier *Gyrostasis* of 1968, apparently relate to nineteenth-century systems of logarithmic expansion, or to organic and crystalline growth, or perhaps even to the spiral as a biophysical symbol of life itself. Not until the building of *Spiral Jetty* in 1970 did Smithson's usage become clearer; the spiral is related to his notions of entropy and irreversibility. A spiral vectors outward and simultaneously shrinks inward – a shape that circuitously defines itself by entwining space without sealing it off. One enters the *Spiral Jetty* backward in time, bearing to the left, counter-clockwise, and comes out forward in time, bearing right, clockwise. In 1967 Smithson wrote:

> I should now like to prove the irreversibility of eternity by using a *jejeune* experiment for proving entropy. Picture in your mind's eye the sand box divided in half with the black sand on one side and white sand on the other. We take a child and have him run hundreds of times clockwise in the box until the sand gets mixed and begins to turn gray; after that we have him run anti-clockwise, but the result will not be the restoration of the

* First published in *Artforum*, April 1974.

original division, but a greater degree of grayness and an increase of entropy.

Of course if we filmed such an experiment we could prove the reversibility of eternity by showing the film backward, but then sooner or later the film itself would crumble or get lost and enter the state of irreversibility.

Smithson used the spiral as an entity outside the logic of current art. He took giddy pleasure that the viewer coming to the end of *Spiral Jetty* finds nothing there. This alone gives his work a different kind of vitality.

It may be difficult for those who live outside New York, especially in Europe, and who have a different sensibility, to appreciate or understand the special kind of force Smithson represented. After 1966 he felt a unique sense of mission, and his personal presence on the New York art scene as writer, film-maker, theoretician, maker of exhibitions, and finally as a powerful conscience was by no means easy to ignore: he delighted in pushing people to their intellectual limits by verbal and esthetic challenges.

Beyond this there is the problem of Smithson's Earthworks. However widely known as an image, *Spiral Jetty* is nevertheless extremely inaccessible to firsthand viewing. The same is true of *Amarillo Ramp*, which is sited on a private ranch closed to the public. Despite the hundreds of drawings for incompleted projects, Smithson's body of work is small. His premature death meant the end of his developing range of ideas as well as of the realization of many projects. This raises the problem of how an artist becomes part of the culture through his residue – Smithson left enough work for us to assess him, but not enough to canonize him. So Smithson proved to be a problem at the beginning, and remains one at the end.

After completion of the *Spiral Jetty* in 1970 (funded by Virginia Dwan), patronage became a thorny issue for Smithson, who constantly sought ways and means to continue his work. *Texas Overflow*, conceived in the same year for an abandoned quarry between Fort Worth and Dallas, was to consist of a large circle of white limestone rocks with liquid

asphalt poured into the center and overflowing the sides. Though negotiations extended over several years with the Fort Worth Art Center Museum, the money to build the project never materialized. Another project that fell through was *Ring of Sulphur and Asphalt*, to have been constructed near Houston, Texas, of local materials – sulphur and asphalt. The Dutch government financed *Spiral Hill* and *Broken Circle*, built in 1971 in Emmen, Holland, in a nearly exhausted sand-mining quarry slated to become a recreational center. (The local citizenry was so taken with Smithson's Earthwork that it voted to allocate funds to maintain it permanently, a reaction that affirmed to Smithson the democratic goals of his art.)

Smithson explored several abandoned quarries in Maine, but found them too mellowed by time, too picturesque. He bought a small island off the coast of Maine, but abandoned any idea of using it for the same reasons. He explored the Florida Keys and the Salton Sea in California for sites.

Smithson's overriding concern, especially in the last two years of his life, was to propagate his art as "a resource that mediates between ecology and industry." He visited several strip mines, and negotiated for Earthworks which he argued would be ways of reclaiming the land in terms of art. He wrote to numerous mining companies, especially those engaged in strip mining, reminding them that "the miner who cuts into the land can either cultivate or devastate it." Through a Wall Street friend, Timothy Collins, he finally contacted a receptive mining company, the Minerals Engineering Company of Denver. They were enthusiastic about his proposal for a "tailings" Earthwork at a mine in Creede, Colorado. At this mine, vast quantities of rock are broken up, subjected to a chemical process to extract the ore, and the residue washed into tailings ponds – a hydraulic system for flushing waste. Since the company required a new pond anyway, and since Smithson's Earthwork would cost very little more, his ideas aroused their interest. In his proposal for *Tailings Pond*, Smithson envisaged a work that would continuously progress over twenty-five years or so. Some nine million tons of tailings would complete the Earthwork, to have been approximately two thousand feet in diameter. Smithson allowed for an overflow if the projected quantity of tailings exceeded expectations by

extending the design to accommodate the excess tailings into another half-section. Though sketches for *Tailings Pond* might suggest some similarity in design to the *Amarillo Ramp*, the concept is entirely different. The basic shape of *Tailings Pond*, which also consists of a partial circle, is entirely tiered into the surrounding hills, and the remaining half of the circle is held in reserve for the extension. The rocky terrain strongly contrasts with the desert prairie around the *Amarillo Ramp*; moreover the shape of *Tailings Ponds* is scooped and dished, rather than built up on a flat surface.

After two years of site selections, fund raising, and inevitable cancellations, his proposal for the construction of *Tailings Pond* realized at last Smithson's vision of an art that mediated between the industrial/ technological processes at work within the landscape. It confirmed his idea that the artist could become a functional worker within society; and making an art that restored to the common man his sense of place in the world.

The *Amarillo Ramp*, however, came into existence by chance. Smithson and his wife, Nancy Holt, visited Creede to work out the final design for *Tailings Pond*, but actual work on the project was delayed for a few more months. All the abortive attempts over the preceding two years to make a piece had left Smithson with a sense of repressed and contained energy that needed unleashing. While passing time in New Mexico, they met a friend, Tony Shafrazi, who told of a ranch with desert lakes he was about to visit in the Texas Panhandle. The thought of desert lakes teased Smithson's imagination to such an extent that he and Holt decided to go along.

The Marsh Ranch is about 15 miles northwest of Amarillo township, situated near the rim of the Bush Dome, a giant underground cavern deep in the earth, used to supply the Western world's readily available supply of helium gas. The rich helium source, found in the Texas gas fields near Amarillo after World War I, was first tapped locally; then as other fields were opened in the Texas Panhandle, Oklahoma, and Kansas, helium gas was piped to the Bush Dome, processed and stored there. Helium is a "noble" gas, one that will not react chemically with other gases or burn, and one crucial to the space program since it is used to maintain pressure in rocket fuel tanks.

Other than a small, heavily fenced, and quite anonymous industrial processing unit nearby, there is little evidence of its presence near the ranch. It is typical of the area that until one has probed around, it is hard to grasp the extraordinary evolutionary process the surrounding land has undergone, especially in recent times – a quality that fascinated Smithson.

This part of Texas, east of a line drawn from Amarillo to New Mexico, appears on early maps as the Great American Desert, and the Panhandle (which, in fact, is the northern part of Texas) is still called West Texas, a reminder that geographically it was considered within the arid Western frontier. The Indians have inhabited the area for thousands of years, beginning with the archaic Plains Indians. Until the last quarter of the nineteenth century, when they were cleared out by the US Cavalry in one of the last actions against Indians, the nomadic Comanches lived there. The area is rich in flint, much prized by the Indians, who sought, worked, and traded it widely. The remains of a pre-Columbian trading kiva exist 12 miles south of the *Amarillo Ramp* on the bank of the Canadian River, and I picked up chips of worked flint all around the bluffs overlooking the *Ramp*, as well as on the rims of the canyon below the Tecovas Lake dam site. The area was considered unsuitable for white settlement until the 1880s, when the railway line was built. The opening of the area for ranching immediately attracted speculative international capital, principally English and Scottish, and settlement of the area by whites began in earnest.

I'm told that when the first ranchers came, the buffalo grass sup-ported a greater number of cattle. It is a natural species of the dry plains east of the Rocky Mountains, a tender protein-rich grass, the food of the great herds of buffalo wandering the prairies, and requires no artificial fertilization. Unlike other ranching operations which must grow feed, the Amarillo ranchers were blessed with a natural food source for their cattle. Continual overgrazing systematically depleted the grass. Now the grass is cropped short and laced with mesquite, yucca, and other noxious weeds that got a toehold from seeds in the droppings of the first cattle driven into the area.

Although at first it seems impossibly desolate, the Amarillo area is a dynamic center of agribusiness, a central geographic location where

cattle, grain, and rail transportation come together. Now, only 90 years after the opening of the Fort Worth and Denver City Railway, what was formerly considered unuseable desert has become one of the beef lockers of the world.

The Marsh Ranch straddles a primeval watershed (probably a lake or sea bottom at one time) covered by a red rock of compressed clay. Nowadays, water flows down through this watershed into Tecovas Creek, which feeds into the Canadian River about 12 miles north of the ranch, and then into the Mississippi. At the flood point of the Tecovas Creek, just beyond Tecovas Lake, which is a man-made dam, the action of the water has gouged a deep, twisted, rocky canyon.

The dam that forms Tecovas Lake was built in the early sixties. Since then it has been silted some 30 to 40 percent with fine red clay. Before the dam was emptied for the building of *Amarillo Ramp*, the water level was roughly eight feet. The dam is part of a unique irrigation system called the Keyline, the first of its kind built in the Western hemisphere. Pioneered by a visionary Australian, P. A. Yeomans, the system is based on the local control and development of land and water resources. large dams can cost enormous sums of money, and the feeder canals and pumping systems necessary to distribute the water can be equally expensive. By contrast, the Keyline system utilizes every drop of water where it falls. Rainwater usually runs off the land faster than the soil can absorb it, and is consequently wasted. Yeomans' plan doctors the land in such a way that water is conserved as close to the watershed as possible. At the Marsh Ranch the water running down the watershed is dammed, pumped to a ridge 80 feet above, fed through five miles of ditch to a lake, then conducted by gravity downhill, point by point over the surface of the land. The land is plowed to get an even coverage from the water. The sparse rainfall of 20 inches a year is utilized to the maximum. I think what interested Smithson was the wonderful simplicity of the system, the manner in which it so economically employs smaller and smaller systems to overcome the aridity of the area.

After Smithson saw Tecovas Lake, he was able to convince Stanley Marsh to let him build an Earthwork. Marsh hired a plane so Smithson could take aerial photographs to chart the lake's position and size.

Smithson went up in the plane, photographed the lake and made some drawings. Later, he and Holt waded into the lake and staked out a piece, but Smithson rejected this plan and began again. A second proposal, for a work about 250 feet in diameter, was dismissed because he felt it displaced too much of the area of the lake. He reduced it to 150 feet. After this third proposal was staked out, Marsh hired the same aircraft to view the staked-out piece from the air. On 20 July 1973, the plane was flying low over the site when it stalled and dived into the ground, killing everyone on board.

Soon after Smithson's death Holt thought that the piece should be built. Shortly after her return to New York, she saw Richard Serra, who had witnessed part of the construction of *Spiral Jetty*. He brought up the subject of finishing *Amarillo Ramp* and volunteered his help. After the funeral, he reminded Holt of his offer, and she made the decision to return immediately and finish the Earthwork with Serra and Tony Shafrazi.

It took about three weeks for the *Amarillo Ramp* to be built. I know objections will be voiced as to whether it really is a piece by Smithson, and whether during the process of building, Smithson would not have altered his plan. But Holt attended all the initial planning. She worked with him on many of his projects, and Smithson discussed with her the final shape of the *Amarillo Ramp* in great detail, including the use and piling of the rock from the nearby quarry, from which he had decided to draw material. Smithson left specific drawings giving the size, gradation of the slope, and the staked-out shape of the piece in the water. It must be remembered, too, that Smithson never visualized the final design of any work as completely predetermined. The workers who built the *Spiral Jetty* were not just hired hands; they offered their own suggestions as to how the machines and materials could be employed to realize Smithson's plan. This mode of approach is vital to the anticlassical side of Smithson's temperament.

When Holt, Serra, and Shafrazi arrived in Texas, they found that the water level of the Tecovas Lake had risen, and the stakes were almost covered. Their first problem was how to begin to work. They could not find the drain to the dam which they knew existed, even though they searched for hours in the muddy water. To pump the lake

dry would have taken three weeks, so they cut the dike and emptied the lake, according to Serra's report, completely changing the place. The mud lay several feet deep, like a quagmire. The lake bed quickly became covered with crabs, crayfish, and sand-dabs dying in the sun.

You come across the *Amarillo Ramp* suddenly. You drive across the ranch following a track that meanders according to slight changes in the topography of the landscape, which is rolling, yucca-studded prairie. You don't realize that you are on a plateau, about 90 or so vertical feet above the lowest level of the land, until you hit the edge of the bluff that slopes first sharply, and then gently down to Tecovas Lake. There below, beached like something that has drifted in, is the Earthwork. The curve of the shape repeats the rhythm of the edges of the lake and the surrounding low valley. As you walk down the slope toward it, there is a point – about three-quarters of the way down – when the higher part of the ramp slices across the horizon, after which the sides loom up vertically to block the horizon. From the top of the bluff (an upper sighting platform) the Earthwork is planar; it gradually becomes elevational on approach, but you don't really sense or grasp the verticality of the piece until you are close, at the very bottom of the incline and about to climb the ramp.

Seen from above, it is a circle; as you climb, it becomes an inclined roadway. Walking up the slope of the ramp, you look up valley, far off toward low, flat hills; as you negotiate the curve and reach the topmost part, you look down valley, across the dike, to the land below that gathers into the canyon beyond. The top is also a sighting platform from which to view the whole landscape 360 degrees. Returning down the Earthwork, you retrace your footsteps, going past your own past, and at the same time you see the makings of the Earthwork, the construction of the construction: the quarry in the nearby hillside from which the rocks were excavated; the roadway to the Earthwork along which they were transported; the tracks of the earth-moving equipment; the tops of wooden stakes with orange-painted tips that delineated the shape still sticking out here and there; and the slope of the ramp shaped by the piled red shale and white caliche rock. An acute sense of temporality, a chronometric experience of movement and time, pervades one's experi-

ence of the interior of the Earthwork. And something else, too: in walking back and looking down toward the inside, you are intensely aware of the concentric shape that holds its form by compression, heavy rock densely piled and impacted. Stepping off the Earthwork, one has a sense of relief from pressure, stepping back into the normal world's time and space, and even a sense of loss. The piece then, is not just about centering the viewer in a specific place, but also about elevating and sharpening perception through locomotion. The *Amarillo Ramp* is mute until entered. And it is only later, when you return to the top of the bluff, and look back, that you realize how carefully it has been sited, how on first seeing the Earthwork from above, in plan, everything is revealed by predestination. Once on the bluff again, you are reminded that even if you think you know the pattern of the world, you still have to move through it to experience life. Thus to think of the *Amarillo Ramp* in traditional terms, as an object or sculpture dislocated from its surroundings, is to view it abstractly, to strip it of the existential qualities with which it is endowed.

The *Spiral Jetty* also concerns locomotion, but there are marked differences between the *Jetty* and the *Ramp* in this respect. In the *Spiral Jetty*, I think one of Smithson's interests lay in the stumbling aspect of walking, forcing one to pay attention to where one is going. I'm told that when he finished the *Spiral Jetty* Smithson ripped up the boulders so that the pathway couldn't be negotiated smoothly. Evidently Smithson wanted to make the locomotion discontinuous – to disrupt it – perhaps because the view across the water is so flat and continuous, and so sublime. With the *Amarillo Ramp* you stop a lot, especially when going up the ramp, to watch how your relationship to the surroundings changes. But in both pieces you become unusually aware of the physicality of your body in relationship to its surroundings, of temperature, the movement of wind, of the sounds of nature, and of how isolated you have been from nature until this moment.

An observation of one of Smithson's heroes, Frederick Law Olmsted, comes to mind:

> Beauty, grandeur, impressiveness in any way, from scenery, is not often to be found in a few prominent, distinguishable

features, but in the manner and the unobserved materials with which these are connected and combined. Clouds, lights, states of the atmosphere, and circumstances that we cannot always detect, affect all landscape in which the vicinity of a body of water is an element.

Smithson never chose sites according to what might be described as norms of beauty. The Salt Lake is a somber, moody, dead lake that supports no life within its waters. I think I saw the *Spiral Jetty* under the very best of circumstances, under romantically sublime conditions. On the day I was there the vast, horizontal stretch of lake water that filled the horizon for 180 degrees, was shot through with the widest range of coloration, from bright pink through blue-gray and black. On the left, near the abandoned drilling wharf, and for some 12 miles out, a storm was raging, with black clouds massed high into the sky, claps of thunder and flashes of lightning, and the surface of the lake in turmoil. Toward the center the storm eased off, but with lower clouds and sheets of rain scudding across the lake surface, almost obliterating from view some islands lying offshore. To the right, a blue sky almost clear of clouds with a high moon and stars, and on the extreme right, the sun going down in a mass of almost blinding orange. Where I stood, in the center of the spiral, a warm wind blew offshore, carrying the smell of the flora, the sound of the wind rustling through it and the cries of birds. The scrubby, low hills behind began to flatten and darken against the twilight. The site is a terribly lonely place, cut off and remote, conveying the feeling of being completely shunned by man.

Though equally strong, the feeling of the land around the *Amarillo Ramp* is different. The climate is hot, with little daily variation in temperature, which hovers between 96 and 100 degrees in the summer. But there is a marked dissimilarity in what the land looks like at different times of the day. The color changes constantly. Between seven and eight o'clock in the morning the shadows are heavy and purple, the reflection of the sun off surfaces bright, giving a high contrast to form. At midday the land is flattened by the haze of the heat and sun. In the afternoon, as the sunlight softens, the whole land becomes rust covered. Once you are used to the differences in light it is possible to tell the time

by the color of the land at a given moment. The land blazes with heat. Local people say that when the Indian hunters traveled, they ran across the land by following the shadows of clouds. It is a very repressed landscape, very primordial, not at all generous, though there is evidence that in prehistoric times the land was lush – the area around the site and further down in the canyon is littered with pieces of fossilized trees. The fact that the land has not been worked until recently, and then only for grazing cattle, and that the Indians who inhabited the land were nomadic hunters, has a tendency to obliterate all human effort. The *Amarillo Ramp* seems to be almost engulfed at times by the landscape and the blazing light. I never saw Tecovas Lake filled with water; the dike is now repaired, and when the lake is refilled, the *Amarillo Ramp* will look very different – hold its own even more in the vastness of the Texas landscape.

Robert Smithson had a heroically romantic attitude toward nature and the industrial processes. He had the ability to accept anything, including ugliness and the pathology of decay, and to make a virtue of these qualities. Impurity, degeneration, and collapse were central to his view of the dialectics of entropic change. He understood the process of evolution: improvement is always at the expense of some other quality – it always involves loss of energy. We speak of improvement or evolution when the results appear to benefit man, but one species advances by destroying another; one thing replaces another by progressive default; improvement involves a gradual reordering of the landscape; progress is by degeneration and decay; and man consumes his world with man-centered shapes and processes. This is not to imply that Smithson was unaware of the evils underlying these processes: they may mirror man but man is not the measure of everything. Smithson was a highly cultivated thinker and artist, a visionary, yet an optimistic and practical man, fully aware of the Fall. He was not obsessive in the sense of producing things – an endless series of objects; his art obsession was with the mutual dependency of the parts of our world in maintaining their vital processes.

Smithson had a generous sense of the irony of egotism: by unashamedly being yourself, and by being proud of your uniqueness you are merely another grain of sand – a part of the general whole. It is

a very American trait, wholly consistent with the Abstract Expression-
ists and their style. There is no moment in Abstract Expressionism, as
there is in Cubism with the early painting of Braque and Picasso, when
the artists can be confused. The Abstract Expressionist painters are
like a roomful of extreme individualists who resemble each other only
in their extremism. Their art is all about "me," but this me includes
all of us, and by thoroughly investigating the self one can best under-
stand others. One must appreciate one's weaknesses. This is in
extreme contrast, say, to the English attitude, where the culture aims
at suppressing differences – educated men speak with a cultivated
accent, and to have manners as well as to be cultivated is important.
Smithson's attitude was the very opposite: how to open oneself up to
the world – cultivation is very useful provided it doesn't preclude
awareness or action.

Smithson's art is not founded on analytical operations. It does not
derive from a closed system clogged by its own fixations and systems
of criticism. His art does not satisfy fixed constructs deduced from
theoretical implications structured to a historical notion of a main-
stream. His art is open, about the breadth and scale of this country,
about being an American. His exemplars were Melville, Whitman, and
Pollock, as well as William Carlos Williams, his childhood doctor.
Smithson felt that many of his colleagues were too civilized and
European, and their art too citified, inbred, and incestuous.

In seeking a less elitist art, more republican in essence, without the
overrefinement and the overtones of luxury common to much current
art, he was forced into situations outside the then current structure of
art itself. He was not against the artist making money, but against his
accommodation to production, marketing, and sales, which troubled
him because it inevitably reeks of compromise and contamination. Art
seemed too far from the everyday life of ordinary people, and without
a culturally socialized character. Smithson wanted an art free from
traditional patronage; he wanted an economically innocent art; and
in attempting to move from private to public and industrial patronage,
he fully realized he might be exchanging one prison for another.

It's not that Smithson was different from anybody else – more
righteous or fastidious. His attitude was formulated out of sheer

frustration. Smithson realized that the options were stacked against him, and if an artist has brains, energy, and imagination, then it's necessary to force issues. Nor did he wake up one day with a neatly packaged set of solutions to his problems. As a man boxed in continuously by circumstances the only resource open to him was to take the offensive, and step by step to challenge his peers and the support system, which he did with relish and abrasive humor.

There was much of the transcendentalist to Smithson. I think it finally never really mattered to him who owned his art. Why? Because finally he realized that art, like knowledge, is never owned. It was important to him that the process of getting money to make or in payment for a work of art should not determine what the art should be. It was freedom enough to be able to go down to a ranch, to hire machines to make art out of the easily available material, and to believe that the art he made will be there after any economic and social revolution of the future. He was a pragmatist who realized the necessity to take risks and took them into account – things falling apart, or going through natural changes, the *Spiral Jetty* being inundated by water or land-locked by evaporation. Embracing the positive as well as the destructive potential of nature. Smithson understood that finally it doesn't matter – chance and planning turn out to be the same.

Pasadena's Collapse and the Simon Takeover: Diary of Disaster*

> Patron: commonly a wretch who supports with insolence, and is paid with flattery.
> — Samuel Johnson, *Dictionary*

The financial collapse of the Pasadena Art Museum, and its subsequent takeover by Norton Simon, an exceedingly rich and powerful southern California industrialist, raises issues that extend far beyond the problem of the survival of this particular museum. It poses acute questions about the accountability of museum trustees, and the lack in many American art museums of carefully thought out policies within their local communities, and the general role a museum should assume within the community of art museums throughout the country.

Problems of control and direction exist for museums throughout the United States, but in museums in the East they appear to be less severe if only because most of them had an earlier start, better funding, and a larger reservoir of available art objects in both public and private hands. The sheer concentration of resources on the Eastern seaboard – schools of art history, libraries, scholars, experienced museum directors and curators, art magazines and art writers, plentiful collectors, specialist dealers, private galleries, and finally, thousands of artists themselves – far outweighs those in the rest of the country. The pressure of the informed opinion of this art audience plays a considerable role in checking excesses. True, such resources exist elsewhere, but they are thinly spread. This means the isolated regional art professional, especially in museum work, has less of these resources to use in struggling against the intense pressures of the wealthy and powerful.

Over the past two decades in northern California, there has been a veritable fever to build new museums and increase the space of existing ones, often disregarding the fact that there are few existing collections of significance to require such housing. Despite the existence of the California Palace of the Legion of Honor, the M. H. de Young Museum, the San Francisco Museum of Art, and sundry smaller institutions, the past decade has seen the building of two more large complexes at huge

* First published in *Artforum*, February, 1975.

cost: the Oakland Art Museum and the University Museum at Berkeley. But apart from the forty Hans Hofmanns given by the artist to Berkeley, a few isolated post-World-War-II American works, and the Rodin Collection at the Legion of Honor, scarcely any important *modern* works can be seen in the combined museum collections. Even if all the collections of modern art in the three museums were to be combined with the late nineteenth- and twentieth-century holdings of the Legion of Honor, it is doubtful whether one first-rate collection would be formed. Moreover, this skimpy body of work is displayed in an area equivalent to or greater than that of New York's Museum of Modern Art, the Whitney, and the Guggenheim museums combined.

There are comparable discrepancies in southern California. The Los Angeles County Museum of Art and the San Diego Gallery of Fine Art both have undistinguished collections of historical art. Although they attempt to cover nineteenth- and twentieth-century European and post-World-War-II American art, neither has collections of excellence even in these areas, the major exception being the fine de Sylva Collection at the LACMA, much of which was given in 1946. The point is that the museum holdings are so spotty that they cannot give an overall view either of the achievements of European art since the middle of the nineteenth century, or even of American art of the past quarter-century, to say nothing of periods such as the Renaissance or Baroque. The Galka Scheyer Bequest, which the Pasadena Art Museum fortuitously obtained in the early fifties, on the other hand, is a very special resource. Although it basically consists of art formulated in Germany, were it to be united with the LACMA's School-of-Paris holdings, southern California would have the beginnings of a first-rate collection of early modern European art under one roof.

As for more recent art, despite a string of exemplary shows by postwar Americans, many of whose works entered local collections, museums are very deficient in this area. One obvious explanation: available museum funds were spent on bricks and mortar.

Problems with museum architecture in California have compounded the dilemma. If the Bay Area has erected two buildings capable of functioning well as museums (Berkeley and Oakland), the same can

hardly be said for their southern counterparts. The LA County Museum of Art, a finned fantasy with boardroom chi chi interiors, designed by William Pereira, and the Pasadena Art Museum, with its ribboned antiseptic caverns, designed by Thornton Ladd and John Kelsey, are as monumentally vacuous in spirit as they are in ideas. The general inhospitality of the buildings to art acted immeasurably to depress local art audiences; so much money was given in good faith, and when the dreams were finally delivered, the sheer obtuseness of the architecture strangled hope at birth.

Ed Ruscha's painting *The LA County Museum on Fire* might be taken as a symbol of the art community's bitter disillusionment and frustration when faced with this fatuous building which betrayed the lack of insight and taste of the LACMA trustees who control so much of the future of art in southern California. In 1969, the Pasadena Art Museum, with its enlightened focus on modern art, was the only hope left. But such a promise was dashed with the opening of its new building and the realization that this boondoggle was also unworkable.

At a time when one can enter at least half a dozen museums in Germany, Switzerland, and Holland and encounter extraordinary collections of recent American art, when vast sums have been spent in California on bricks and mortar, when museological standards run second to the interest of trustees in one of the wealthiest states in the Union, and when an exceptional public museum and collection is handed over to an entrepreneur whom it assumes is a public benefactor, one is forced to ask, what happened? What are the social and cultural sources of this situation, and what are the lessons to be learned from this series of disasters?

Ever more clearly today, especially because of recent developments on the American political scene, we understand that our institutions depend upon the character and behavior of those individuals who constitute the leadership. The history of the ambitions, and the decline and fall, of the Pasadena Art Museum, reveals many of the problems that have retarded the development of effective museums in California. It is a history of compromises, conflicting goals, egomania, and private greed that has acted against the common good, and has ended finally in a violation of the public trust. This chronicle of pathology reflects more

diffuse, hidden, and complex workings in larger institutions. But what has happened to the Pasadena is only an extreme instance of the outcome of predicaments that afflict museums from one end of the country to the other.

The Pasadena Art Museum is 50 years old. It was founded at the height of the largest internal population shift in the history of the United States, when over two million people moved to California. A million and a quarter of these moved into Los Angeles County alone between 1920 and 1930. Still, the city of Pasadena remained an anomalous island within the county. The city was settled during the 1870s by wealthy Eastern families from Chicago, Pittsburg, and New York as a retreat from the rigors of winter. The palatial, neo-classic, winter "cottage" built by the Wrigleys, of the chewing-gum fame, still stands on Orange Grove, a wide, treelined boulevard. Most of these huge and elegant homes that once lined the street have been torn down and replaced by expensive, banal apartment complexes.

Pasadena is connected to downtown Los Angeles by one of the first freeways built in America in 1941. The tunnels and overpasses are decorated in the thirties style, and the narrow lanes were designed more for Ford Model T's than today's vehicles. In the twenties, Pasadena had the highest percentage of widows and divorced women of any city in the United States. Seventy-five percent of the taxable wealth was controlled by women. This attracted, according to Cary Williams, "scores of playboys, amateur actors, amateur musicians and amateur writers." He notes, "It is the wealth of Pasadena that has sustained such institutions as the California Institute of Technology, the Pasadena Playhouse and the Huntington Library."

Apart from its cultural institutions, and the annual Rose Bowl Parade which attracts people from all over southern California, the city's only other claim to fame lies in the two local architects, the Greene brothers. Influence by Japanese and Swiss architecture, they built a number of extraordinary houses around the turn of the century. Extremely modern in spirit, with interpenetrating interior and exterior space, their buildings are exquisitely detailed, with Art Nouveau stained glass and pegged woodwork, offset with huge bouldered fire-

places. In the midst of turn-of-century priggishness, the Greene brothers also managed to catch a whiff of the real primeval in their timber frame and boulder houses. One of their finest, the Gamble House of 1908 (a winter home commissioned by the Ohio family of Ivory Soap fame), is sited on the edge of a deep arroyo the Pasadena Indians used as an encampment site, and which abuts the new Pasadena Art Museum.

The museum was first named the Pasadena Art Institute and housed in a wooden building in Carmelita Park, the site of the present museum building. By tapping into the local wealth, the museum's founders intended to build an ambitious building in the park, but their plans were aborted by the Great Depression. What with the movie, oil, and citrus industries, southern California did pretty well during those years, but the wealthy Pasadenans from the East who relied upon their stock portfolios were hard hit. As a growing community, Pasadena was dead by 1930. From then on it has slowly decayed, eroding into a self-contained, largely retirement community. In time, large numbers of blacks and chicanos moved in, and the city slowly gained a reputation for the worst de facto segregation record in the western United States. The city administration, ever resentful of outsiders, runs a notoriously bad school system, most whites preferring to educate their children in one of the many private schools within the city.

In 1942, the museum moved from Carmelita Park to Grace Nicholson's Chinese House and Oriental emporium. She had given this exotic building to the city upon her death in lieu of taxes unpaid during the Depression. The trustees, at the time, made a pact with the city to retain rights to the Carmelita Park site for about 20 years, providing they raised the funds to build a permanent museum there. Their anxiety to fulfil the terms of this pact eventually led to the ill-conceived and prematurely forced building program of the new museum.

The Nicholson mansion was a solidly built two-storey concrete building with a gabled and ornately tiled roof. The building surrounded a beautifully planted Oriental garden. The upper part, originally the living quarters, was used for offices, and what had been storerooms and shops around the courtyard became the galleries. It proved to be an excellent building for a small museum, and for years it rendered yeoman service. Unlike the old Carmelita Park building which was on

the old exclusive residential edge of the city, the Nicholson mansion was downtown on Los Robles Boulevard, right in the main shopping center. Pasadena is probably one of the last cities in southern California where it is comfortable to walk downtown, window gaze, and shop. Small blocks, laid out long before the onset of the automobile, made it easy for people to drop into the museum while shopping, a mode of casual visiting which was impossible once the museum was rebuilt on the Carmelita site.

From the beginning the museum was a local institution housing, for instance, annual shows of various local artists, and whatever was available in the way of small exhibitions of European art or the art of other cultures largely borrowed from or arranged by other institutions. Nothing very special. Basically staffed and funded by volunteer women's groups such as the Art Alliance and the San Marino League, it served the community and ran without deficit. (In recent years, the city contributed $19,000 a year to maintain the building.) After World War II, the museum opened an education department that pioneered a progressive approach to teaching children art in southern California, giving many of the minority children in the Pasadena school system their first awareness of art.

In the fifties, a number of factors changed this situation radically. In 1951, the museum was deeded (and accepted) the Galka Scheyer Blue Four Collection in trusteeship for the people of the State of California on the condition that a catalog be published within a set number of years. Scheyer, a German child psychologist, came to New York in 1924 to pioneer the exhibition and sale of the work of the Blue Four group – Feininger, Klee, Kandinsky, and Jawlensky. She was friendly with all four artists, who were evidently pleased to let her act their joint agent, provided, according to Klee, "in agreement with Kandinsky, that theirs should not be considered an official association." Scheyer was not a dealer in the narrow sense of the word, but rather a friendly agent who followed her own profession – teaching art to children – and did the best she could to sell and exhibit her friends' work, acquiring a large hoard of them for herself in the process.

She gave away her entire collection upon her death. The somewhat ambiguous name "Blue Four" was chosen by Scheyer herself on the

basis that: "A group of four would be significant though not arrogant, and the color blue was added because of the association with the early group of artists in Munich that founded the 'Blue Horseman' ... and also because blue is a spiritual color."

Scheyer moved from New York to San Francisco in 1925, and from there to Los Angeles in 1926 where she lived until her death. The collection she gave to Pasadena consisted of 66 Klees (mixed media), 150 Jawlenskys (mostly oils), 5 Kandinskys (1 oil and 4 watercolors) and a number of Feiningers. In addition, several other artists were included in the bequest who have little or nothing to do with the Blue Four, notably Picasso, who is represented by a major oil and collage work from 1913. The Klee section of the bequest is probably one of the finest collections of this artist's work in existence. The Jawlensky collection is unique, consisting as it does of ten extraordinarily fine pre-World-War-I Expressionist heads and a full spectrum of each of his later phases – the Murnau Landscapes, the semigeometric and geometric heads influenced by the Bauhaus, and the late mystical cruciform heads. Included in the bequest to Pasadena was Scheyer's archive which included years of friendly correspondence with all these artists. The many Feininger letters in the archive are often illustrated with small watercolors and drawings, recording recent or intended works discussed in the letters. The Scheyer bequest, including many drawings, numbered 600 works all told, and is crucial to the history of German art.

The trustees of the museum must have had some glimmering of the importance of the bequest that had fallen into their hands. It changed the status of Pasadena within the community of museums from a small, unassuming local art center with no significance to the outside world, to one containing an internationally prized asset. Still, for years nothing much changed within the museum itself, largely because there was no professional staff. True, soon after the acquisition of the collection, museum director W. Joseph Fulton traveled selections from the bequest to other museums. But the undated catalog-cum-checklist of the bequest apart from biographical information on the artists and a brief note to Scheyer merely illustrates some of the works.

Fulton was the first of a long series of inexperienced directors. A bright and promising young man with a PhD in art history, he and his

wife were brought out to Pasadena from the East. Despite the affability of the board, and what seemed a promising, open situation, he discovered after his arrival that there was little or no money available. Fulton tried his best. In 1954 he organized a survey of Abstract Expressionism, and later a show of Man Ray (who was living in Hollywood), and of Siqueros. This exhibition caused severe problems because of the hostile climate to this artist's politics.

But the board had no sense as to what should be done with the museum, and for a professional like Fulton the sense of frustration this engendered must have been severe. A fragile personality, stunned by the adverse circumstances of his situation, Fulton had a nervous breakdown in 1957.

For six months after Fulton's disappearance from the scene, the museum was without a director until another young historian with a PhD was appointed. Prior to his appointment at Pasadena Thomas Leavitt had been Assistant Director of the Fogg Art Museum, a university museum devoid of the complexities surrounding a community museum. Leavitt was a patient, low-keyed, and very private personality. He was the last director to remain at the museum for more than two or three years. As we go forward in time, each new director has a shorter and shorter span of tenure. As Leavitt admits, it took him two years to puzzle his way through the network of relationships surrounding the museum and assume leadership.

The museum was entirely dominated by volunteer women's groups, particularly the Art Alliance, which maintained (and continued to do so thereafter) their own bank account, and would release funds to pay for an exhibition only when it met with their approval. They had direct lines of communication (especially social) to influential members of the board and continually bypassed the director. In short, the Art Alliance, rather than the board of trustees, was really running the museum. Their power was abetted by the curious circumstance that few, if any, of the 32 trustees ever reached into their own pockets to support the museum.

As he saw it, Leavitt's first task was to professionalize the museum. It kept poor records (even of what it owned) and lacked even a registrar, let alone a curator or curatorial staff. A difficult and tough situation for an inexperienced director was compounded by the determination

of the board to build a new museum on the Carmelita Park site before the option of land expired, this despite the fact that no real endowment existed to run the small museum as it was. Finance was left to fortuitous largesse, and any annual deficit had to be cleared by begging from the trustees. This situation was an invidious and imperfect way to run a museum, and made hiring staff, planning expansion of activities, and steering a course free of hazard impossible.

When Leavitt became director, the president of the board of trustees was Eudoria Moore, a local woman of immense energy. Although herself without private wealth, the handsome and formidable Moore and various volunteers were in effect in control of the museum; and in the period between Fulton's departure and Leavitt's arrival – some six months – Moore had been calling the shots in the day-to-day running of the museum. In addition, she was the principle force behind the projected new building in Carmelita Park.

Plans for this project were well underway by the time Leavitt arrived, and during the course of Moore's tenure as president this project, rather than the professionalization of the museum, seems to have been her consuming passion. Leavitt didn't get any professional help until the sixth year when he was about to leave. It was in 1962 that Walter Hopps, who had freelanced a few shows for the museum, was hired as a full-time curator. But still there was no registrar, and Hopps himself was completely self-trained.

Moore conceived of the new museum as "a contemporary expression of all the arts." She wanted to see it housed under one roof various established local organizations: the Pasadena Playhouse, the Pasadena Symphony and the Coleman Chamber Music Association. This collage of activities, Moore said, would represent "the creative expression of modern man." Apart from these diverse activities, Moore's plan included a single administrative office to co-ordinate publicity, ticket sales, fund-raising, and more.

Although her zeal and rhetorical stance indicated a wide range of interests, Moore was entirely parochial in outlook. She was a dynamic and well-intentioned amateur. Her knowledge of museology scarcely covered southern California, let alone the rest of the country, and any European models were beyond her ken. She masked rather than sup-

ported the chauvinist insularity of Pasadena, but in the end it came to the same thing.

Pasadena was a deeply inbred WASP community. Although no board member ever gave any indication of being anti-Semitic, the leadership was completely hostile to members of the mostly Jewish Beverly Hills community, who, with their wealth, sophistication, and emerging collections, could have played an important role early on in the plans to extend the museum. Under Moore's presidency, Beverly Hills people were denied access to the board, and consequently they gravitated toward the Los Angeles County Museum of Art. When the new LACMA building was built nearer to Beverly Hills, this community, aware of Pasadena's "neutrality" toward it, naturally fell into its orbit. Only after Moore's tenure as president of the board the first Jewish Beverly Hills collector, Donald Factor, joined the board largely at the encouragement of Walter Hopps. Years later, some of the younger Beverly Hills collectors associated themselves with Pasadena. Few of these younger people were allowed to participate in the real decision-making. They remain outsiders, juniors who had walked into a weird and complex situation in which they were reluctant to assert themselves: in short, it was their money and not their ideas that was welcomed, and the control of the museum at trustee level was to remain almost exclusively in Pasadenan hands.

As her ally in advancing the new building project, Moore enlisted another trustee, Harold Jurgensen, a self-made millionaire with strong roots among the city bosses, and owner of a chain of fine wine and gourmet stores modeled after Fortnum and Mason in London. Jurgensen, anxious for the social cachet of public service, became head of the museum's building committee. He had the power, drive, experience, and connections to make the project a reality.

Together, Moore and Jurgensen elicited the interest of another trustee, Wesley Dumm, a remote, mysterious, but extremely wealthy figure who lived like a hermit in the Altadena Hills. Dumm never attended board meetings, and the only evidence of his involvement in the museum was a gigantic star sapphire mounted and displayed in the hallway near the bookstore. Dumm knew a man connected with Stuart's Pharmaceutical Company in Pasadena who had hired architect Edward

D. Stone in 1957 to design the company's new pill factory up on Foothill Boulevard. At Dumm's urging, Stone was hired to design the new museum complex, and the board hoped for a large donation from the pill factory owner to swell the building fund. Wesley Dumm himself paid for feasibility studies and other preliminary costs, and promised to make a half-million-dollar donation to the building fund. Angered later at the direction the museum took, Dumm never honored his pledge.

A preliminary design from Stone included a theater, concert hall, and various other performance areas, as well as exhibition galleries. Conceived in an Egyptian revival style, Stone's building was huge, and far beyond the resources of Pasadena either to build or maintain. The initial proposal was eventually revised and cut down in size. By the time Leavitt left the museum, funds had been raised from different donors amounting to somewhere between $1.5 and $2 million. The lack of an endowment fund to maintain the museum was constantly and conveniently fudged over. Monies were held in so many different funds that what was endowment for maintenance and what was purely for the proposed building became a matter of conjecture – a question of who juggled what to get the answer that was required at any given moment. For example, a Mrs. Crosset gave $750,000 to the endowment fund, which was subsequently used with her consent as a guarantee on the building loan. The board called the Crosset endowment "unattached securities," which clearly they were not. In addition, at the very height of the stock market boom Mrs. Crosset's $750,000 was so poorly invested that within a year or two its value tumbled to around $300,000.

After six years without a professional staff, with a substantial collection on his hands and the most inadequate of records, a tiny operational budget, and no fixed endowment, Leavitt was worried at the way things were going. He felt that the museum was on a "doomed course." He did not have the basic concurrence from the board that a dollar for the building should be matched by a dollar for the endowment before the project could go ahead. Instead, he had Mrs Moore's incredible enthusiasm. Leavitt felt that the level of community support had yet to be correctly assessed, and that reasoned planning had become wishful thinking. He approached individual board members to sound them out on his anxieties, but got the brush-off. Leavitt couldn't see that the

means were available to jump from a small museum with an annual budget well under $100,000 to a major institution which would require several hundred thousand to keep its doors open. He began to negotiate quietly for another job, which he found – director of Santa Barbara Museum of Art, a general museum in a very small and very wealthy community a couple of hundred miles north. The last important show Leavitt organized at Pasadena was a Robert Motherwell retrospective, and, to the surprised annual general meeting held in May of 1962, Leavitt announced his resignation.

It was at the 1962 annual general meeting that Mrs. Moore, too, stepped down as president of the board, and Harold Jurgensen was elected. Although she resigned as president, Moore retained her position as a trustee. At the same time, she extended the range of her activities in the museum by opening a design department to which she appointed herself curator. In doing so, Moore founded a separate corporation within the museum called California Design.

She campaigned vigorously and most successfully for state and private funds, mostly from industry, over which she retained full control. Perhaps if the same amount of energy had been directed into raising funds for the museum itself, a quite different picture would have emerged. The straightforward purpose of California Design – to promote knowledge of design in the state – allowed Moore to give full rein to her populist instincts. She began organizing what became an annual exhibition. This included a large and expensive colorplate catalog and a specially designed installation which took up the whole of the Nicholson building (and later, the new museum) for several weeks. In essence the show is a juried annual of handicrafts – pots, weaving, art furniture, bits of industrial design, and commercial and household knick-knacks. The exhibition was tasteless, immensely popular and brought considerable gate receipts. It also successfully alienated every designer and architect of note in California.

Most disturbing of all was the introduction of a former president of the board and a trustee into the museum's structure as a working professional. Though Moore headed California Design, she nevertheless saw herself as *the* curator of design, and she demanded that she supervise anything related to design and architecture. Beyond this, she cast a

jaundiced eye upon the everyday activities of those professionals who were within the museum. What was at variance with her own firmly held opinions was immediately carried either to the director, the other trustees, or straight into the boardroom. After all, she could demonstrate that her program made money and had a huge attendance, two ingredients every board member understood. This impossible situation was aggravated by Moore's incapacity to distinguish the meaningful in art from the insignificant; since everything was equally significant, everything deserved a place in the museum.

When Leavitt left the museum, Walter Hopps was appointed acting head of the museum. Hopps, a third-generation Californian, is one of those people who fits into the contemporary art world with such natural ease that it would appear to have been created especially to use his talents rather than the other way around. As a schoolboy he had hung around the Arensbergs, and he knew their remarkable collection intimately before it had left for Philadelphia. At Stanford and UCLA he studied biochemistry, but chucked it to immerse himself in the California art scene and later married an art historian. His earliest activities centered as much around San Francisco as Los Angeles. Between 1953 and 1956 he began to organize exhibitions in Los Angeles wherever he could find the space. In 1957–58 he started the Ferus Gallery in Los Angeles with Edward Kienholz, which in fact was more an artists' co-operative than a commercial gallery. When Irving Blum became a partner in the gallery in 1959, Hopps began to work more at Pasadena as freelance curator, and by 1962 had become a full-time curator there.

Hopps knew artists' studios in both northern and southern California, and he understood the interrelationships between the two scenes. The museums at the time were doing little to support the work of younger artists. The San Francisco Museum had atrophied under the dead hand of George Culler. The Los Angeles County Museum of Art didn't yet exist – art was still mixed up with natural history at the old county museum. In 1962, *Artforum* started up in San Francisco and by 1965, when the magazine moved to Los Angeles, it had already proved to be a natural vehicle for giving the West Coast (as it came to be called, instead of northern and southern California) some confidence about its

own affairs. The time was ripe for a knowledgeable and energetic museum man who could steer a small contemporary museum in the right direction, and with Leavitt's exit, Pasadena seemed to offer Hopps the chance.

Immediately after the May 1962 annual meeting at Pasadena, newly elected board president Harold Jurgensen took Hopps aside to define their relationship: "You don't know anything about business, and I do, so don't you ever argue with me on that score. I don't know anything about art – I don't know the difference between a Ming bowl and a Bangkok whorehouse – so I'm not going to argue with you about art. Understood?" Busy as he was, Jurgensen was in and out of the museum, going over every aspect of its operations as if it were one of his stores, even down to checking to see that the toilets were clean and stocked with soap and paper towels. Jurgensen didn't bother with the social rituals Pasadena so loves; his meetings with Hopps were sharp and to the point.

Leavitt had briefed Hopps on the problems with Stone's proposed building. When Hopps raised the matter with Jurgensen, he found that the board president couldn't care less whether or not the architecture was good or not. Only one thing interested him – its cost. Though the building had never been put out to bid he figured the cost on a square-foot basis, and decided that it would be outrageous. Without consulting the full board Jurgensen ordered Hopps to dismiss Stone. The decision was good for action but bad as policy; the other trustees didn't know what was going on, and many were severely alienated – most particularly, Dumm.

Hopps proposed to the board that the Nicholson mansion that housed the museum be extended north, into the parking lot. The plan provided for access to a loading dock and left parking for the public. Hopps also suggested that the museum should acquire the two run-down brick hotels that abutted the museum on the west. These could be converted into spacious gallery and storage space. Plans, in fact, were drawn up for this project, and there was money aplenty in the kitty to finance this extension and leave substantial endowment.

Yet Mrs. Moore, among others, couldn't bear the idea that the museum should lose its option to build in Carmelita Park. Trustee

Robert Rowan led a faction that declared Hopps' proposal was too tacky, and that it would not attract monied people needed from Beverley Hills. Rowan was one of those trustees who felt these people needed to be brought into the orbit of the museum as collectors and supporters, despite his personal dislike for the brash nouveaux riches of the movie industry.

Hopps counterproposed that if indeed a new museum must be built on the site in Carmelita Park, then the architect should be a southern Californian, someone with whom the museum could work closely. He suggested that a competition be held for the design of the museum, and Jurgensen directed him to draw up a list of names for the board. Hopps nominated Richard Neutra, John Lautner (a protégé of Frank Lloyd Wright), Craig Ellwood, Thornton Ladd, and Charles Eames. Hopps felt that a lightweight industrial structure (such as Eames was skilled in designing) might save the landscape of Carmelita Park, and some money for the endowment.

During the next few months, Jurgensen evaded his director. When Hopps asked him what was happening with the competition, the board president put him off. Finally Hopps demanded an explanation. According-ing to Hopps, Jurgensen said, "Your list of names was good. The com-mittee has considered everyone, and Thornton Ladd has won the competition."

"How?" Hopps asked. What competition? he thought.

". . . from time to time I'm gonna tell you that something is just the way it is. And this is one of them. Ladd will be the architect."

At first Hopps felt betrayed. But, since Jurgensen had backed him to such an extent in his attempts to put together a professional staff, and in his proposed exhibitions program, Hopps began to feel that the building the museum would get from Ladd and his partner John Kelsey could be negotiated. Hopps had hired Gretchen Taylor, a research librarian and art-history student at UCLA, as registrar, and a preparator, Hal Glicks-man. In 1965 Hopps hired Jim Demetrion as curator (Demetrion had already guest-curated the museum's Jawlensky exhibition). Now, Hopps thought, things were beginning to make some sense. He had planned a series of scholarly exhibitions around the Blue Four collection, as well as a series of shows of particular interest to him: a Duchamp retrospec-

tive, exhibitions of Schwitters, Johns, Cornell, and some Californians, John McLaughlin, Hassel Smith, Frank Lobdell, among others.

The national economy was booming, and there seemed plenty of money around. Collections could be built. Hopps himself was closely advising collectors such as Gifford Philips, Betty Asher, Ed Janss, Frederick Weisman, Monte Factor, Donald Factor, and Betty Freeman. Perhaps California might at last have a first-rate modern museum. Hopps' last exhibition as Pasadena's curator, "The New Painting of Common Objects," the first American museum show of Pop Art, had attracted national attention, partly through extensive coverage in *Artforum*. (I had written on the exhibition myself after I had arrived in Los Angeles from San Francisco in 1963. It was then that I first closely followed the Pasadena Art Museum's programs and problems.) The exhibition set a major goal in Hopps' programing, a goal which par-alleled the ambitions of artistic culture vying with that being made in New York. Issuing from that year, also, was the major coup scored by the museum in the international art world, Hopps' retrospective of Marcel Duchamp.

In setting up Ladd and Kelsey as the "appointed architects" for the new museum, Jurgensen promised Hopps that the design would fulfil his requirement. Jurgensen was so convincing, said Hopps. Everyone figured, "Oh, to hell with it, we're all going to have a hand in it, so it can't be that bad. Its a beautiful park anyway. Maybe it will work out for the best after all." Meanwhile, galleries in the old building were ripped apart and refurbished, and the planned exhibitions program began to absorbed staff energies. Hopps made contact with Ladd and Kelsey, to sound out their thought, discern their general theoretical approach, and to find out if there were immediate problems to be discussed. But neither architect wanted to discuss theories. "We had lunch, we gossiped, and chattered, and no talk on the new museum. Ladd talked about a glider he flew. It was weird; they were completely evasive." Hopps saw them frequently over the next year or two, but without learning any concentrated proposals about the form the museum might take. Pressed by Hopps, Ladd promised, "I'll show our design first and then we'll really talk about it. You see, we're working in three dimensions so we can't even show you a sketch."

Some three years after their appointment (unbeknown to him), very near the end of Hopps' tenure to Pasadena, Ladd phoned to say he had a surprise and invited Hopps over to the firm's offices. In a loft above the offices Ladd and Kelsey had built a large model of the new museum from bent kraft paper. The museum was designed in the shape of an H with circular galleries at the end of each arm combined with the auditorium; the museum complex resembled a flayed skin spread over the ground. This design apparently evolved from the interpenetrating rhythm of the bent paper and the ground plan was superimposed – function followed form. Jurgensen and board president Robert Rowan were beaming over the model when Hopps arrived. "They were so excited that they were practically toasting each other in champagne. The building was grotesque," says Hopps, "and I was unable to get a word in edgeways to stem the tide of praise."

The site had been flattened and destroyed. And, since the architects had noted that sculpture in a rectilinear gallery often had to be viewed against the angle formed by the corners, Ladd and Kelsey had rounded every corner in the galleries and halls. All the halls, except in the extensive corridors linking the pavilion-like galleries, were curved. Lens-like domes were to flood the floors – not the walls – with pools of light which would shift with the sun. The lighting system concealed within finned recesses of busy ceiling detail harshly illuminated the wall. The galleries couldn't be shut off for installations and for the most part, the focal point from one access to another revealed not walls but windows opening onto Pasadena. Several of the galleries ended in small u-shaped chambers like apses, completely unsuited to the display of works of art. What was left of Carmelita Park – that is, the grounds for the display of sculpture – were taken up by a long reflecting pool, and a huge asphalt parking lot behind and at the side of the museum. The design segregated the museum from its ground to such an extent that (unlike a courtyard situation) it was impossible to have a continuity between large works displayed outside and more fragile works inside the museum.

It was clear from the plans that the security of the museum would be an immense problem. Instead of the two or three guards used at various times in the Nicholson building, a veritable platoon would be required for the new museum. Since access to the grounds would be

restricted, it would be impossible to guard sculpture outdoors. The auditorium could only be entered by walking the entire length of the museum, which meant the galleries had to remain open whenever events took place in the auditorium at night. The firecode required that the four exits nearest the public toilets in the auditoriums be left open for emergency use. This meant that a guard had always to be stationed at the entrance to the auditorium whether it was in use or not. A door in the lower level graphics gallery opened onto the offices and the main storage area of the museum. Since there was only one staircase down to that gallery, this door abutting the main vault had to be left open as a fire exit, and yet another guard had to be permanently left there. (On one of my own inspection tours of the building during its construction I noticed that an overhang above the main loading dock was built so low that a semi-trailer or other tall truck could not back up to unload. The architects refused to alter the design lines of the building to accommodate a truck. Consequently, whenever it rained no works of art could be bought in or out of the museum.)

It was a disastrous, crackpot design: instead of a flexible building suitable for displaying a wide variety of art, the architects had designed a sleek decorator's dream, full of awkward restrictions. When Hopps saw the plan he felt totally betrayed. "In my fantasies, the only thing I could have done to express my true feelings would have been to make noises like a character from an Ionesco play, and throw myself bodily into the model, crushing and wrecking it. And just as I was just about to spout out my shock, and say, 'No, it won't work, it's all wrong,' Thornton Ladd had me by the arm in a comforting way, saying, 'Don't worry. We can change anything. Don't worry. This is merely a presentation. It's a beginning, a temporary.' And I'd say, 'Well, look. What about those corridors?' to which he replied, 'We don't have to have those corridors.'"

Ladd and Kelsey, Hopps said, "had a polished verbal technique where they would present some terribly accomplished fact, and then smooth things away by saying, 'Things don't have to be that way ... Don't worry, everything will be all right. That doesn't have to be that way.'"

"But you've destroyed the site," Hopps complained.

"Oh, no," Kelsey or Ladd would reply, "We can do anything with the site."

"But the model shows you've leveled the site," Hopps said.

"Oh, well, that's just for presentation," they replied in unison.

The wasteful design of the new building finally was to prove a mortal blow to the independent survival of the museum. The cost of extra personnel to guard the rambling space, as well as power to heat and air condition the building, was to add a huge sum per annum in excess of what a more tautly designed building would have cost for these same items. Moreover, Ladd and Kelsey had purposely designed it so that it would be impossible to build the museum in stages, adding wings or galleries as funds allowed. It was an all or nothing job which, once built, would be extremely difficult to add to or change.

Some minor amendments were made in the design at Hopps' insistence. He told the architects point-blank that he would seal off the light domes above the galleries once the building was completed. So Ladd and Kelsey, instead of revising the design, kept the domes as external decorative features, sealing them and planning an internal lighting system with metal fins to conceal the fixtures. Also, the planned entrance on Colorado Boulevard was shifted nearer to the car park, and more toward the middle of the museum. A section of the grounds was fenced for sculpture, but apart from several minor details, Ladd and Kelsey were unyielding in their determination to force their design concept through regardless of consequences. And, with Jurgensen's and Rowan's uninformed but evident pleasure at the design, there were no forces on the board strong enough to say them nay.

Even those who saw the folly of the design could not bring themselves to urge a cancellation. One architect had already been fired at great expense. Ladd and Kelsey had worked so long without consultation that getting rid of them would involved another huge fee. Moreover, these board members felt that such a move would damage the morale of the small community of support, and hurt the museum financially. In 1963, Jurgensen stepped down as chairman of the board to devote more time to his business. But he resumed the chairmanship of the building committee, and at the same time managed the museum's fund. The board also appointed a full-time business manager. This

wise move might have saved the building program. The appointment, however, went not to a sharp young man or woman who would have welcomed the job as a step in an ongoing career, but to one of the boys, Donald McMillan, a retired Pasadena city manager on full pension. McMillan, who was in his late sixties, was also chairman of the Southern California Rapid Transit District board at $30,000 per annum. He appeared in his office at the museum a few mornings a week to sign cheques. He was not responsible to the director, but through Jurgensen to the board. He was salaried at a higher rate than the museum's director, so that over several years around $100,000 was paid to an aging and ineffective man already earning a substantial salary from two other sources.

Whatever might be said in criticism of him, Jurgensen was a man of his word, warm, human, approachable, and if at times far from correct in his decisions, at least decisive. He never interfered in esthetic decisions made by the museum staff. Robert Rowan, a trustee collector, who replaced Jurgensen as president of the board, was, on the other hand, one of the most equivocating people it has been my misfortune to come across. He was, I would guess, in his middle fifties when he became president. Well educated and married to a charming younger woman far wealthier than he, Rowan is affable, courtly, and a good host, albeit somewhat distant, in the English manner. His father's aggressive speculation in southern California land provided the family fortune. But neither Rowan's birth nor his stylish education had provided him with business skills, and in his hands the family business that he and his brothers had inherited declined. His father's primary investment was in downtown Los Angeles, which, like many other urban centers, went through a period of extreme decline. During the years after his father's death, Taylor Caldwell Company moved in to replace R. A. Rowan & Company as the major real estate firm in the downtown area.

Like many of his generation who had inherited their wealth, Rowan was haunted by the specter of the Depression, of being poor. His whole attitude toward money is defensive; he cannot bear the strain of parting with it. As he began to shoulder the financial burden of the museum's deficit, small as it was in the early years, he became less affable. Always nervous, he became more irritable and erratic. A constant worrier, he

was uncomfortable at meetings of the museum's executive committee and the board. He preferred to meet more informally, usually at the Annandale Golf Club, or at his own house. There were lengthy meetings, usually over lunch or around social affairs, at which nothing was really decided. Hating arguments, fearing any bad publicity, he either put off decisions or made them privately.

Tragically, the trustees and the interested local community believed that the future success of the museum depended entirely on Rowan, that his wealth and participation were crucial to its success. The other board members were by and large local people of no particular cultural sophistication who looked to Rowan for guidance. He had a social cachet, and he collected. In most communities, it is the people of Rowan's class who make so many cultural decisions because they have the background that provide the contacts that attract the money so that everything can fall into place. Despite the reservations about his leadership capacities, the Pasadena trustees came to feel that Rowan was necessary to link everything up.

For Rowan, because he was directly financing the deficit, the museum became a private preserve akin to his own household where he could order things according to the standards of his own taste. His only problem was the staff. Although a nuisance, they could always be replaced. During the period of Rowan's tenure as board chairman, 1964–70, there were four directors and such a rapid turnover of staff that the only person capable of grasping what had happened and why was the president of the board. Behind all of Rowan's decisions lurked the assumption that an endless reservoir of better people existed who would gladly come to Pasadena.

Rowan rarely disagreed outright with any member of the staff, especially in a meeting. Rather he would wait until the next meeting or chance occasion brought him face to face with the person with whom he had taken issue. According to the directors of the sixties, he would announce that he had checked on the matter with other more senior and experienced professionals at other museums, that their advice was contrary to that of the staff, and that he would be inclined to follow it. He developed this indirect decision-making formula to the point that directors and board members never quite knew who was making the

decisions, Rowan, some other museum officials *in absentia*, or themselves. Since Rowan had an endless number of "consultants" up his sleeve, any matter which was at one moment agreed upon might later be called up for question.

Rowan, like many of his trustee colleagues in other museums, persistently restricted the decision-making processes to as small a group as possible and one dominated by himself. In this, he was abetted by the usual truancy of most board members when meetings were held. Consequently, most of them hadn't the faintest idea as to what was going on. Since they had only a vague notion of what a trustee's duties at a museum consisted of in the first place, from the point of view of both museology and public accountability, the trustees at Pasadena basically served to rubber stamp Rowan's decisions, at least between the years 1964 and 1970. The president, therefore, was able to promote an image of himself as a decisive leader. He could assert that the growing importance of the museum was the result of his leadership, not the efforts of the staff, an indulgence he would never have allowed himself in the world of business affairs.

And the museum was indeed becoming important. The greater Los Angeles area, unlike other regional cities, is an important art center with a vast network of varied educational institutions and a large population of artists. Pasadena was their principle resource for the firsthand viewing of modern and contemporary art which they would not otherwise see except through slides, and magazine and book illustrations. It was this audience, not simply the small community of Pasadena, that the museum was addressing.

Few trustees understand that the museum directors and curators, since they function in the open, are directly accountable in a way that trustees are not. Exhibitions will be examined in the press, both local and national, lay and professional. Directors and curators are subject, too, to the judgments of their peers in a jealous and begrudging profession, and their efforts are scrutinized as well by art historians, artists, dealers, and the others who make up an informed art community.

Should a curator pioneer or cater – or do a little of both? To what extent should a regional museum devote its program to local artists, to nationally known ones, or to historical or didactic exhibitions of its root

culture? What is the importance of each exhibition within the program as a whole? Considering a museum's overall resources – budget, space, staff – what exhibitions should be purchased, and which originated?

Once the trustees have laid out the general concerns of the museum, to which extent and in what direction should the collection be extended? And with which specific works? To what extent should the staff advise trustees what to collect? Is the collecting activity speculative, or might it eventually bring works into the museum? Is it ethical that trustees' works be shown in the museum's exhibitions, and illustrated in its catalogs – since this will doubtless enhance the works' market value?

There is, then, a nexus of questions that museum trustees are not obliged to deal with but which directly concern the staff. The constant tug-of-war between Rowan and the senior staff, a process of proposal, counterproposal and compromise, ill served the dynamics of the Pasadena's situation. Typical was Hopps' experience in 1965. Before he was to leave for Brazil to organize the American section at the São Paulo biennial, Hopps had booked a traveling exhibition of Larry Rivers paintings, organized by Sam Hunter to fill the museum during the summer. Hopps and his curator Jim Demetrion were installing the paintings when Rowan strolled into the museum to watch them at work. Said Hopps, "Rowan was looking around, enjoying the paintings and laughing. Suddenly, he was looking at Rivers' full length portrait of Napoleon, and his mood changed, his attitude became chilly. Something was wrong. He took me aside and said, 'Walter, that painting has to leave the show.'

"I said, 'You mean Napoleon?'

"'Napoleon, Napoleon,' he replied. 'That painting!'

"'Why?' I asked.

"He took me over to the painting and said quietly, 'It's called *The World's Second Greatest Homosexual*.' I thought he was joking, and I laughed. But he was serious. 'We can't have homosexual paintings in this museum. There must be others!' He looked around in fear and worry, and repeated, 'Everything with this homosexuality has to come out of the show.' He went over to a full-length painting of Frank O'Hara standing naked in a pair of big shoes and said, 'This one too.' I knew

I was leaving soon, and that Demetrion would have to be in on this matter, so I called him over and told him what Rowan had said. Demetrion thought Rowan was kidding, but then, sensing the anxiety in the air, he realized Rowan was serious, and he came on tough."

"He said, 'Bob, you can't order the removal of these paintings. We'd be a laughing stock.'

"Rowan replied, 'You boys had better think this over. I'll be back this afternoon for your reply.' At which point he left."

Hopps and Demetrion stuck to their guns about the paintings, but they had to compromise. The paintings were exhibited without titles, and identified only by catalog numbers.

Rowan was also easily influenced by other board members in matters of decorum. Barnett Newman, pleased by the way Hopps and the museum had handled his presentation with a group of younger artists' work at São Paulo, offered to travel his upcoming exhibition at the New York Guggenheim Museum to Pasadena. Rowan suggested that the 14 abstract paintings linked thematically by the title *Stations of the Cross* might offend the local clergy. Other board members agreed, and the exhibition was canceled.

Like many other regional collectors, Rowan bought according to the signal of Clement Greenberg. He bought Louis and Hofmann in depth, and Olitski by the square yard. Rowan owns the largest collection of Olitski's work in private hands, as well as many other Greenberg-certified artists. At the same time, Rowan obtained remarkable examples of early works by Lichtenstein, Warhol, and Rosenquist from Leo Castelli, practically all of which he later sold for a handsome profit. By "handsome" I mean roughly ten times what he had paid.

At first Rowan gave $15,000 or so a year to help make up the annual budget deficit of the museum, and later this tax-deductible amount grew to around $50,000 annually. But in his profit from the sale of Roy Lichtenstein's *Temple of Apollo*, for example, a painting he bought for $6,000 in 1964, and sold this year for $250,000, Rowan more than recouped the money he gave to the museum. He sold many other paintings in this manner, starting in the mid sixties when he sold an early Frank Stella he had purchased for $1,500 to the San Francisco Museum of Art for $15,000. At the time, Pasadena owned nothing by Stella. But there is

more to this incident. One day visiting the museum, I chanced to meet Rowan chatting to Demetrion in the courtyard. He asked Demetrion and me to look at two Stellas of the same size, date, and series. He said he had decided to sell one, and asked us to judge which was the better one he should keep. Since a promise was implied in his request that the better of the two paintings was being kept for Pasadena, we were eager to comply. Demetrion and I made a judgment that coincided, and Rowan concurred.

Only then did it become clear to me that the rejected painting was being sold to the San Francisco Museum of Art. And, though it was transported there directly, I overheard Rowan instructing his secretary to make sure that the Andre Emmerich Gallery in New York invoice the museum for the Stella, and use the $15,000 paid by the museum to buy a Louis painting. Rowan, then, bought the two nearly identical Stella paintings for speculative purposes. The sale of one recouped the cost of both, and gave him a handsome profit. The Stella he retained would now bring around $60,000. The Louis he bought for $15,000 in 1966 is worth around $125,000 so, for an original Stella investment of $3,000, he gained $137,000 in a period of ten years. It was invoiced through Emmerich as if it were simply an exchange of one painting (the Stella) for another (the Louis).

In the spring of 1966, the plan and model for the new building was to be presented by the director and the president of the board of trustees at the museum's annual general meeting. Hopps, exhausted, in the midst of a split with his wife, felt unable to face the membership and explain why the plan was a disaster. He had flown from New York for the meeting, but when he arrived at the LA International Airport he wandered aimlessly, suitcase in hand. He felt himself about to have a nervous breakdown. Through a psychiatrist friend, he had himself admitted to a hospital, and rested up for a couple of weeks. The new building was enthusiastically received at the meeting. Not long afterward, Rowan told Hopps he doubted his capacity to handle the directorship, and fired the man who had virtually single-handedly lifted the little museum into international prominence.

Upon Hopps' departure in 1967, Demetrion, whose total museum

181

experience amounted to the two and a half years he had been curator, became acting director. Demetrion, however, is a straightforward man who correctly assessed that the problems at Pasadena were beyond his competence. He rapidly discovered that Rowan and Jurgensen, and not the board of trustees, were running the museum. He didn't know until later that the director had no fiscal responsibility for the museum, but that the business manager reported via the treasurer to the board. In any event, Demetrion accepted the directorship on four conditions: 1) that his salary be a dollar a year more than that of the business manager; 2) that an outside expert be brought in to go over the plans for the new museum, and his recommendations accepted by the board; 3) that a sum of not less than $25,000 per annum should be made available for acquisitions; and 4) that the director should have the right to appoint his own staff. These terms were agreed to.

But, when he was in Chicago borrowing some Joseph Cornells for the exhibition of this artist's work that Hopps had planned, the cab Demetrion was riding in overshot the turnoff, backed up, and was rammed by a following car. Although himself injured, Demetrion rescued the Cornells before the cab caught fire. During the time he was in the hospital, the plans to retain an outside consultant were delayed. After much stalling, David Vance, who worked as associate registrar at MOMA, was brought in as consultant. In his report, Vance castigated the museum because "security was a sieve." He made many other recommendations of which only a few were incorporated. Nothing relating to the esthetics of the building could be altered, of course, but Demetrion pushed hard for the widening of the corridors. It was only after Leo Castelli saw the plans and told Rowan that "they were ridiculous" that Rowan finally convinced the architects to make some alterations. Still, though both Demetrion and Vance knew that the lighting system was inadequate and unsuitable, nothing said would convince the architects or Rowan.

Since the museum already had serious problems meeting its annual deficit, the trustees met Demetrion's demand for a $25,000 acquisitions fund by forming the Fellows of Pasadena Art Museum. This group of younger people donated an annual sum in return for which they became involved in the affairs of the museum and attended evening classes on

the history of modern art. With these funds, Demetrion was able to buy over the next two years a Cornell box, a Kelly painting, an Oldenburg sculpture, and the works of several West Coast artists, including Robert Irwin and Larry Bell. These were the first works of any significance to enter the museum's collection since the acquisition of the Blue Four collection.

Demetrion insisted on appointing his own staff since Rowan wanted to name Alan Solomon, former director of the Jewish Museum, as curator *in absentia*. It is interesting that Solomon was among the growing number of directoral émigrés from trustee intrusions. Rowan's idea was that Solomon would continue to live in New York and curate exhibitions for the Pasadena from there. Demetrion refused. I was then director of the art gallery at the University of California at Irvine, and had just guest-curated a Lichtenstein retrospective for the Pasadena in 1967. Demetrion invited *me* to become the new curator (although he didn't tell me of Rowan's attempt to hire Solomon), and I accepted. My first work as curator at the museum was an exhibition of Cézanne watercolors.

Demetrion tried hard to bring order to the affairs of the museum. He met regularly with the seven volunteer groups, trying to get them together in one meeting at a time, which proved impractical. He kept pushing for the resolution of the problems with the Oriental wing in the new museum. Ground had been broken, and the building was proceeding apace, yet no Oriental curator had been appointed, nor could Demetrion obtain the funds to pay one, Still, Rowan and Jurgensen constantly promised Mrs Steele, a major donor, that an Oriental wing would be included. Finally Demetrion realized that the problems of funding and staffing the new building would be so insurmountable that in early 1969 he decided to quit. He looked for another directorship for barely two years. Demetrion announced that his resignation would take effect prior to the opening of the new building.

The following history takes the Pasadena Museum on to further stages of inevitable deterioration and imminent defeat. As a director's appointee, without mandate from the board, I offered an undated resignation to Rowan. Circumstances would have inspired anyone in my position with an extreme reluctance to lobby for the thankless director-

ship. But it was agreed that I would be a caretaker officer, seeing the museum through the critical period of its new opening and programs. The immediate interim should be characterized, mildly, as a panic. Lacking visible access to the executive committee, and faced by the departure of the professional staff with that of the outgoing director, I devoted myself to making the new plant a working museum, with a guaranteed schedule of events. A strike at the building site jeopardized all construction deadlines at about the moment I discovered the lighting system, once we were finally able to test it, bore no relation to the needs of lighting works of art. At the same time I had to redesign the lighting system, it was also necessary to campaign for new gifts for the museum, so that the 80,000 square feet at Carmelita Park would not ludicrously dwarf our present slim holdings. (There was an under-the-wire urgency about this campaign because we were in the last year that artists could give works of art to a museum and deduct them from their taxes.) As for upcoming shows, we booked an exhibition of Oriental art from the Brundage Collection, to be followed by the Bauhaus exhibition from Germany. The "grand" opening was to be celebrated by a survey of postwar American art, East Coast and West, guest-curated by Alan Solomon, now settled at the University of California, Irvine. Such, then, were projects that came variously undone through the predictable con- fusion of mismatched interests, and grudging and negligent patronage.

In order to earn money for purchase of works of art, I proposed that the museum review and deaccession a number of middling nineteenth- century paintings in the basement, of market value, though of no museum quality. But the funds realized were used for general expenses, and never for this purpose. Then, too, nothing could have better sabo- taged gifts from the trustees than the rumour that Rowan was about to bestow his collection upon the museum in time for the opening. But if collectors shied away from the thought of competing with his vast assets, the Noland and the Schlemmer contributed by his family would have allayed their fears. Nevertheless, on a trip to New York in that year, 1969, I secured fine gifts from or of Kelly, Lichtenstein, Albers, Andre, Rauschenberg, Judd, Serra, Nevelson, Warhol, and Morris. In Los Angeles, Larry Bell, Robert Irwin, Ron Davis and several colleagues also gave generously. With a Frankenthaler and Flavin donated by

trustees, and a dealer's benefaction of an Agnes Martin, the museum suddenly had enough works to rotate around the American wing, and the beginnings of a good contemporary collection for the first time in its history.

At this time, shortly before Demetrion was to leave, two events occurred. The first was that Tom Terbell, a young banker and vice-chairman of the board, took a leave of absence from his job in order to serve as acting director. The second, far less amiable, surfaced when the museum learned that Solomon interpreted his assignment survey-ing postwar American art to exclude all but "Painting in New York, 1944–1969." In view of his West Coast identity, record of and commit-ment to local support, his was a discriminatory conception. We were to inaugurate our new building with a show that would not acknowledge the enterprise of West Coast artists, for over 40 years proudly featured by the museum (Kienholz, Turrell, Irwin, Chicago, Wheeler, Thiebaud, etc.). Neither Solomon nor Rowan, ten of whose paintings were in the exhibition, would allow it to be modified. Only upon rude protest to the executive committee, was $5,000 allotted to mount a lame grouping of the artists that had made the West Coast significant in contemporary culture.

It is perhaps tedious to chronicle all the physical headaches en-tailed by the museum's move to its new quarters. From the lighting, to fending off eager cocktail parties while plaster was still being troweled, the countdown atmosphere grew more and more nerve-wracking. With its bizarre space and curved walls, Ladd and Kelsey's design resisted sane installations. I should mention, also, the sudden harassing of city officials and fire inspectors, who lent an unconstructive hand to the proceedings. (These cavils were spurred on by the architects, who felt that their building was sullied by those who required it to perform its function.) Twenty miles to the west, meanwhile, the Los Angeles County Museum of Art was about to experience its own debacle at corporate hands, in the "Art and Technology" exhibition, while earlier, across the continent, Alan Solomon had had a heart attack and died. Somehow, Pasadena got everything together, and opened to congratulating hordes. Only Los Angeles artists, in a foul mood, quite rightly bad-mouthed the way they had been treated as second-class citizens. All this disorder and

wretchedness, which had produced a sterile and forbidding building, elicited from the trustees a cavalier benevolence. Their good spirits, of course, had all along been relieved of practical responsibility, and were in any event innocent of the taste to inform it.

From my point of view, the aftermath of their gala was in dreary and squalid character with all that had preceded it. Upon my return from New York and preparation for a Judd exhibition, Rowan informed me that he was substituting an expensive Warhol show in its place. The president of the museum had blithely bypassed the art committee to arrange a project with a private dealer. Since the Warhol would be bracketed by an earlier Stella and a later Judd exhibition, Pasadena was to look very much like the Western headquarters of Leo Castelli. In true form, Rowan sold two Warhols for about 1,500 percent markup, and with each rise in that artist's auction sales, owners would frantically contact us with escalating insurance estimates to accompany their loans. It was very much like the Dow Jones breaking new records.

By the beginning of 1970, it was clear that the museum's financial affairs were in a shattered state. Pledges weren't coming in fast enough to pay the interest on the building debt, which alone amounted to some $10,000 a month. Expenses were enormous: the air-conditioning plant cost $12,000 a month to run, and the platoon of 17 guards, at an annual salary of $100,000, was sucking the museum dry. These expenses had to be met before salaries were paid to the office, curatorial, and educational staff. Then there was the exhibition budget, insurance and other general costs to be paid. True, the $2.00 entrance fee produced a good income at first. But once the novelty of the new museum wore off, it fast became obvious that the audience would not much exceed the 300 to 400 weekly that had visited the old museum. Though the museum's attendance was always small and was to remain so once the excitement of the new building wore off, it was nevertheless a unique focal point for the Southern California art community, especially the museum's openings. Los Angeles is a highly urbanized but nonetheless diffused area. Unlike New York, common meeting groups are virtually nonexistent. Consequently firsthand contacts across generations and professions are extremely rare. The museum's openings were more than social events. They brought together a large array of people from all over southern

California who normally had little contact with one another, but a strong common interest. The openings engendered a rare intimacy, which broke down, if only for a single night, the sense of isolation that the LA art community felt.

Although Terbell was worried and harassed as acting director, he felt optimistic about the museum. I did not share this view, since the first financial problems were accelerating rapidly, and there was little evidence of rational decision-making by the board. Terbell had more than once told me that, given his background as vice-president of a well-known bank, and his close relationship to Rowan and others on the board, he could see no real objections to himself becoming permanent director. There was no money to bring in a professional director from outside, one who would be prepared to cope with the impossible financial situation, and since Terbell was personally prepared to put money of his own into the museum, I agreed that his appointment might be the answer. Perhaps better communication with Rowan might help, since Rowan seemed uninterested in hiring a professional director. It might force him to relinquish some of his control.

The day before the board was to vote on Terbell's appointment as director, he took me aside and with some anxiety told me that the word had come down to him that unless I resigned, he couldn't become director. Would I please resign? I told him I would think it over and give him my reply that afternoon. When I returned, Terbell had told me that he had changed his mind, that he didn't mean what he said that morning. I told him it was too late. The long exhausting hours, the constant killing pressures, Rowan's persistent and arbitrary interference, made Terbell's offer too attractive, however much he might want to renege. The next day, he was appointed director by the board.

In February of 1970, I sent my letter of resignation to all 32 trustees, setting forth the problems of the museum. The new museum was operating with less than half the professional staff of the old, while often working as much as 112 hours a week; salaries were pitiful; it was impossible to operate the Oriental wing without a staff and a budget; trustees had accepted gifts on behalf of the museum without consulting staff; several of these works (mainly nineteenth-century American) had in the past turned out to be of dubious authenticity, or outright fakes;

and monies from deaccessions had not been spent on buying other works of art, but on operations. The majority of the trustees, I maintained, didn't understand the matters on which they were voting. I suggested a complete restructuring of the board's operating procedure to obtain better communication with the staff, and a more rational decision-making process.

Terbell, at a loss to mount approved exhibitions, approached me once again to guest-curate them on a contract which I accepted. This arrangement was honored only until a replacement could be found for me. Terbell caught William Agee, a curator at MOMA, the very day he was resigning there, and suggested that he come to Pasadena. The job title was changed to Director of Exhibitions and Collections, and Agee took over. Rowan had reached the statutory limit set forth in the museum's articles of incorporations, and so stepped down as president of the board at the 1970 annual general meeting. Rowan was given the honorary title of chairman of the board, and Alfred Esberg, a tough local businessman, was elected president. About six months later, I left for New York to assume editorship of *Artforum*.

In late 1970, Esberg and Agee united to fight off the inevitable – it was to be the last struggle for the life of the doomed institution. With Rowan now in the background, Esberg could make unsentimental reflective decisions in an effort to save the museum. Although Esberg was not a cultivated man who understood the deeper issues at stake, Agee was. But Agee was not prepared to lead what looked like a losing battle. When he pulled out to take the directorship of Dallas Museum of Fine Arts, the last faint hope of saving the Pasadena Museum went with him.

Before he left, Agee got the trustees to give up the Oriental wing. The board finally realized that the museum had to be straightforward with the community, and the name was changed to the Pasadena Museum of Modern Art, a request that the directors had been making since 1967. The new name became a declaration and an invitation for those interested in modern art in the LA basin to lend their support. It was also the first attempt to rationalize Pasadena's relationship to the LA County Museum of Art, and indicated that the relationship between the two institutions might be something like that between

the Metropolitan and the Modern in New York. LACMA would be the general museum and Pasadena the modern museum.

This situation was discussed in the local press, and many at the LACMA thought that it was sensible to bring Pasadena into the county system as the modern museum. But the internal politics at the LACMA would not allow it. When the county museum was set up in 1964, it received a basic annual budget from the County Board of Supervisors. But the Board of Supervisors then appointed a self-perpetuating board of trustees for the new museum, who had enough muscle to negotiate their own agreement in return for paying for the construction of the building. LACMA board became another private club of rich men, who were and remain unaccountable to the taxpayers who maintain the museum. The supervisors realized this, of course, and wanted to regain some measure of control in LACMA by overhauling the county museum system to include Pasadena. The LACMA trustees, however, simply wouldn't consider jeopardizing one iota of their autonomous control, and the suggestion was never taken up.

Terbell, who had put $125,000 of his own money into Pasadena, was wholly opposed to these negotiations, perhaps because he felt that his new job as director would be imperiled. Informed people began to realize that Terbell wasn't thinking straight. In early 1971, when it became obvious that the county deal was off, the Pasadena board decided that Terbell had served his purpose and fired him to make Agee director. They had now worked their way through four directors in a space of five years, rather like South American oligarchies, who play musical chairs for their governments.

Meanwhile, the Pasadena City Council was split over the museum, and reluctant to support it beyond keeping the grounds in order. Since the city gave Pasadena no basic operating budget, Esberg had to go each year, hat in hand, and beg. The museum's education department was doing an extraordinary job in support of the local school system, but the city didn't see it that way. Esberg felt lucky to get the usual annual grant of $25,000, although the museum desperately needed more.

Esberg slashed the operating budget to the bone. Guards were dismissed, museum hours restricted, and every effort was made to save money. The social elitism that previously operated in the election of

trustees was dropped, and the board was opened more widely to the Beverly Hills community, some art professionals, and new blood from Pasadena itself. Women volunteers began to take over many of the previously salaried jobs. Almost singlehandly they kept the museum open for more than a year. Esberg had been seeking just such a broader working board committed to the museum. He got it, but it was too late. Had it happened even a year or two earlier, things might have turned out differently.

Mrs. Gordon Miles, working with Agee, organized the first strong campaign to get money from the state and national foundations. Single-handedly, Miles raised a $25,000 grant from the National Endowment's museum education program. In the year prior to Agee's departure in 1973, the National Endowment contributed over $100,000 to the museum's program. In 1972, the state contributed $5,000. The rest of the board attempted to raise money from the private sector, but the effort was singularly unsuccessful. Rowan put in two paintings that fetched $50,000, and another trustee, Gifford Philips, put in $5,000, but it didn't seem to be enough to stem the museum's drift towards financial disaster.

Other new avenues were explored to raise money. Discussions were held with MOMA about starting a chain of modern museums across the country (of which Pasadena would be the first), and it was suggested that a national board be formed to start fundraising. Although MOMA was interested in the proposal, it had troubles of its own to face, including a large budget deficit. The Smithsonian was approached with a similar proposal, but that too never got off the ground.

Since Agee was spending too much energy trying to raise funds with too little result, the museum budgeted for a professional fund-raiser. (The position was never filled, because by 1973, the last phase of desperate negotiations with Norton Simon had begun.) It was senseless, of course, for volunteers and the director to spend so much time and energy raising funds, but the board had avoided the issue for so long it had become a matter of habit.

The operating expenses of the museum amounted to $665,000 in the 1973–74 budget. But this did not include the interest due on the $850,000 building debt, which (after the receipt of some pledges) added $75,000 onto the net deficit. All possible income from within the museum –

bookstore profits, catalog sales, membership fees, etc. – amounted to $264,000, which left a net deficit of $390,600. Various supplemental incomes could be subtracted from this. The city of Pasadena gave $25,000, and the National Endowment $70,000. But still the picture looked desperate.

Despite similar budget figures, Agee had somehow managed a miracle in the previous year by raising special contributions that held the net deficit to an incredibly low $11,000. But for 1973–74, the trustees felt that the bottom of the pot had been scraped. Mrs. Crosset, for example, who had repeatedly given the museum large sums in the past as she had been appealed to by one desperate director after another, gave the museum another $100,000 in 1972–73 with the warning that it was the last money the museum could expect from her. Coleman Morton, the treasurer of the museum, constantly impressed upon the board that it was a panic situation, and declared that there was no hope in carrying on.

Various alternatives to save the museum were discussed at the January 1974 board meeting. Every month when the executive committee met, the question of selling part of the collection was raised, and now the matter was put before the full board. It seemed the logical solution to end a continuous agony, or at least to gain time. Face reality, sell a quarter of a million dollars' worth of art, and be done with it. Agee was to fight this until the moment he left, and with the help of some trustees, the executive committee proposal was barely defeated. Had the old crowd of Pasadena socialites still been in control of the board, the massive deaccessioning might have gone through. But the revamped board included several professionals, artists, and women who had worked hard within the dying museum. They felt it was wrong to sell part of the collection to buy time for the museum, and, united under the leadership of a determined director, they prevailed.

At the same meeting, Agee proposed that the museum get out from under the building it found itself in by whatever means could be found. The board could sell it, rent it, give it to the city, or simply walk away from it, taking what assets they had to continue the museum in a rented building somewhere else. Nearly everyone present thought this proposal impractical or impossible.

Without knowledge of the director or the other trustees, a secret steering committee had been formed by four powerful trustees and officers of the museum: Alfred Esberg, the president, Robert Rowan, the chairman, Gifford Philips, a member of the executive committee, and in reserve, Coleman Morton, the treasurer. The first three were the active committee, but Morton was kept fully informed so that in case any of the three were out of town he could then stand in. The purpose of the committee was to save the museum through a last desperate plea to Norton Simon.

Simon had first been approached for money in 1971, but he had turned the museum down. From 1972 on, there had been intermittent contact with Simon's representatives, and appeals had been made to them for help. Simon's people never responded favorably. The steering committee felt certain that, as things stood, the museum was sinking for the third time, and Simon was not only the sole owner of a life preserver, but the one munificent force that could assure the museum's future. To think of him was to contrive a fantasy of instant total rescue. He was after all an enormously rich philanthropist, a powerful public figure, a famous art collector interested in and involved with museums throughout the country, and a Southern Californian with funds already set aside within various foundations which could easily be directed toward Pasadena. The committee felt secrecy was essential to their effort, for if it were to be known that they themselves had given up hope for Pasadena's independent survival, the museum would be flicked down, like an overbuilt house of cards. Even when Agee and the rest of the board learned of these negotiations, the information was still kept under the hat so as not to discourage fundraising efforts.

The committee kept after Simon persistently, but raised no response and got no offers beyond the loan of a few works of art. Robert McFarlane, the president of Simon's complex of foundations, would do nothing to either obligate either Simon or the foundations. Simon's people appeared to be interested, but in what, it was hard to say. By January of 1974, their attitude seemed to have softened. This indication was not confirmed by any specific offer. Simon's people simply became a bit more open and frank in discussing the situation, suggesting that under some special circumstances, Simon *might* be prepared to help in some undefined way.

The Pasadena finally got a little impatient, even angry at the amorphousness of the situation. Since nothing was being proffered, they began to feel that even to be irrevocably turned down would at least resolve the protracted and fruitless negotiations. The committee members kept trying, and McFarlane kept listening. They could never walk out of a meeting in the knowledge that Simon was uninterested in helping.

At length, Simon's people drafted a letter asking, as a precondition to their assistance, that the Pasadena Board of Trustees be dissolved and a new one formed. The new board would consist of ten people. Simon's people would appoint four, the Pasadenans would have three, and Simon would nominate three outsiders to be approved by the other seven. Even then Simon wouldn't promise to do anything. The full board, of course, rejected the proposal as ridiculous, and, in March of 1974, the board's planning committee directed the steering committee to assure that Simon's people would guarantee the museum enough space to operate with its full identity preserved. If that were impossible, the steering committee was to negotiate some kind of cash deal from him that would allow the museum to rent space elsewhere and begin again.

Simon's agents absolutely refused. They countered with a proposal that the museum be divided: 75 percent of the space would be used to exhibit Norton Simon's collection of historical art, while the board must be content with "25 percent of the exhibition space *for five years* for exhibiting modern and contemporary art from the permanent Pasadena Museum Collection, the Galka Scheyer collection and other modern and contemporary art loaned to the museum for exhibition" (my italics).

As word of the negotiations leaked out, the forces that had long hated Pasadena's contemporary program and wanted to be rid of it began to shape up and make their presence felt. The sentiments of former trustees, friends of trustees, and members of the museum's own support organizations might be paraphrased along these lines: "Things may look desperate from the viewpoint of contemporary art, but from the total community viewpoint, we'll be getting a fantastic collection. The Norton Simon collection is worth $200 million. The museum will be saved. There's no choice. It'll be a great plum for the community. Think of all the people who will come out of the San Gabriel Valley to see the museum! Maybe ten times as many as came to see the contemporary

art. The present museum is the wrong kind of museum in the wrong place. There is no audience for this modern stuff."

By the end of March 1974, at the last board meeting Agee attended, the full board agreed to proceed with the negotiations with Simon, although at the time it didn't look as if they would come to anything. By mid April, it looked as if the whole deal was off. The executive committee drew up plans for an austerity budget to be implemented on a crash basis. Then Simon's people called to say they were prepared to talk turkey.

Ironically, this was probably the only time that the Pasadenans ever really had an option to negotiate because something had gone awry with Norton Simon's plans. A land deal he had been negotiating to build a museum in Century City had fallen through, and Simon's people were moving fast. On 20 April, they dispatched a letter of intent to the Pasadena Museum. The board members were alerted and 29 of them arrived at the museum on 26 April for what was to be the last board meeting of the Pasadena Museum of Modern Art. There was no argument, however. The written agenda given to each trustee set forth the acceptance procedure, which included an amendment of the articles of incorporation changing the name back to the Pasadena Art Museum, a reduction in the number of trustees from 35 to ten, four of whom would be Simon's nominees, and a request for the resignation of all the trustees except Esberg, Philips, and Rowan. The meeting went like clockwork, those few questions raised met with reassuring answers, and the vote to accept terms was passed unanimously. The museum was Simon's. Rowan, Philip, and Esberg could breathe a sigh of relief; they had rid the museum of its independent status very skillfully. That same day the five senior staff members were fired by the new Simon-appointed director, George Peters, like Robert McFarlane Jr a clergyman without an iota of museum experience or training.

On 13 May, an announcement went out to the museum's members, stating that the trustees had voted to accept an "agreement" offered by Norton Simon's foundation to "dramatically expand the scope of our Museum by combining our collection with the world renowned art from the Simon collections. By this action, we have created a Museum which will achieve world-wide acclaim."

194

When Agee heard in Houston that the deal had gone down, he was astonished. He had thought that maybe the trustees would come to the conclusion that the only way to keep the museum going was to walk away from the new building with what money they had, rent new quarters and start again. After all, Pasadena's 50th Anniversary Ball had raised some $80,000, there was money due in from the National Endowment, and the members contributed nearly $100,000 a year. Moreover, Agee felt that the letter was so vague about the 25 percent that would be allocated to show the museum's collection that it was virtually meaningless. Twenty-five percent of what is called galleries in the plans, for example, might only be the entrance hall and the downstairs gallery.

Rowan would make no public comment about the takeover. In private he blamed Harold Jurgensen as the villain; it had been he who rammed the new building past a reluctant board, he who had sold them a deal based on false optimism, since much of the money that was pledged was never paid. It is well known that pledges are never the same as money in the bank, and it was Rowan who, as president of the board, allowed the building to be constructed without anywhere near enough cash in the bank. Yet Rowan constantly reiterated that he had been against the new building and that he only voted for it because everybody else did.

The blame clearly lies with the board itself, and specifically on those members who abetted the uncontrolled expansion. But the museum's directors were not entirely guiltless. Although none had ever run a museum before, they were only too anxious to take the helm, which was in itself a form of recklessness. With the exception of Terbell (who was a banker although he knew little of running a museum), the directors were wholly unschooled in business practices, and therefore unable to assess how the museum was to survive financially. Worst of all, none were able to develop a *modus operandi* with the board, and hence none could really provide any dynamic leadership. Leavitt, Demetrion, and Agee, when they discovered the truth about the situation, ran from it, without grappling with the basic structural challenges.

It is difficult to disagree with trustees. Unlike their European counterparts, the tenure of most American museum directors is tenuous.

Most museums in Europe are run by the city or state. Directors and staff have civil service tenure, and can be fired only after proof of misconduct is given before a civil service commission or a similar tribunal. The relationship of the trustees to the staff is strictly defined, and the roles of each are well-knit and meshed. But in the American system of private (and sometimes city) museums, the trustees arc all-powerful. Newer modern art museums very often lack an adequate endowment, and depend on trustee support for financing. To offend deeply a powerful trustee (many of whom belong to the clubby International Council of the Museum of Modern Art) may mean that the word is passed along, and the former director suddenly finds the doors of the private contemporary museums closed to him.

When Leavitt left Pasadena to become director of the Santa Barbara Museum of Art, he knew that they were linked to Pasadena's board in various ways. The chairwoman of Santa Barbara's board, for example, is an in-law of Robert Rowan, and Rowan maintained a residence in that city. Leavitt probably thought that his only recourse was to keep his mouth shut about the problems at Pasadena or give up working in the California museum field. But, in light of what subsequently happened, Leavitt's decision not to speak out was a bad one. It forestalled public embarrassment of the board, one thing that they always feared greatly. At the least, Leavitt should have strengthened the hand of a future director and helped him to initiate reforms.

The American Association of Museum Directors has yet to take strong action to protect its member professionals. In cases of the questionable dismissal of a director, the AAMD has rarely investigated and never taken action despite public censure. The AAMD's standards for the appointment of museum directors are often not followed and, as a result (as recently happened at the Brooklyn Museum), a director who lacks professional qualifications can wreak havoc with the staff. Although AAMD was founded in 1903, not until 1971 did they bring out a report on the standards they considered necessary to the maintenance of a museum. The report, however, serves only as a guideline for trustees. They are standards without teeth, since no legal or even coercive power exists to enforce them.

Although he was a brilliant organizer and an extraordinarily intel-

ligent man, Hopps had little museum experience. Leavitt left him in a poor situation. The organizational structure of the museum, in which the business manager received a larger salary than the director and was directly responsible to the board and not the director, confused and alienated Hopps. The more his advice was disregarded by the board, the more he withdrew from active participation in the affairs of the museum other than organizing his exhibitions. During the last year of his directorship, in order to protect his program, Hopps avoided turning up at board meetings, and worked mainly at home. This unhappy situation was terminated by his enforced resignation.

Demetrion's demand that his salary as director be one dollar more a year than his business manager's was merely palliative. It changed nothing and gave the director no control over the museum's finances. And, though with Demetrion's appointment the lines of communication between the director and the board were re-established, it was too late to stem Rowan's overblown command. Demetrion had neither the experience, the sophistication, nor the social graces to deal with Rowan. The whole situation baffled him, and he could only find another job and walk away from the mess, taking with him a major part of the experienced staff. Like Leavitt he left without a word on paper for the board for the benefit of his successor. This happened, of course, just prior to the opening of the new museum.

Agee had been a curator at the Whitney and the MOMA, and although he had never directed an institution, he was an experienced museum professional. But he inherited a financially shattered institution and, particularly after the departure of Terbell, he had his hands full merely keeping the museum alive. And in the end, Agee, like Leavitt and Demetrion before him, bailed out and took another job. He knew perfectly well that the museum hadn't the resources to hire a new professional director, and that few would consider taking the job given the situation. Agee's departure was tantamount to a signal to abandon ship. He knew before he left that the three senior trustees were negotiating with Simon, although nothing conclusive had yet been arranged. Without his skill and energy, the new and younger trustees were leaderless. There was a point before any agreement had been reached with Simon when, had Agee been there to lead them, a faction on the board

would have been willing to walk away from the hideous building and begin again in rented quarters. There was money. Not much, true, but the 50th Anniversary Ball had raised $80,000, and there was a membership and its dues. There was the National Endowment, and there were willing hands. But in the end, three tired old men were allowed to hand the museum over to a strong man. To the public at large they were saving a great public institution. But in fact, they were saving face, hiding their own failures and attempting to save their reputation as cultural leaders.

But what of Norton Simon?

Simon personally, and his various foundations, owns an extraordinary body of the very finest works of art of various periods and cultures. He is genuinely concerned that the foundations' art be seen and appreciated by as wide an audience as possible, and to achieve that goal he had been showing his great collection in museums in various parts of the country on a rotating basis.

But the particular question I shall address is his "takeover" of the Pasadena Art Museum, his governance of it, his accountability for its policies, and the management that he will bring to bear. All of Simon's procedures to date are antithetical to what is generally regarded within the museum profession as a whole, and by the informed public, as a responsible attitude toward the development of a public institution. Of course there are certain time-tested general policies that all art museums, both in this country and in Europe, subscribe to. Museums are responsible for preserving their collection; showing it to the public; elucidating it by scholarship, publications, and additional exhibitions; and finally, they should try to add to the collection so that it builds an even clearer picture of the culture it represents. It is the responsibility of the trustees, once having agreed upon these policies, to insure their maintenance.

But in fulfilling these basic obligations, each museum in time builds policy and accumulates resources specific to its role and function at a local or regional level, which eventually come to define it within the general context of the community of museums integral to Western civilization. This is a subtler yet crucial point, since despite its mis-

directed and often self-serving management and its tragic history, the Pasadena Museum of Modern Art remained absolutely committed to the notion of culture as a living identity, as a palpable phenomenon. The museum, in fact, was founded expressly to realize this purpose. The driving force behind its foundation in 1924 was the thought and effort of two internationally renowned scientists from the California Institute of Technology, George E. Hale (1868–1938), an astronomer after whom the Hale Observatory is named, and Robert A. Millikan (1868–1953), a Nobel Prize-winning physicist. Millikan and Hale realized that whatever the nature of science, its remarkable power to probe and bring under control knowledge of the material and physical world, without the complementary presence of living art, and a museum (or art institute as it was first called) to give it public presence and being, they and their community would be deprived of something essential to their lives. Within a short distance from Cal Tech itself, and not far from the major historical collection of the Huntington Museum and Library, they laid the foundations of what was to emerge years later as a significant cultural institution.

When Pasadena's three senior trustees came to Simon for help, he knew that they were near the end of their tether. He, together with his foundations, had the means to save the museum – assume and reorganize the management, guarantee that the museum's program would at least be partly salvaged. He could divide the space more equitably, build a contemporary exhibitions pavilion within the grounds, or give the museum money to start from rented quarters elsewhere. The economic pismire could be handled by him as if it were a minor indulgence.

But why should he? Simon had no particular sympathy for contemporary art. He obviously has a deep understanding of the contemporary industrial process, and the manner in which an advanced technological society creates wealth. But this has not encouraged him to develop a corollary response to contemporary art. Those who have clearly observed Simon have noted that abstract art is alien to him, closed off as from a different world.

In his relationships with different museums he has always sought personal control. His final and only offer was in character – a blatant takeover, to be negotiated in a matter of days, to which the trustees in

their desperation were forced to accede. The takeover documents were deliberately larded with vast uncertainties, leaving Simon free to walk away at any moment without legal hindrance. And all this was worded with a bravura arrogance. A major art museum, then, a public institution of standing, built on city land, funded directly and indirectly by federal and state funds, private citizens and foundations, has been handed over to the arbitrary control of one man, to be completely subverted from the field of contemporary art, which has been the hallmark of the institution since its outset.

At first Simon's actions might look like a throwback to the nineteenth century when any monied person could set up an art museum on his or her personal terms and make it go. But in the past, by and large, when private individuals of great wealth established public institutions, be they museums, universities, or foundations, they at least formulated responsible means of governance and funds to assume stability and effectiveness of purpose. Simon's takeover document does none of this. He reserves all powers to himself, yet commits himself in no way whatsoever. We are not dealing with Carnegie, Ford, Frick, Mellon, or Rockefeller, in the eastern United States, or a Mary Hopkins (California School of Fine Arts), or Layland Stanford (Stanford University) in northern California. No matter how tough and vicious these men may have been in conducting their business affairs, their concept of public responsibility and the manner in which they approached the institutions they founded and funded derived from an ethic of public charity entirely different from that of Norton Simon.

Simon operates within the tradition of the southern California eccentric, of extraordinary cranks such as William Randolph Hearst became in time, of the lone wolf, crazily furtive and secretive, such as Howard Hughes. The art world for Simon is a theater existing mainly to dramatize his own will and ego: this unhindered mobility becomes the vehicle for this wilfulness, disguised as philanthropy. Simon, I think, has some obsessive dream of himself as a superman, surely gained from triumph as a corporate raider during the conglomerate era of American business in the early sixties, a role he is now playing out in the art world.

Simon's first great business success hinged on a variation of the

Trojan horse strategy. In 1929, at the age of 25, he purchased a tomato-canning plant that was on the verge of bankruptcy for $7,000. Over the next decade under Simon's management, the company became highly successful, with an annual turnover of $9 million. At the same time, Simon quietly began to build up a pile of shares in a much larger rival concern, Hunts Brothers Packing Co., until he owned a very substantial block. Simon sold his company to Hunts for $3 million, and then used his shares to seize control of Hunts. In one stroke he regained his own company and his rival as well, and pocketed an enormous personal profit in cash. From this point on, Simon's appetite became voracious, as he schemed, planned, and built a gigantic industrial empire – Norton Simon Inc. – in takeover after takeover.

Simon has described himself as an "existential businessman." The future has no substance for him personally, and he therefore tries to deny its substance in his planning. It is the fluidity of a situation, the fugitive, improvised approach that gives him his freedom to act, and incites him rather than the sense of a fixed substantial accomplishment. Simon has the lust for battle of a professional general. He is an Alex-ander constantly seeking Darius, and he must win at all cost. It is no wonder, then, that he appointed Frank McCarthy, a retired army general and producer of the film *Patton*, as one of the ten trustees of the Pasa-dena Art Museum. Everything Simon encounters must bend before his will. He tried hard to take over the Los Angeles County Art Museum in the mid sixties, packing the board with his own nominees, but the rest of the trustees fought him off. Since his takeover of Pasadena, several on the county staff have expressed their relief at his disengagement from LACMA affairs, despite the loss to the collection that the withdrawal of his loans will mean.

Simon has remarked, "I'll do what I do in my lifetime, and not another damn thing matters. When I'm gone it's all gone. I have the courage to be honest and face this. The rest of you live with a lot of illu-sions, sentimental attachments." And as much as he believes that no accomplishment will outlast his corporeal being, so does he believe in the disposability of all that he may own. As he has remarked to myself and others, "I don't like to get attached to anything. My power is my ability to get or get rid of anything, of any work of art – no emotional

attachments, I can sell anything. I could sell any painting tomorrow if the whim struck me. I can do what I want, take or dispel."

In his presentation to the Pasadena board on the day it voted to hand the museum over to Simon, McFarlane said:

> He [Simon] is *constantly sorting and evaluating, selling, and buying art. Currently we are net buyers* and that is generally our position. One of the reasons that this is possible has to do first with the Norton Simon family that very generously established the Norton Foundation and endowed it and then the continuing gifts from that family, particularly Norton Simon himself, and there have been other donors that are outside the family that Simon Inc., consumer product company located with headquarters in New York. They support the foundation substantially each year and we are hopeful that the future will continue as the past has. So we have a situation that seems to be *growing, expanding and changing and thus the collection's undergoing metamorphosis constantly.*
> (Attachment No. 2 to the minutes of the Board of Trustees meeting, Pasadena Museum of Modern Art, 26 April 1974, my italics.)

McFarlane's reference to Simon being a "net buyer" means in essence that he and his associates are dealing. Out of the massive amount under option to him, and art that his various foundations own, Simon is playing the market. In private conversation, Simon has referred to the works of art in his home as being in a "state of suspense," meaning that they are under option, being bought, or are for sale. Agee reports that approximately 20 percent of the sculpture that Simon's foundations lent to Pasadena for various exhibitions was withdrawn at different times, often with as little as two days' notice, packed by local shippers and then replaced. Some of these works turned up immediately thereafter at the Parke-Burnet auction house in New York. Identical reports have come from the Princeton University Art Gallery, where a large body of Simon's work has been on loan. Faculty members would arrange to lecture students on specific works, only to find, on arriving at the gallery with the class, that the works were gone. Many of these too have turned up in New York at auction.

The 1973 tax returns of the Norton Simon Foundation indicate that it sold $3,347,784 of art that cost $1,905,054. Similarly, Norton Simon Inc. Museum of Art sold $1,608,450 of art that cost $1,033,856. In all, then, the two foundations sold $5 millions' worth of art at a profit of $2 million.

And this trade continues. In any museum, practices such as these would be condemned outright, and their legality questioned. A foundation is a quasi-public legal entity with a purpose which is strictly defined in its articles of incorporation. The funds to set it up have been deducted from both state and federal taxes, and it continues to operate exempt from taxation. There is, then, a presumption that these operations shall be responsible, and in accordance with the established practices and procedures of public institutions. The articles of incorporation of the Norton Simon Inc. Museum of Art state that its purpose is:

> Principally the purchase of works of art and their loans to major public museums for exhibition to the public. Developing public knowledge of and interest in art. Construction and operation of a museum.

Both the tenor and the intention of this declaration are clear. And clearly the massive and continuous deaccessioning of major works of art, many of which have subsequently been purchased by other museums, falls outside the boundaries of established professional practice. It would appear that Simon is treating the works of art in the two foundations under his control not as esthetic objects, but as securities, the equivalents of stocks and bonds, to be manipulated to produce profits in much the same manner as an art investment trust. Such a conjunction of the activities and outlook of the business world with the disposition of cultural objects, robs the work of art of its true function and makes it into an object of currency. It is the patronage of illiteracy.

Weegee the Famous*

... is not every spot of our cities the scene of a crime? Every
passerby a perpetrator? Does not the photographer – descendant
of augurers and haruspices – uncover guilt in his pictures?
It has been said that 'not he who is ignorant of writing but
ignorant of photography will be the illiterate of the future.'
But isn't a photographer who can't read his own pictures worth
less than an illiterate? Will not captions become components
of pictures?

— Walter Benjamin[1]

Weegee was a forceful photographer with a unique style and person-
ality, but among those photographers currently judged as serious
artists, this maverick almost defies acceptance. The images Weegee
brought back from another world deeply trouble us. A gritty, raucous,
and self-advertising voyeur (who called himself "the famous"), he
prowled the nights as a press photographer, making the lives of "the
tenants of the city"[2] his subject matter. Much of his seedy, squalid
imagery explores human degradation. He reserved his sharpest
sarcasms for the rich, whom he portrays as vacuous and greedy, and his
exposure of the concrete horrors of the poverty, filth and violence
of big city life, especially in New York in the late thirties and forties,
insists that life just about batters people senseless.

Weegee was born Arthur Fellig in the Austro-Hungarian Empire
in 1899. In his early days he used a police radio to get to events ahead
of his competition. He adopted the name Weegee, a phonetic rendering
of "Ouija," the board device which is assumed to predict events, as a
way to promote his uncanny ability to be where the action was about
to happen.

No other art form rivals photography's capability to be meaning-
less, to topple into a void. As a hedge against vacuity, ambitious
photographers cloak themselves in a knowledge of art. But Weegee
was an innocent, a primitive who described strong emotions and guile

* First published in *Art in America*, September–October 1977.

lessly jabbed at ours. In his autobiography, *Weegee by Weegee*, he discusses his early days as a fiddle player in a silent movie theater:

> I loved playing on the emotions of the audience as they watched the silent movies. I could move them either to happiness or sorrow. I had all the standard selections for any kind of a situation. I suppose my fiddle playing was a subconscious kind of training for my future in photography.

His photographs are always immediate, action caught on the sly or just after it happened. He was a street photographer out for a scoop. His concern was for the life of the city, people at work, at play, asleep – and in death, particularly as the aftermath of criminal activity. These are the categories in which he blocks out his imagery and to which he continuously returned, territory that had deep psychological fascination not only for his audience, but obviously for him. But he was not only out to get memorable chance images; they had to have a consistently archetypal character. All Weegee's passion was centered on getting close to his material, to snatch the explosive moment out of the air. Nothing else counted. There is a frantic edge to Weegee's imagery. He worked at a point-blank range and at a desperate pitch, the better to catch people in the raw.

The only other photographer of note that Weegee apparently had some awareness of was Lewis Hine, whose work is grounded in reformist social judgments, an attitude antithetical to Weegee's apolitical stance. I would imagine, too, that he would have sensed that Hine, above all, was a visual idealist. There was nothing Weegee could have used in the beautiful faces of immigrant kids, or toiling workers bathed in Hine's sweet rapture. People don't work as so much scavenge, grimace, or screw-up, in Weegee's tacky, rundown circus.

His own tawdriness led him to where few other photographers were willing to go, and gives a terrific edge of remorseless tension to some of his images. Take one from hundreds: the photograph of the psychopathic cop killer who has been arrested, savagely beaten up by his captors, and caught by Weegee's camera at the moment of being booked, finger-printed and photographed. The bedraggled, abject and beaten criminal, eyes puffed and almost closed, hunches head downcast. Two plain-

clothes detectives stand with their burly backs to the camera, dwarfing the killer. A huge, out-of-focus hand of the police cameraman cranking his camera fills the left top corner. It's a portrait of a brute cuffed by other brutes on our side of the law.

Weegee's use of flash in this photograph creates a luminous ovoid shape from the dark visual field, a clear center whose edges fade. This effect gives a startling nearness to the image. We momentarily feel that we ourselves are there observing the scene.

Weegee successfully evades isolating people's movements. His photographs, including those taken in daylight, give a continuous sense of implied movement. This potential for movement, perhaps the expression of a face about to change, the rhythmic movement of feet, or the syncopation of various glances, is one of his graphic strengths. It keeps his photographs continuously alive. It's usually hard to guess the next motion of a person in a still photograph, but the behavior in Weegee's seems instinctively charged with animate and continuous reflex; or is it, perhaps, that he startles it into being? In *Cop Killer* the blurred hand of the camera operator seems to be in motion, the detective who took the fingerprints is turning his head, the detective in the foreground has his hands on the criminal's jacket, and is about to push him forward. Finally, the culprit himself, who is holding the palm of his hand upwards after the fingerprinting, is about to straighten and drop his arm. Such incipient movement endows Weegee's photograph with unforgettable vibrancy and urgency.

Weegee had an esthetic predilection for artificial light. He liked the way in which an object is highlighted and flattened by the freeze action of flash, and slowly dissolves into a saturated black background. He called this "Rembrandt light." This effect is only partly due to his equipment. He used a 4-by-5-inch Speed Graphic with a synchronized flash attached to the chassis, or capable of being hand-held nearby, with exposure preset to 1/200 of a second, stopped down to f 16, focused to a distance of ten feet. The fast shutter speed and synchronized flash were ideal for Weegee's style of candid photography, which demands split-second judgment combined with equally fast reflex action.

His images are snapped rather than compositionally planned. The flash automatically vignetted his subjects, well within the frame. This

means he worked without a preconceived notion of composition or its decorum. He focused in on an event, and if an image failed to compose itself, he used the enlarger to crop and bring the image closer by eliminating superfluous detail, especially in the background, which he often burnt to a deep flat black. Thus, Weegee's images are unleavened by tonal gradations. They have the expressive qualities, rawness and punchy visual impact of a woodcut, in comparison, say, to an etching.

Weegee's sense of graphic design is modulated by the fact that his photography was primarily made for reproduction. His images had to survive the printing processes used by tabloid newspapers, in which the coarse black screen dot turns gray when the ink is sucked into cheap newsprint. Moreover, it was tough for an independent to sell photographs during the Depression, especially to newspapers which employed their own staff photographers. Picture editors are primarily journalists who will not buy a print unless it looks catchily newsworthy. Weegee spent long hours with police reporters at police stations waiting for stories to break. The Black Maria was his studio. He knew as well as the editors the "what, why, when, how, where and who" of journalism, and that a photograph must tell it quick, especially if it is to be peddled to the tabloids, whose story headings are simplified and sensational. Weegee's photographs make no concessions to what photographers call print quality, or the idea of a photograph as a beautiful object (though later in life Weegee evidently reprinted some of his best photographs to make them look more arty).

Most photographers differentiate themselves from one another on a style basis, in terms of specific, predetermined and recognizable ways of composing their images. This can hardly be said of Weegee, whose style is dominated by a raunchy casualness that is uniquely his. By virtue of culture (Austrian Jewish), education, (the streets) and temperament (neurotically insecure), Weegee developed an expressionist's edge.

The use of infra-red photography in reconnaissance flights to expose a concealed enemy is well known. Similarly, Weegee used infrared film in his photographs of high-society cafe life to strip away the artifice of his subjects' elegance or pretensions. With infrared, a woman's make-up is separated from her face, it floats on the surface like a mask, and concealed pimples or facial defects are uncovered. Veins

normally hidden rise to the surface of the skin, and suavely dressed and neatly groomed men look tigerish as the film reveals capped or artificial teeth in their grinning mouths. The infrared also penetrates the skin of their freshly shaven faces and brings out hidden stubble.

It is not unusual for candid photographers to want to conceal their presence. Ben Shahn, for instance, used a right-angled viewfinder to disarm his subjects. But he shot people in public places, going about their ordinary lives in daylight. Weegee's voyeurism is more furtive and unfair. Infrared film could be shot in near-total dark, which concealed his presence. He penetrated the protective gloom to expose people's intimate secrets: shamelessly entwined lovers in a movie theater, who feel doubly safe from observation as the rest of the audience watches a 3D movie wearing colored glasses that blank out all except the image on screen. Or children picking their noses, or sucking their fingers, entranced by a movie. Weegee also prowled Coney Island beaches on warm summer nights to secretly photograph couples making love. One of his most extraordinary photographs is of a lone young woman sitting on top of the lifeguard's watchtower, apparently gazing out to sea. As Weegee's book *Naked City* makes clear (where her image is juxtaposed with two others taken at the same time and place), there are lovers on the beach below her perch. So she, like Weegee, is a voyeur, who sits in the night listening to the muffled cries below her. What is the dictionary definition of voyeurism? The obtaining of sexual gratification from secretly looking at sexual acts. This image brilliantly mirrors his malignancy.

Weegee also exposes the terrible disorder and chaos of life for the poor. Sometimes his camera catches transients scurrying around the deserted city at night, hugging the shadows, bedding-roll in hand, searching for a safe haven for to sleep in. Or sleeping anywhere they can, on a bench or in shop door. Or grimy children of all ages and both sexes pitifully huddled together in a disorderly mass, sleeping like young animals on a tenement fire escape to avoid the summer heat of their squalid rooms. In a photograph shot vertically from above, a flabby and nearly naked man sleeps on a mattress on the fire escape below. He is transformed by Weegee's merciless lens into the image of an ageing, helpless child.

Because Weegee was dependent on selling his photographs for a livelihood, he was as close to a photojournalist as any photographer ever got to be. Weegee had the instincts to nose out a story for himself, which he would juice up by extravagant, callously written witticisms *à la* Raymond Chandler, such as "Covering Murders Gets Messy" (a photo of himself having his shoes shined), or "Special Delivery" (a corpse under a letter box). Although Weegee began as an evidentiary photographer, his captions often imposed upon the documents he stored up the accents of a certain kind of pulp fiction. This lent to his several books, supported by his own narrative texts (*Naked City*, 1945; *Weegee's People*, 1946; *Weegee by Weegee*, 1961), the character of hard-boiled fables.

Sometimes his presence at the scene of a photograph became an active element in introducing a grotesquely humorous touch, as in the picture of a drowned man at Coney Island beach, in which we see serried ranks of hypnotized spectators watching an ambulance team, headed by a doctor, attempting to resuscitate the swimmer. Kneeling at the side of the supine figure is a pretty companion, his wife or girlfriend, clad in a swimsuit. It is a moment of high drama. Is the man dead or alive? Yet, at the very moment Weegee takes his photograph of the scene, the woman's head turns and flashes a coquettish smile at the camera. Let us admit that this could well be an accident – but not the inspired bad taste, or rather the human knowledge, that wanted it published.

In the fifties, Weegee shifted his attention to tricky distortions and manipulated photographic cartoons, among the finest of which is a series on Khrushchev, whose pudgy round head is variously transformed into a droll, long-nosed Frenchman, a Disney-like Roman emperor, an aristocratically smiling New Englander, a Russian peasant with a jaw-breakingly crooked smile and, finally, an egghead. Weegee obviously identified with the peasant in Khrushchev and admired his cantankerous and unpredictable public behavior.

Weegee was a hustler incarnate, who lived off his wits, and by his abilities to solicit and wheedle. At the same time, he knew that he was incorrigibly unpresentable in either high or art society. But he nevertheless had some contact with society. And it dawned upon him that he, Weegee, could become an object of exotic curiosity to this upper-class

stratum of people, that his slobhood could be engaging in much the same way that he made his subject matter the object of their curiosity. It is a strange idea, but not at all inconsistent with his character. After all, the flash-bulb is literally a booster of light, and here he used it to catapult his subjects into fame, even if it was a very ephemeral type of media celebrity. Unlike so many of the punks he photographed, he would become a perpetrator *with* a name. He, too, could be transformed into a fit subject for the kind of brazen exposure he visited upon others. Weegee the Famous promoted himself as a colorful braggart and made himself into the pet of the cultured set (he was included in a show at the Museum of Modern Art, and was given assignments at *Vogue*, etc.). A trespasser in society, he clamored his way upward with real savvy into Hollywood as *the* news photographer – the greatest. But his fame was only in the news sense, and not for his cultural accomplishment, which had to wait a decade after his death in 1968 to be recognized.

There is a demonic edge to Weegee's quirky endeavor that bears discussion. Many of his photographs are morally dubious, not just because of their evident prurience, or his anti-social attitudes or even his outrageous hucksterism – it's that he sold for money images that exposed and exploited the involuntary, naked emotions of people he photographed without their permission, often by deliberately spying. One does sense animus in Weegee. Sleep, self-absorption, and unaware-ness were continuing obsessions, and people shocked, in terror, convulsed in pain, or blown out of their minds were his special targets. In the moment he comes across them, after seeking them out instinc-tively, it's as if he knows that in capturing their images, he has a supreme power over them. They cannot prevent his act. His distressed subjects were literally the most completely vulnerable people imagin-able at that moment – in extremis, torn by grief, or totally helpless. This is what makes Weegee's work pitiless. It blazes away with its own kind of totally unsolicited awareness, thereby bringing off what photogra-phers claim for the medium, but which it so rarely accomplishes – the rhetoric that unmasks.

Weegee belongs to a very American photographic vein, *to tell it like it is*. But the extremes to which he was willing to take this rhetoric make the viewer's complicity in it apparent. To view a typical Weegee

is to have the stakes in the photographic contract very much upped, both emotionally and morally. Diane Arbus and even Les Krims, who surely owe him a great deal, allow us to recognize that self-indicting shiver which Weegee was the first to explore. Once we give public permission to the photographer to invade people's lives, how can we object to his zeal in the matter, especially when it is slapped into form without any hypocrisy whatsoever?

The element of journalism in Weegee, as I said, mixes with his expressionist intent. There are a number of journalistic photographers who are equally involved in the critical moment, simplifying the image to make it more telling. It could be that with Weegee, we are not really dealing with a photojournalist at all, but one who instead used photo-journalism as a cover, unconsciously or not. There is a large and recognizable sector of his work in which Weegee is not a detached reportorial professional. Weegee was aware of his whole enterprise as being surreptitious and contraband. This gave him a thrill. Thus, there is a contradiction in his apparent nerveless willingness to look upon appalling scenes and drink them in passively, without any apparent tremor. In one sense his images were no less or more than ghoulish still-lifes to him, but on the other hand, it was his very insistence on focusing on these lurid moments for his own personal satisfaction which give them their exceptional resonance. Finally, our awareness of Weegee's excitement promotes these images of ostensibly banal horror which is capable of moving us. Weegee does not apologize. This private eye had a vital insensitivity that is precious. This is his fascination.

Notes

1. Walter Benjamin, "Kleine Geschichte der Photographie" *Literärische Welt*, 18, 25 September and 2 October 1931, translated by Phil Patton and republished as "Walter Benjamin's Short History of Photography" in *Artforum*, February 1977, pp.46–52.
2. *Ibid*.

C. E. Watkins at Yosemite*

From the beginning of the 1960s, and for slightly more than a decade, I lived in California. My curiosity about the roots of California art was avid. I got to know firsthand the widest range of artists, photographers, art historians, and museum people, yet never once did the name of Carleton Watkins ever crop up. Nor do I recall seeing a single photograph of his exhibited at any of the numerous museums dotting the state.

I therefore reacted with astonishment when I viewed Watkins' photographs in the Metropolitan Museum's 1975 exhibition, "Era of Exploration: The Rise of Landscape Photography in the American West. 1860–1885" (organized by Weston Naef and James Wood), and read the excellent documentary catalog. To my eye, whatever the merits of the other photographers included in the exhibition (especially T. H. O'Sullivan), Watkins' photographs stood apart; they were different, not at all from the same mold. Inexplicably, they seemed in some strange way to be linked to the potency of spirit and ideas haunting the work of Clyfford Still, an artist whose work flowered almost eighty years later. True, Watkins' photographs are grounded in the seen world, and a show of basic fidelity to the factual experience of a specific landscape; nevertheless, they throb with a powerful mythic quality, a sense of mystical revelation that somehow manages to impart an allegory of American space very similar to the large abstract paintings of Clyfford Still, who also came out of the West.

But Still is a sophisticated artist who fairly early in his career was in touch with the best artistic minds of his generation in America. Also, he had an extraordinarily finely honed grasp of the roots of modern European art; consequently, his painting is dialectical in thrust as well as revelatory in character.

I knew that in 1854, when Watkins came to San Francisco as a young man and worked there as a clerk in a stationery store, the city was small, with barely 10,000 inhabitants, and though the population doubled in size over the next decade or so, it could hardly be thought of as a sophisticated urban environment in comparison, say, to Boston or

* First published in *Art in America*, November/December 1978.

Philadelphia, let alone to London, Paris, or New York, all of which could boast rich intellectual accomplishments and a wide access to knowledge in many forms. Despite this lack, it was obvious to me that Watkins was no frontier photographer. By the early 1860s his work could be ranked with the finest anywhere, and in many respects was superior both technically and artistically to most. How, I kept asking myself, did his strange genius flame out of nowhere? Not previously being aware of Watkins' existence had led me to assume that Muybridge had gained his model from England and New York, where he had traveled and learned photography. I had not realized until the Met exhibition that Watkins had laid the ground for him. (Nor do many Europeans to this very day.) Muybridge was a very impatient and restless man, he was always forcing the pace, always trying many different things, that's where his intensity came from. The more I looked at Watkins' work the more tremendously hermetic it seemed. Paradoxically, it may well be that this very inwardness has led to the eclipse of his art from the high regard in which it was once held in Europe and America, for as I criss-crossed America over the ensuing two years seeking out Watkins' photographs in libraries, museum basements, universities and historical societies, they seemed to be surrounded by an aura of benign neglect. No one quite knew what to make of them: the custodian would often remark, "Yes, Watkins is interesting, isn't he, but Muybridge is *really* important, you know."

Even the closest examination of the early records does not illuminate the mystery of Watkins' beginnings.[1] Nor do we know how he raised the capital to finance the building of his giant wet-plate camera, or to purchase the costly Globe lens and all the necessary darkroom equipment. If such information ever existed, it appears to have gone up in flames with his studio in the 1906 San Francisco fire. A major problem is our uncertainty of the specific stream of cultural ideas informing his early years. True, in the middle of the nineteenth century the subject matter of painters and photographers often coincided, but they did not necessarily share the same outlook. No academy existed to ground the photographer in the technique, esthetic principles and ambitions of the medium. Photography, at least in San Francisco, was essentially a

commercial medium. Thus we are insecure in our knowledge of what led Watkins to create with such great devotion and passion the series of extraordinary photographs that emanated from his camera over the ensuing years. We sense that his photographs contain a uniquely independent outlook, but we lack data upon which to erect an informed critical exegesis. We can only deduce our ideas from the photographs themselves and speculate on their making.

Watkins' 72 signed, albumen glass stereoscopic views of the Yosemite valley (from the collection – now housed in Yosemite Park Museum – of Professor Spencer F. Beard, 1823–87, the noted American naturalist) can be firmly dated 1861. Naef suggests European picturesque romanticism as the source of these stereos, citing and reproducing as exemplar an 1856 work by the English photographer Francis Frith. And since Frith stereos were marketed in San Francisco, his ground for this assertion may well be firm.

These stereos provide the first cohesive overview of Watkins' earliest images of Yosemite. They look like a bunch of random, inchoate images until seen in the stereo viewer, where their extremely effective three-dimensional qualities can be appreciated. The images are complex fragments, glimpsed bits of nature. Compositionally they are severely cropped. Only in rare instances is there an attempt to give an overview of the valley, of how parts relate to the whole. Mostly they are close-ups, or details of peaks or deep chasms. The stereos are numbered and entitled, but the sequence itself makes no sense; there is no implication of an orderly journey.

Yet in two respects the stereos seem to be crucial to Watkins' future development: 1) he had found a subject that obviously stirred his imagination and ambition, and 2) in these stereos there is an unusual equilibrium between what is nearby and what is far off. The veining on the polished surface of a cliff in the background and the leaves of a bush in the foreground are described with equal clarity. This parity of detail may be thought to be the result of some optical superiority of the stereo camera's eye over that of the human. Not so.

It is inherent to the valley itself, and forces itself upon the naked eye. The valley runs on an axis roughly from southeast to northwest, and is approximately seven miles long, averaging half a mile in width.

Toward the northern end it burgeons out to about a mile in width and then constricts at the end, at Mirror Lake, to a quarter mile or so. The Merced River coils irregularly through the middle, meandering from side to side, often closely passing the base of a cliff. Ten million years ago the river bed was situated 2,000 feet higher and directly connected to the tributary streams and valleys at either side. Beginning a million years ago, and up to the last 30,000 years, a giant glacier filled the valley and eroded the weakest rock with great vigor to form a deep U-shaped gorge; it ground down the river bed, shearing and polishing the granite formation on either side to form high vertical cliffs and peaks.

Astonished by the sight, the first white men in the valley reported a granite cliff "sliced like a loaf of bread." At the entrance of the valley, El Capitan's polished face rises vertically over 3,000 feet above the floor; at the other end, the sliced bulk of Half Dome looms 4,800 feet above the floor. In between these two landmarks are equally vertical elements that rise up either side. The tributary streams that fed the prehistoric valley were left hanging high on the sides by the glacier's deep erosion and became waterfalls. Yosemite Valley Falls, for example, tumbles 2,425 feet to the valley floor. The valley's enclosure and the vastness of the vertical elements make a stupendous impression pictorially; everything is compressed, and natural scale is distorted. Enormous trees, 200 feet high, are dwarfed by the towering backdrop, mountainous peaks loom over meadow and water. The clarity of light in the valley is superb. Constant mirror-images of the tall trees and high backdrop are reflected whenever the waters are still. There is an aura of extravaganza to all this, of elements of nature compressed into an arena of visual abundance, of visions foreshortened and magnified. It was the optical element that Watkins concentrated on, leaving the picturesque to look after itself. As a result, he compacted into his imagery an unusual detailing of nature, a quality that pervaded his work from the beginning, and which was to become a major element of his style.

Though stereos are small in size, they cannot be thought of as small photographs. Paradoxically, when viewed in a stereo holder, the stereo image seems larger than the largest photograph viewed with the naked eye because of the way in which it consumes the total field of vision. It provokes a sensation similar to that of looking through a pair of binocu-

lars, where peripheral vision is cut off, and sight is intensely magnified.

I think Watkins wanted to match the intensity of stereo sight in his ordinary photographs, and for this reason adopted the mammoth format. (The largest photograph that cold be made at the time, it involved a huge camera and an 17-by-21-inch glass plate negative.) For this, he needed an image that would fill as much of the viewer's field of vision as possible and would get as much detail as possible along with a maximum sensation of depth. We may presume that by adopting a format as large as the average easel painting of the time, Watkins thought it would be possible to elevate the photograph to the realm of art. The stereo and the mammoth were to complement each other, and Watkins used a stereo camera side by side with the mammoth throughout most of his career.

The making of his mammoth Yosemite photographs was a self-imposed task not contingent on outside pressures or events, commercial or otherwise. Watkins brought to this task the imagination, flexibility and reflectiveness characteristic of major art. It was purposeful activity in which new answers were sought rather than services rendered; he used photography as a form of learning process. There is no taint of commercialism in Watkins beyond the mundane circumstances of survival.

Watkins knew the large wet-plate photograph long before he began in Yosemite. He had made photographic copy enlargements of smaller works in other mediums, a lithograph and a painting. Moreover, there exists a mammoth (15-by-20-inch) wet-plate photograph of Mission Los Dolores, a cropped portion of which is included as folio 30 in the well-known G. R. Fardon album published in 1856.[2] The uncropped version looks suspiciously like a Watkins. Be this as it may, by the late 1850s Francis Frith had already published mammoth outdoor photographs, a fact surely known to Watkins.

One of the problems facing the nineteenth-century landscape photographer was that the wet collodion compound used to coat negatives for albumen prints was so sensitive to blue that if the landscape was correctly exposed then the sky became overexposed and printed out white. As a result, most landscapes from that period are weighted with

detail toward the bottom and visually bland, even blank, above.

Watkins overcame this problem in his valley floor photographs by melding organic shapes formed by the contours of mountains, or branches of trees, etc., into the white sky zone, turning it into a positive compositional element. This served to lock the background into position, to stabilize it and thereby to create a frontal rather than recessive space. In addition, the distance between the farthest point in the background and the nearest point in the foreground is rendered in well-defined and tangible steps. In the valley floor photographs, although Watkins masses an amazingly wide variety of lights and darks, piling detail upon detail, he manages to bring to order a great diversity of elements.

A number of the valley floor photographs are composed around reflections, which enabled Watkins to vary mood and to vivify and enhance the viewer's experience of the valley. Two photographs, numbered by Watkins 37 and 38, reveal the contrast between similar views, one without reflection and the other with. The first consists of a long horizontal shot down the valley that frames the massive bulk of El Capitan and positions the viewer on the unseen but opposite side of the Merced River bank, with a small part of the river below in the foreground. Obviously shot immediately afterward is a vertical photograph of the same scene. El Capitan appears again in the upper half and roughly the same size. Less of the valley and more of the river below can be seen. The river now contains a perfect mirror-image of El Capitan. On the left, where the sky is reflected in the water, floats a large tree with branches. The opposite river bank is in the center and acts to hinge the lower part to the upper, the reflection to the reflected, creating a unified shape of the two parts so that a continous transaction between the real and the reflected is sustained in the viewer's mind. The log implausibly floats in the reflected sky. But which of its branches are real, and which are a reflection? Fact and mirror-image commingle, and the photograph becomes ambiguous and dreamlike, inducing a state of reverie.

Because Watkins focuses on lateral vision and the perception of the far horizon in his high ground vistas, in these he is forced to compose differently from the valley floor photographs. In several photographs,

for example, *First View of the Yosemite Valley from the Mariposa Trail*, 1866, the viewer seems to hang in mid-air, as if there were no ground for the camera and tripod to have stood upon. The viewer is metaphorically levitated in an uneasy way. This gives a sensation of the great heights encountered in the valley. In these high ground pictures, the landscape is bulked, blocked, and compacted, then divided by arcs, diagonals, verticals, and horizontals that gently demarcate one form from another; finally, irradiated by contrasting lights and darks that fade plane by plane until the horizon is reached, it gently melds into white sky. Watkins' use of such transposition is very painterly. By this I mean that although a photographer cannot invent to the same degree as a painter, the detailing within a Watkins photograph – for example, the relationship of figure to ground, of dark to light, or the arc of a shadow to a notch of a tree – is so carefully ordered that it *appears* to be under the same kind of control that a painter can exert.

Not only was the wet-plate process deficient in its ability to render the sky, but in the mammoth size it was also unable to freeze movement. Neither shutters nor fast emulsions existed. The cap was taken off the lens and replaced after the appropriate interval of time, sometimes as long as half an hour. The artifices to render various effects within nature in paint, part of the artist's stock in trade, were denied to the photographer: no scudding clouds, threatening storms, flashes of lightning or racing waters. All these effects, so central to rendering the sublime in painting, were beyond the range of the nineteenth-century camera, as was the use of color.

With rare exception, Watkins' valley is seen devoid of man or traces thereof. Though there are very religious feelings apparent in Watkins' approach to nature, his pantheistic outlook is devoid of threat, danger or anxiety. Yosemite is revealed as Edenic. In contrast, Muybridge's use of vast recessive spaces in his Yosemite photographs focuses on the awesome aspects of nature – one can almost imagine a gargoyle sprouting from one of his rocks. With Watkins, the traditional theatrical effects of the sublime, so dependent on ephemeral surface phenomena of nature for mood, are exchanged for straightforward perceptions of the wilderness and its wealth of details that are articulate in themselves. In their utter stillness his photographs have an edge of intense receptivity

to nature that differentiates them from the melodramatically weighted compositions of Muybridge, who sometimes also added clouds with a second plate. Watkins' sublime is emotionally serene.

Because Watkins often photographed into the early morning light (particularly form the heights), the brightest elements of his imagery are most often those things remote from the camera's position. Paradoxically, this creates a reversal of expectations in ordinary experiential terms, in which the most knowable is closest to the picture surface and usually rendered in light, and the most baffling is distant and dark. Those elements nearest to Watkins' camera are invariably vegetable, often trees – things that reproduce, grow, flourish, and die, and which signify something related to life itself. These areas are rendered dark, mysterious, and flat. (In the wet-plate process, green registers as black; also, in Watkins, the light usually does not fall on these foreground elements.) Likewise, his black shadows are invariably of vegetable origin. The brightest elements in Watkins' views of the valley are invariably the geological structures – equally they are the most lucidly described. But the strength of Watkins' photographs is not in this reversal; nor in the heights, the vastness of the sweep of the valley, the mysteriousness of the giant sequoias, or even in the predictable responses to this melodramatic valley. Rather it is within the finely honed balance of his dramaturgy. Each natural part of the valley claims to define itself and its sense of sweep, thrust and energy, its feeling of upheaval. Watkins balances all these contradictory claims; he fits all the parts together so that nothing overwhelms. And by doing so he asserts his own artistry against man's generalized sense of awe of nature.

Each of Watkins' photographs was composed freshly and inventively to reveal a hitherto unknown aspect of Yosemite. However, each revealed a piece of the valley, and, because of the very limitations of photography in comparison to painting, no one photograph was capable of projecting the archetypal significance and scale of the place. It required many of them to unfold the valley dynamically as a total spatial and emotional experience and to project this experience in some comprehensive and comprehensible way to an audience.

In 1866, some five years after Watkins first began photographing Yosemite, he made a decision to reorganize the imagery to make the experience of the valley more inclusive and holistic. By themselves, the views of the valley floor failed to reconstruct the overall experience. By adding photographs from the high ground at the beginning and end of his series, and by numbering the pictures sequentially from one to over 100, he transformed them from a set of random views into a series which initiates an orderly journey through the place. The views now become photographic metaphors for a traveler's stopping places as determined by the urgency of Watkins' sensibility. At the same time Watkins names the high points and gives the heights and other data in captions. Thus he is responsive both to fact and his audience.

First he oriented the viewer by leading his eye from the opening of the valley in a distant sweep above and beyond to the cap of Half Dome on the northern rim and then past, to Cloud's Rest and the High Sierras. Each image thereafter leads progressively down and into the valley until the floor is reached, then through the valley floor to the end, at which point he once more climbed the high ground and photographed. From Sentinel Dome he made vistas toward the north and west, from Glacier Point he made a 180-degree pan of the valley to the west, north and east. The last photograph is a close-up of the Half Dome that reveals the dizzying drop to the valley floor some 5,000 feet below, the mountains visible beyond.[3]

In the nineteenth-century photographic milieu the word "series" is used very loosely. Usually, but not always, it denotes any cluster of work linked by a shared theme or subject matter, rendered in a similar technique, and the same size. In addition, for purposes of easy reference a series may be numbered. But the numbering system and any order within the series, such as the sequence the images were taken in or even a correct sequence for viewing, might or might not relate.

In Watkins' photographs, however, *series* takes on a special, innovative meaning.[4] Inherent to his use of seriality is the notion of a beginning and end; the coequality of the parts, which are self-sufficient as images yet part of a set; and their uniformity of size, format, and technique. However, what more than anything else differentiates Watkins' use of seriality is the notion of a macro-structure, which he was, it

seems, the first to employ. His macro-structure is defined by relational order and continuity. There is a consistent semi-narrative structure and syntax to the Yosemite photographs, encompassing both vista and panorama – distant and lateral vision – and endowing the pictures with their serial quality. Watkins, then, subsumes the notion of painterly masterpiece into photographic seriality.[5]

To what extent were the structure and ideas informing Watkins' Yosemite photographs influenced by outside sources? We know that C. L. Weed, another San Francisco photographer who had made stereos in Yosemite as early as 1859, reappeared in Yosemite in 1865 with a mammoth camera and most likely began photographing from the high ground before Watkins. But he had an insipid eye and proved to be no rival to Watkins, despite the fact that Watkins' *Valley from the "Best General View,"* 1866, derives from a Weed photograph taken from the identical location a year earlier. No, all that could be claimed for Weed is that he took that particular view first.

Then what could have led Watkins to the solutions he arrived at? Could he have been influenced by the fact that there existed in San Francisco since 1850 a local tradition of daguerrean panoramas?[6] Perhaps. Because of the steep hills overlooking the bay, San Francisco provided a natural platform for 360-degree panoramas of vistas that sweep over buildings down to the shipping waters and across to the foreshore and hills on the opposite side.

There is also the question of the previously mentioned Fardon album, reputed to be the earliest *published* photographic album known of views of any American or European city. It contains a cut-up panorama of San Francisco bound out of sequence.[7] It also contains views of street and buildings massed against a backdrop of hills. The space is shallow and even the farthest buildings are clearly detailed.

Could not Watkins have looked at the valley floor and decided to approach it with his giant camera in a similar manner – the river and the bushes and grasses in the foreground substitutes for the streets, sidewalks and street furniture; the trees for architecture; and the rearing granite walls for the hills upon which buildings rise? There is even a cropped telegraph pole in the album that is reminiscent of Watkins' cropped tree in the high view of the valley. Even more important,

implicit in the Fardon album is the idea of recording the inside and outside physiognomy of a site. Were Watkins' ideas influenced by this album?

Certainly Watkins must have been aware of panoramas, and he may have known of the Fardon album. But this proves nothing, because it is most likely in early photography, and particularly with Watkins (as well as O'Sullivan), that pragmatic choices – temperament working with opportunity and subject – played a greater role than precedent. Unlike more modern photographers, Watkins gave no clue as to how he conceptualized his ideas; he published nothing. Nor do we have any evidence that he saw solutions to pictorial problems in terms of how the problem had been solved elsewhere. He seems to have been mainly empirical in his approach: his photographs reveal a great deal of observable trial and error, especially in the beginning, around 1861, where the same subject is photographed time and time again with a wide range of results. I think we simply have to think of Watkins as a pioneer who technically explored landscape with a big camera, and in the process extended the possibilities far beyond his contemporaries.

Watkins had an exceptional pictorial intelligence, particularly in the way in which he organized his image on the ground glass, balancing light and dark into a completely integrated surface. One doesn't come across this quality too often in nineteenth-century landscape photography, the exceptions that spring to mind being O'Sullivan and Samuel Bourne, the Victorian photographer of India. Bourne was a romantic imperialist and very clever tourist who went around photographing in a documentary vein to convey information to the public back home about the glories of their empire.

Watkins is very different from Bourne in spirit: Watkins became deeply involved in an obsessive fantasy which was simultaneously personal and collective; for him, the world of Yosemite, and the many other places in the West he was to photograph later, became a dreamscape of total possibility. The mountains of India meant little to Bourne except as a romantic backdrop, a marvelous stage setting, whereas to Watkins, Yosemite offered archetypal monuments of the massiveness of American space and of potential energy as yet unleashed. I also think

that as with many other American artists, both painters and photographers, there is a sense of history involved in Watkins' outlook, of past chaos and future meanings. It's as if his discoveries hover between these two possibilities.

Watkins' Yosemite photographs contain a great deal of incident yet they are extremely factual. He seems to insist on this in his work. At the same time he generalizes very successfully. His images are not mysterious like O'Sullivan's, not at all laced with his taste for passionate extremes. There are none of O'Sullivan's crazily silhouetted mountains, asymmetrically composed with abrupt blackenings, and surrounded by an empty, awesome and menacing landscape.

O'Sullivan was heavily influenced by Clarence King's anti-Darwinian theory of "catastrophism" that proposed: "If catastrophes extirpated all life at oft repeated intervals from the time of its earliest introduction, then creation must have been oft repeated." This trauma-oriented theory finds clear expression in O'Sullivan's histrionic imagery. Watkins, on the other hand, seems to have been singularly uninspired by King's theories. Among his most insipid photographs are those he took for King's 40th Parallel Survey in 1870, and indeed the air of steadiness and incremental change in Watkins' work seems to have something of the Darwinian about it. In contrast to O'Sullivan's tendency to extremes, Watkins always maintained in his work a certain distance from the putative viewer. His imagery is without conceit; he never exaggerates to gain an effect.

Notes

1. True, there are the recollections of his friend, Charles Turrill, published two years after Watkins' death in 1916. Turrill, however, only knew Watkins later in his life, and his memoir is based on the hearsay of a failing mind describing events that occurred some 50 years before. So far, very little in the way of proof has been turned up to substantiate this account. See. C. B. Turrill, "An Early Californian Photographer: C. E. Watkins," *News Notes of California Libraries*, 13 January 1918, pp.29–37.
2. The album has been republished in paperback with an introduction by Robert Sobrieszek, G. R. Fardon, *San Francisco in 1850s*, Dover, New York, 1977.
3. I'm aware that Watkins' numbering is a mess. At various times he numbered the valley floor images, for, I presume, catalog purpose only, and the numbers do not

match a sequential journey from south to north except at the beginning and the end. Watkins also sold photographs to other publishers, one of whom (Houseworth) used his own numbering system. In addition, Naef mentions that Watkins' early valley mammoths are not numbered at all. However, the fact that the numbers are not always sequential does not affect the seriality, since we now, or Watkins then, could have arranged the images in a sequence that followed the topology of the valley in a southern to northern direction.

4. See my *Serial Imagery*, New York Graphic Society, 1968, for further elucidation of serial systems.

5. Shortly after Watkins, in 1871, O'Sullivan also employs seriality in his journey up the Colorado River on the Wheeler Expedition. As he journeyed up the river he photographed each campsite, including whenever possible his boat, the *Picture*; the view upriver; and then a second, matching view down river. Thus each linked pair of photographs reveals the present (the campsite), the future (the view upriver) and the past (the view back the way they had come). These photographs are united by a macro-structure, the journey recorded from stop to stop. O'Sullivan was in San Francisco in 1867 and most likely saw Watkins' photographs. However, it is just as likely that the journey itself suggested the structure. In addition, there is O'Sullivan's Green River 1872 serial set of six photographs recording at intervals from a fixed point the light passing over the river canyon.

6. One of the more famous surviving daguerrean panoramas is *View of San Francisco*, 1853 (maker unknown), a six-plate panorama reproduced in the Oakland Art Museum catalog of the 1973 exhibition organized by Therese Thau Heyman, "Mirror of California."

7. I'm grateful to Beaumont Newhall for pointing this out to me.

The Private Eye of Philip Guston*

Philip Guston's recent paintings, drawings, and these new prints ruminate on life itself. They must be counted among the most important accomplishments of American art in the past decade for the way in which they open alternative pathways of expression.

The mood of Guston's new work is one of pervasive silence. His imagery is languid and sleep-charged, private, personal, and arcane. The time frame is non-linear, mixed, zig-zagging elusively between the present and the past. Nor are we certain at any given moment as to whether Guston is awake or asleep or, implausibly, both. His imagery is at once zany and sinister, part dream-world, part real. Guston's art is autobiographical, distilled from his ruminations. The brushwork and drawing imparts a feeling of his persona. It is as if Guston has abstracted aspects of his own craggy features and his slow-moving, bulky figure, transforming them into elements of line and shape. He parodies himself and his subject matter, menacingly plays the clown at the same time that he ironically solicits our sense of pity.

Central to Guston's hallucinations and muddled dreams is the contest between structure and subject, between his slurps of paint and the ridiculous objects depicted. The outcome is always suspenseful: we never know for sure what's winning that continuous contest. If a drawing goes sour, Guston can discard it, take another piece of paper, and start again. Easy. The paintings, on the other hand, are never abandoned. They are battlefields between a mutinous ego and id refusing to conform to their roles, with Guston standing to one side and egging them on. Guston thus becomes his own best enemy. Guston's sense of structure, his will to order his canvas surface, is that of his abstract paintings and it regularly threatens to submerge his gritty imagery, only to be rescued at the last moment by the energy of the brushed line which darts and slithers, piling and jamming tragicomic inventions that pun on memory and language. A heavily stitched football, for example, opens its despairing eye only to transpose itself into the eye of a potato.

* First published by Gemini G.E.L., Los Angeles, 1980.

In another example, the primordial Jungian sea momentarily disgorges to reveal mindless flotsam and jetsam – an empty man's jacket, rotund from human usage, held up on either side by booted fingers attached to stockinged legs adrown in helpless existence.

Guston loves paintings of battles, especially those of the great painters of the Renaissance. In fact, he recently said that the whole trouble with abstract art, its restrictiveness, is that it denies painters the right to paint what they want. "It's as if Moses came down from the Mount and commanded Thou Shalt Not Paint Battles." So Guston does just that, and we see his American battlescapes of humanoid garbage lids held up by hairy, bent, pistonlike arms battering at each other like a squadron of goons run amok. Or, a dark storm rages over a desolate battlefield and pours bullets of rain on the drenched and sorry corpses of Guston's expired brushes and boots.

At times Guston's imagery moves from the private to the public domain by mocking self-denunciation, derision thereby becoming the father of invention. For example, Guston is a heavy smoker of the strongest non-filter cigarettes, and utterly imprisoned by this habit wherein guilt constantly succumbs to the pressure of inhalation. This pleasurable ambivalence begets two unattached fingers, holding a smoldering cigarette in a cluster of wide-eyed, half-drowning heads drifting aimlessly within sight of land and salvation. Or, again, in an image that spoofs de Chirico's style, an artist's mouth is sealed by layers of tape yet smoke issues forth from his drawing hand, thereby establishing once and for all the axiom: there is no creativity without smoke.

Guston's most nightmarish memoryscapes are those without vegetation: treeless urban deserts littered with intestinal inventions that propagate and feed upon themselves, or with similarly sinister agglutinations of monstrous science fiction things that rear up from the deep. At other times, Guston cocks a drowsy eye, only to find that his hanging clothes have a life of their own and threaten him from afar. There's no peace, no getting away from his own mad imagination. Guston persistently and unwittingly haunts himself and us by turning harmless

household appurtenances – doorknobs, hatracks, chairs – into ominous portents. Only occasionally is Guston able to outwit himself. Pulling a concealed trap in the floor, he gleefully tumbles a jumbled pile of excrescences back into the void.

With his humorous and droll invention, Guston maintains a precarious balance between contradictions. This balance is the stuff of fairy tales, both grotesque and charmed. Guston is a modern-day Rip van Winkle who, having awakened, keeps pinching himself to see if he is alive, to see if what is real is true and if what is true is real. And, if the world that Guston depicts is topsy-turvy, then the viewer is free to tug at one of the fancy velvet bell pulls – Guston provides an adequate supply in convenient locations – to summon psychiatric help. The question is for whom?

Brancusi as Photographer*

At the turn of the century other sculptors besides Brancusi had made or used photography. Medardo Rosso, for example, made photographs of his sculpture. And Auguste Rodin (with whom Brancusi briefly studied in 1907) was evidently fascinated by the medium and used it extensively. According to Albert Elsen, Rodin employed a number of photographers as collaborators by contractually retaining control over the lighting and composition of the photographs; thus they were taken according to Rodin's specific viewing of the subject on the ground glass.

Though by 1918 Brancusi had established the principal thrust and themes of his sculpture, and was already a noted and influential artist, he was still hardly more than competent as a photographer. Man Ray's recollection, that Brancusi's renewed surge of interest in the medium around the early twenties was occasioned by his dissatisfaction with the photographs of his work taken by others, may indeed be correct, but seems inadequate to explain the intensity of Brancusi's concern. There must be a more plausible explanation for the large body of photographs left in his studio. Equally difficult to either prove or accept is the suggestion that Brancusi documented the progressive evolution of each stage of his sculpture. Such data appearing in his photographs is probably no more than coincidental, for all photographs are to a greater or lesser degree evidentiary: they record the specific appearance of things or people at a given moment. Whatever the apparent circumstances, a more likely factor is the implicit correspondence and common linkage between sculpture and photography because of each medium's intricate involvement in light, space and temporality.

In contrast to painting, sculpture is a medium crucially affected by light, the palpability, intensity and location of which irradiates sculptural form to reveal and define mass, contour, surface, color, and even mood. The expressive appearance of a sculpture can be radically altered by changes in light. Sculpture is also an ambient art. Light conjoins sculpture to the space in which it is seen. (Different materials, for

* First published by the Akron Art Institute, 1980.

instance, wood, stone, marble, and bronze will absorb or reflect light according to the way they are worked.) Highly polished bronze will refract and reflect light as well as mirror the viewer and parts of the surrounding ambience. As the viewer moves so does the reflected image. Paintings finish at the edge of the frame; in comparison sculpture is a contextual and temporal medium, and nowhere more so in the first half of the twentieth century than in Brancusi's oeuvre.

The word "documentary" is often used in association with Brancusi's photographs. It should be borne in mind, however, that this word's modern usage derives from film and television, wherein it means to dramatically structure real events to give the impression of an actual event. This sense of the word is applicable to Brancusi's photographs only in that they document his thoughts on sculpture rather than outward appearance of the sculpture.

Paradoxically, though Brancusi had been photographing his work for years, his impulse in the early 1920s to better his photographic vision leads him not toward the photography of his time, but toward the most advanced painting – Synthetic Cubism (nos. 13–17 and 18–25, as well as many others[1]). Though present and carefully depicted, the sculptural objects in many of these photographs appear to be almost irrelevant. In the fusion of mass and void they become props subservient to the structure of the photographs, and thereby subsumed into the overall pictorial surface. Brancusi eschews normal photographic rendition of space for one that is painterly: shallow, impacted, and with any suggestion of a horizon or boundaries completely minimized. The light consciously avoids dramatic highlights and shadows that might detract from the overall unity of surface and form. When Brancusi intensifies the contrasts of light and dark (nos 18 and 26), the detail of the sculpture is explicitly suppressed in deference to unity of surface; they appear as virtually black bulky shapes, mere compositional elements. The introduction of a Cubist syntax into photography at this date is an astonishing move on Brancusi's part, and utterly at variance with the most advanced photography of the time. By and large, with the sole exception of Paul Outerbridge, no photographers thought to address themselves to visual problems of this nature, either in Europe or America, until at least a decade later.

Though he limits himself to the accoutrements and sculptural objects in his studio (and sometimes adds a personal touch such as flowers or a plant), Brancusi's subjects are not randomly found: he selects, stacks, and carefully composes his material. In the *View of the Studio* (no. 35) another subject, another medium, is introduced, the overlapping pile of canvases (in the upper right corner), as a reminder of a different phase of his artistic endeavor. The sculptures he is working on are thrust forward, the light falls back, and the weight of the photograph is at his feet. The unexpected closeness of the viewer to the objects enforces a sense of drama. The photograph speaks of the past, of things completed, of those set aside for the time being, of actions about to be taken, and of a range of thinking going on. The shape of the circular iron mooring ring attached to the massive mooring post corresponds to the image of the head and shoulders in the topmost, stacked painting, to the marble form on the sacking in the foreground, and to the bronze *Newborn* on the soapbox (to the left). This is a very intentional photograph: Brancusi reveals the origins of various sculptures, the occurrence in nature of the original form (the head) and the variety of materials with which he works. Thus the photograph not only documents his working processes but does so within a Cubist mode; the various objects are impacted within a shallow, frontal space of overlapping planes.

Another sensation and a different drama is evoked by a cluster of images in which *Bird in Space* is the focus of attention (nos. 28–32). Positioned above the piled debris of the studio (and above all other sculptures), *Bird in Space* takes on a supravisibility, as if to say that *this* sculpture, having emerged out of the materials, tools and processes, and out of the life of the maker, embodies a reservoir of memories, efforts, and thoughts about art so potent that they will lead to yet other sculptures to be made out of some future, unknown meditations. Above all, these photographs disclose Brancusi's state of mind. The various objects visible in the photos are only incidental to a much larger view of art.

In two views of *Bird in Space* taken from a high vantage point (nos. 31 and 32) Brancusi photographs downward onto the light. The paired photographs reveal how he changes the weight of light and dark to manipulate the eye of the viewer evenly over the surface. The corner of the studio is so arranged that it appears like a giant, faceted environ-

mental sculpture of raw, cubed stones punctuated and accented by many different sculptures positioned to lead the eye to the far-off *Bird in Space*. The space is painterly and suggests the contrapuntal rhythmic vocabulary of analytic cubism. Both photographs seem to have been taken within a short time of each other. In the second photograph there are slight changes in the light, the crop, the position of some sculptures, and another *Bird in Space* has been added. Because of its dominant position, Brancusi seems to state that *Bird in Space* has come into being as a consequence of a vast amount of activity over many years; and that highly focused and intentional gestures are necessary to make a piece of sculpture. But as a result of those gestures, changes occur in the studio that relate to the idea of sculpture as well as to a specific sculpture. These highly intentional actions may be aimed toward producing a single sculpture; however, they also produce consequential actions that change the appearance of the studio. So the photographs frame not only the piece Brancusi has been working on, they also convey information on how his energy has modified the whole environment, and how the space has been modified by the sculpture.

Brancusi consistently probes the possibilities of photography by changing focus, scale, crop and the intensity of light. The exploration and control of one aspect at a time of these properties permeate clusters of his photographs. It is doubtful, however, if technique is the catalyst to the thought. Rather, he bends photography toward his will. In one series (nos. 42–45) different qualities of light are used to alter the appearance of *Bird in Space*. The photographs progress from direct daylight pouring in through an open window, to light filtered through opaque glass, to artificial light (two lamps), to enhanced artificial light (intensification of exposure). Because there is no intention on Brancusi's part to set up a situation whereby one of a number of alternatives is better than the others, it would be pointless to assert which photograph is better or best. Instead, Brancusi is revealing how he works as an artist: not by carving, or casting, or even photographing (these are merely mechanical or technical operations), but by pursuing a continuously renewing potential. Though different, each photograph is about the same subject matter. And like the 16 variations on the *Bird in Space* that Brancusi was to make over his lifetime, the four photographs signal his interest

in that theater of the mind where a state of unfinishedness and progression can play itself out more dramatically and assertively than in the idea if a single image. Once this point of abstraction is apprehended then it is possible to understand these photographs as documentary in the most complex, expressive and poetic sense of the word.

Brancusi's photographs can be split into two distinctly contrasting modes: 1) those in which the studio is the principal field of activity; and 2) single pieces of sculpture isolated from the environment. In the latter, the background tends toward the neutral, and the treatment of forms veers toward the abstract. In many, beauty of form and light is so concentrated, that the rest of the world seems irrelevant. The theme itself is more glamorous than the rough-and-ready working situation in the studio. These photographs have a distinct tendency toward the glamor portrait of the period, especially in the series consisting of the profile, three-quarter, and frontal views of the marble bust of *Mlle Pogany III* (nos. 68 and 70).

There is little doubt, too, that in many of these photographs Brancusi reveals a knowledge of and is influenced by some of the most advanced photographic thinking of the period, especially in the two photographs of *Leda* (nos. 75 and 76). The circular, polished base of this sculpture was designed by Brancusi to be turned, and the photographs are about this implied kinetic quality. When viewing these photographs it is difficult to conceive of the sculpture as a single heavy object. Shadows and reflections disperse the eye over the surface to diffuse the visual center of attention; the sculpture dissolves into a photographic light abstraction, not unlike the (earlier) Vorticist photographs of Coburn, or the more contemporary images of Brugiere.

At times, Brancusi's desire to mold the viewer's eyes and to enforce his own vision of his sculpture seems almost authoritarian. There seems to be no escape. Yet there is another moment when we look at these photographs and realize that they represent a wonderfully condensed and impacted view of a work of art.

Brancusi often appears in his own photographs, as if to say for a work of art to exist there has to be a maker, an artist imposing his will. Brancusi was a wonderfully intelligent and passionately serious photographer. Unlike any other photographer, he not only pressed the

release and made the total photograph, but he made all that is in the photograph: the environment, the way of life, as well as the art itself.

Note

1. All numbered photographic references in parentheses refer to the French language edition of the Centre Georges Pompidou Brancusi monograph.

Epilogue

Dear Joseph:

This letter is about the disposal of my body after my death, and some wishes I have concerning this matter that hopefully will involve your cooperation.

In my current Will I request that my body be cremated privately, without benefit of any religious service, or any ceremony whatsoever. I don't at all mind some of you having a drink afterwards, but no more than that. The problem is I forgot to say what to do with my ashes, and that is what this letter is really about.

Something has to be done with them. The undertaker will put them in a pot and hand them over to you if he is not instructed to do otherwise, for example, store them at an annual expense in some place or other. It is illegal to scatter the ashes on land or sea, other than beyond the territorial limits. So, it is likely that you will take the pot home and put it on the mantleshelf or in the basement or attic (if you have one or the other). Sooner or later your current wife or girlfriend will scream at you that the presence of your father's ashes gives her the creeps; and when you are not looking she will dump me in the garbage, or worse, down the toilet.

I don't look forward to this, so I have a proposal and will leave you money to put it into effect.

What I want you to do is to tell the undertaker to do a good job. He must first remove my dentures in case they won't make fine ashes, and ensure that no pieces of bones are left. Pay him to do the job twice if necessary. Then take the ashes and break them up into a number of little piles and package them somewhat like drug dealers do with grams of coke. I don't yet know how many packages you will need; you will have to use your noodle and work that out. Maybe you can keep some in reserve.

Now, I'm sure you remember your recent visit to London for my exhibition at the Tate Gallery and how I took you around to various places that I have known since my childhood. One of them was

Westminster Abbey, which impressed you mightily, especially the tombs of the various kings, queens, nobles, and famous people buried in the chapels, walls and underneath the floors. Of course, I can't be buried there because first of all I'm not Church of England. Jews, Catholics, Buddhists, Moslems, Hindus, and strange Protestant sects like Mormons or atheists have to go elsewhere. Secondly, you have to be famous in the United Kingdom, or find another spot that will have you (for a fee of course). To be sure, unlike the USA the Brits allow your ashes to be scattered in the landscape.

Now, there is no way I can get into the Abbey by the front door. What I want of you, dear boy, is to get me in via the back door. Take a packet of my ashes to the Abbey. Have a good look around. As I told you, a substantial part of the various buildings and those surrounding the quadrangle are nearly nine hundred years old. Look for an interstice, or hole somewhere in the structure, open the package and pour my ashes into it. Please don't let any one put you off, especially in England, by saying that a more suitable place for an atheist Jew would be Highgate cemetery where Freud is buried. We had enough of Freud in my lifetime. Please make sure that the spot you pick will allow the ash to be permanently resident somewhere in the Abbey structure. Whenever you visit London you can then come and say hello to me.

Of course there are now a number of other packets to be deposited elsewhere. The next city is Paris, and I want some of me buried in the Père Lachaise cemetery, the last resting place of many of the most famous French artists, poets, and writers of the 19th and 20th centuries. This will be an easy job. Make a reconnaissance of the cemetery. Look for the grave of some one you think I would like to be near, and dig a little hole in the grass and put me in it. The hole must be deep enough, so take a child's shovel concealed on you.

I'm not too keen on the United States. If you insist on depositing some of me here then the only place that I will be comfortable in is one of the great Native American mounds. However, either of the great Mayan Temples in Guatemala or Mexico is mandatory. For the moment I can't remember their names, but it is easy to find out if you ask any one who has some knowledge of the Mayans.

There are a number of other places that are mandatory: the

Taj Mahal in India, the Temple of the Tooth in Kandy, Sri Lanca (a Buddhist shrine); the Parthenon in Athens; one of the Pyramids in Cairo. (The temple building of the Parthenon is fenced off nowadays but there are ample grounds abutting it. Maybe you could bribe someone to get you inside. Anyway, being my son I'm sure you'll be able to sort out something suitable. There are conducted tours to the chambers inside the pyramids. You may have to go twice to find a suitable spot.) Then there is the question of Jerusalem. Please, Joe, not the Wailing Wall. I can't stand all those black coated and bobbing hatted Jews wearing black shoes with soles made thick enough to last twenty years. Try Absalom's tomb, just outside the city's medieval walls. (He was the third of King David's sons and slain by Joab.)

I have no interest in Eastern Europe, Germany, or the Scandinavian countries. I don't care that much about Spain or Portugal. Italy is mandatory, but where? Florence, Rome, Venice? All are more than welcome to have a little of me. I especially like Venice, but there is the problem of flooding. You will have to do a reconnaissance, and decide where I will be most comfortable. Forget Australia and New Zealand. However, there is the question of Capetown, where I spent part of my childhood. I would like you to take the cable car up Table Mountain and find a nice place with a view.

I have never been to China or Japan, so I can't advise you where some of me should be placed. I'll make some enquiries, and see what I can find out. Will let you know.

Now, one last matter of some delicacy. It's the question of your Mother. I think it would be nice if you bought a beautiful silver locket and chain, and put a little of me inside, and offered it to her. I don't know the best way you could approach her to find out if I would be welcome. However, the last thing in the world that I want when I'm dead is trouble, so probe delicately into the matter, always bearing in mind that I want to Rest in Peace.

Good Luck!

Chronology

1920
Born in London, England.

1938–46
Served in the British Armed Forces.

1946–47
Studied art in London and Paris and
began to paint.

1957
Work included in *Metavisual, Tachiste,*
and *Abstract Art in England,* the first
survey of postwar British Abstract Art.

1960
Left London and moved to San
Francisco, California. Taught at the
University of California at Berkeley.

1961
Final one-person exhibition of paint-
ings at the M. H. de Young Memorial
Museum, San Francisco.

1962
Co-founded *Artforum* magazine.

1965–67
Director of the Art Gallery, University
of California, Irvine.

1967–71
Senior Curator at the Pasadena Art
Museum, California, where he orga-
nized numerous exhibitions including
Jim Turrell (1967), *Roy Lichtenstein*
(1967), *Robert Irwin* (1968), *Serial
Imagery* (1968), *Richard Serra* (1970),
Andy Warhol (1970), and *Donald
Judd* (1971).

1969
Received John Simon Guggenheim
Memorial Foundation Fellowship.

1971
Editor-in-Chief of *Artforum* magazine.

1973–74
Receives the Frank Jewitt Mather Award of the College Art Association for services to art criticism.

1975
Received National Endowment for the Arts fellowship.

1978
Director of the Akron Art Museum. Founded the art magazine *Dialogue.*

1980
Returned to New York and became a photographer. Received National Endowment for the Arts fellowship.

1981
Photographs exhibited at Daniel Wolf Gallery, New York. Recent portraits exhibited at the Art Institute of Chicago, Illinois.

1983
Biennial, Whitney Museum of American Art, New York.

1984
Began series of self-portraits which continues currently. Exhibition at Pace/MacGill Gallery, New York.

1985
Received John Simon Guggenheim Memorial Foundation Fellowship.

1986
Received National Endowment for the Arts fellowship. Exhibition of self-portraits, 1984–85, at Pace/McGill Gallery, New York.

1987
Exhibition of self-portraits, 1983–87, at Blum/Helman Gallery, Los Angeles.

1988
"A Body of Work: Photographs by John Coplans," exhibited at the San Francisco Museum of Modern Art, California, and travelled to the Museum of Modern Art, New York, the University of Missouri Art Gallery, Kansas City, the Art Institute of Chicago, Illinois, and the Sala d'Exposicions de la Fundacio Caixa de Pensions, Barcelona.

1989
Exhibition of self-portraits, "Hand," at Galerie Lelong, New York, and at Blum/Helman Gallery, Los Angeles. "Mains" exhibited at the Salon d'Angle de la Regionale des Affaires Culturelles, Nantes. Exhibition of self-portraits at Musée de la Veille Charité, Marseilles.

1990
Exhibition of self-portraits at the Frankfurter Kunstverein, Germany. "Hand and Foot" exhibited at the Museum Boymans Van Beuningen, Rotterdam.

1991
Exhibition of self-portraits at Wadsworth Atheneum, Hartford, Connecticut. Exhibition at Galerie Lelong, New York.

1992
Received National Endowment for the Arts fellowship. Exhibition at the Andrea Rosen Gallery, New York, and retrospective exhibition at the Fundação Calouste Gulbenkian, Lisbon.

1994
Exhibition of self-portraits at Musée National d'Art Moderne, Centre Georges Pompidou, Paris; Ludwig Forum, Aachen, Germany. "Upside-Down Series" exhibited at the Andrea Rosen Gallery, New York.

242

1995
Works exhibited in "Rites of Passage,"
Tate Gallery, London.

1996
"Frieze" exhibited at Andrea Rosen
Gallery, New York, London Projects,
London, Yezgrski Gallery, Boston,
Patricia Faure Gallery, Los Angeles,
Galerie Nordenhake, Stockholm.

Index